NEW PERSPECTIVES
ON THE ART OF
RENAISSANCE NUREMBERG
FIVE ESSAYS

Jeffrey Chipps Smith, editor

THE ARCHER M. HUNTINGTON ART GALLERY
COLLEGE OF FINE ARTS
THE UNIVERSITY OF TEXAS AT AUSTIN
1985

Library of Congress Catalog Card Number: 85-72181

ISBN 0-292-75533-3

COVER ILLUSTRATION: Georg Pencz, *Rabbits Catch-
ing the Hunters*, handcolored woodcut, 1534–1535
(1550—with text by Hans Sachs), Boston, Museum
of Fine Arts (Horatio Greenough Curtis Fund).
(courtesy Museum of Fine Arts)

Contents

Foreword

In 1983, as part of its celebrations of the centennial of The University of Texas at Austin, the Archer M. Huntington Art Gallery organized a major international art exhibition, *Nuremberg, A Renaissance City, 1500–1618*. At the suggestion of Jeffrey Chipps Smith, curator of the exhibition and Associate Professor of art history, and Forrest McGill, then Assistant Director of the Huntington Art Gallery, five distinguished specialists were invited to participate in a two day symposium at Austin. Their stimulating papers and the resulting dialogue prompted thoughts of publishing slightly expanded versions of these talks. The result of these discussions is this volume, a publication made possible by a generous grant from the National Endowment for the Humanities. Although it proved impossible for Richard Field's talk to be included due to his prior commitments, Jeffrey Smith's inaugural lecture on the exhibition has been substituted.

Special thanks are due Dr. Smith for developing the original symposium into this completed summary and to the speakers for their distinguished contributions. Acknowledgments are also due to Professors Linda C. Hults (University of Tulsa), Peter W. Parshall (Reed College), and Robert W. Scribner (Cambridge University) who read and commented on early drafts of these papers; J. Robert Wills, Dean of the College of Fine Arts at The University of Texas, for his encouragement; Barbara Spielman of The University of Texas Press for her copy editing; Barbara Jezek for designing and producing this volume; Forrest McGill, who was deeply involved in this project before leaving to accept the directorship of the Museum of Art and Archaeology at the University of Missouri-Columbia; and other Huntington staff, notably Jessie Otto Hite, who assisted with the original symposium and the preparation of this volume, Andrea Norris, Ellie Francis, and Tanya Walker.

Readers interested in obtaining more detailed information about Nuremberg and its artists, beyond the observations made in this volume of essays, should consult Jeffrey Chipps Smith, *Nuremberg, A Renaissance City, 1500–1618* (Austin: The University of Texas Press for the Archer M. Huntington Art Gallery, 1983).

Dr. Eric McCready, Director
The Archer M. Huntington Art Gallery
The University of Texas at Austin

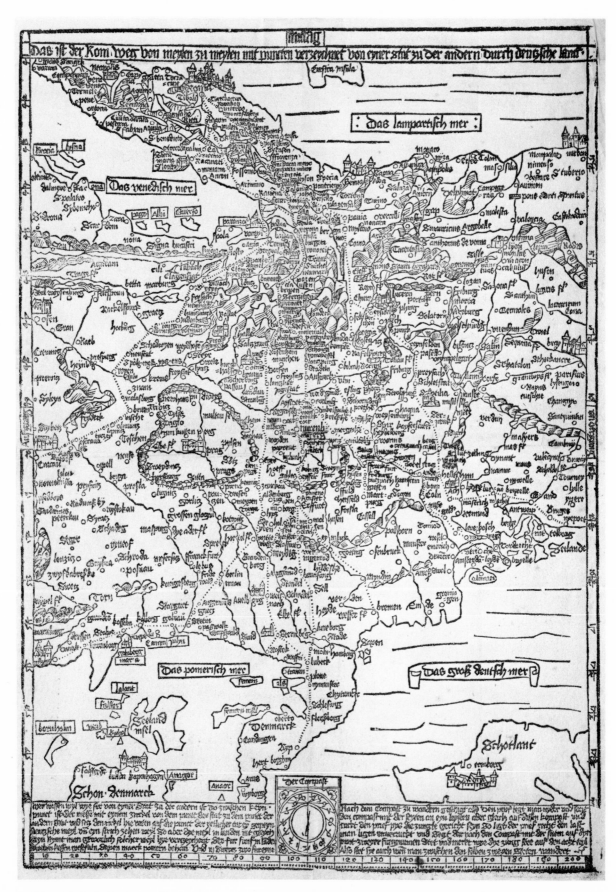

1. Erhard Etzlaub, *Road Map of Central Europe,* woodcut printed by Georg Glockendon the Elder in Nuremberg, ca. 1500, Washington National Gallery of Art (Rosenwald Collection). (courtesy National Gallery of Art)

Introduction

by Jeffrey Chipps Smith

During the sixteenth and early seventeenth centuries Nuremberg was the preeminent artistic center in Central Europe. As seen in Erhard Etzlaub's road map of 1500 (fig. 1), the city was situated at the heart of the Holy Roman Empire and on the principal north-south and east-west trade routes of the day. Its location was propitious not only to commerce but also to the exchange of artistic and cultural ideas. While Nuremberg was neither the largest nor the wealthiest city in Germany, it did support an exceptionally extensive and varied community of artists. No other German city produced as many major artists in as many fields and no other city enjoyed the same long-term influence as did Nuremberg. Only at the end of the sixteenth century did its lead in artistic matters begin to pass gradually to Augsburg, Munich, and Prague.

The reasons for Nuremberg's ascendency and continued prominence are complex and still not fully understood. Contributing factors include the cosmopolitan nature of the patrician, or merchant, ruling class; the active patronage of its members; the city's ability to attract talented masters and retain the best ones; and, paradoxically, the lack of a guild system. The local merchants were both well educated and well traveled, features that certainly influenced their tastes in art. Patronage of the arts was considered an obligation as families competed with each other in the adornment of the local churches and in the embellishment of their residences. The local government, run by the leading patrician families, sponsored numerous artistic projects, notably those for the Rathaus, and the town even had a small civic art collection. Talented pupils were drawn to Nuremberg to learn from Albrecht Dürer, Wenzel Jamnitzer, and other internationally renowned masters; many subsequently obtained citizenship. Local orders and outside commissions were bountiful enough to ensure a fairly comfortable living for the better masters.

Nuremberg had no official guilds. Since the city council, rather than the artists themselves, regulated the trades, it was somewhat easier for a gifted sculptor or goldsmith to settle in the city without paying exorbitant fees or conforming to restrictive trade qualifications. Artists were freer to develop new technical innovations. The city government was, however, highly protective of any artistic secrets that permitted it to maintain its economic advantage over Augsburg and other competitors. Thus goldsmiths and certain other craftsmen found it difficult to obtain civic permission to emigrate.

The citizens of Nuremberg were, I believe, unusually concerned with the city's image. In 1552 Hans Lautensack completed his two great etched views of

Nuremberg. While earlier prospects of Nuremberg exist, none rival the veracity or the audacity of Lautensack's prints. His *View of Nuremberg from the West* (figs. 2 and 3) offers a painstaking representation of the city's distinctive skyline and its immediate environs. The profiles of the castle and the parish churches of St. Sebaldus and St. Lorenz dominate. The viewer stands immediately behind the artist and a group of well-dressed men who gesture admiringly towards the city. This print is labeled "A truthful picture of the praiseworthy imperial town Nuremberg . . ." Its pendant, the eastern view, has the inscription "Here we have drawn the towers and walls of this city, to paint its riches was too great a task." In fact, Lautensack specifically sought to convey both the reality and the mystique of Nuremberg as is evident from the careful delineation of its well-fortified walls, majestic spires, and large houses to the fertile fields being harvested in the foreground. Each view is an encomium to the city's prosperity. It is hardly accidental that the city council rewarded Lautensack with a gift of fifty gulden since the image presented in his etchings is that of the ideal city. Through its art, Nuremberg scrupulously guarded its reputation as a peaceful, wealthy city.

In 1983 I curated the exhibition *Nuremberg: A Renaissance City, 1500–1618* for the Archer M. Huntington Art Gallery of The University of Texas at Austin. The exhibition and the accompanying book were devised as an introduction to the dynamics of Nuremberg during a period of dramatic religious and cultural changes. In conjunction with the show, five distinguished scholars—Christiane Andersson, Richard Field, Thomas DaCosta Kaufmann, Keith P. F. Moxey, and Larry Silver—participated in a symposium. Four of the symposium papers, in slightly expanded form, are presented here. Dr. Field, who delivered a fascinating assessment of Dürer's print style and its relationship to the styles of several of his immediate Nuremberg followers, was unable to include his essay due to prior commitments. My essay on patrician patronage is culled from remarks that I made in my inaugural lecture on the exhibition in Austin and another talk given at the Nelson-Atkins Museum of Art in Kansas City.

This collection of essays offers a stimulating introduction to five different aspects of Nuremberg's cultural patrimony. Each reflects the scholar's current research interests rather than a comprehensive or unified view of the city's art, thus the unusual emphasis on prints. Nevertheless, the authors are all concerned with issues of the social and political functions of art. Specifically, all deal with theories of reception. Why

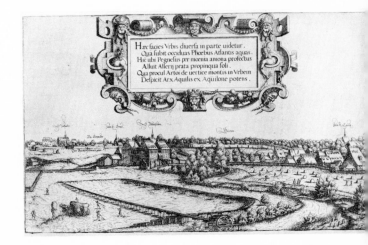

did Emperor Maximilian I need to create and to disseminate flattering imperial images? What role did woodcuts play in shaping religious and social ideas? Did the interpretation of Albrecht Dürer's work by artists and collectors change during the course of the sixteenth century?

Silver considers both the relationship of Emperor Maximilian I and Nuremberg and his exploitation of the propaganda potential of the woodcut print. He discusses Maximilian's revival and transformation of Roman imperial imagery in such projects as the *Triumphal Procession*, the *Triumphal Arch*, and Dürer's portraits of the Emperor. Maximilian, his artists, and his advisors created an ideal and timeless interpretation of the Emperor's reign and his *dignitas*; or, as the author states, Maximilian recognized that "history through poetry thus becomes myth."

Kaufmann boldly challenges traditional scholarly interpretations of Albrecht Dürer and Dürer's significance to the Renaissance in Germany. He argues that our modern view of Dürer is actually one formed at the end of the sixteenth century rather than one contemporary with the artist. Using a series of case studies, Kaufmann demonstrates that Hans Baldung Grien and Lucas Cranach questioned and rejected many of the values embodied in Dürer's art. He suggests that contemporary hermeneutic theory, which has been overlooked by most art historians, may reveal a less rational side to Dürer and to German Renaissance culture.

Andersson explores the cultural phenomenon of the polemical print, woodcuts with short inscriptions that were used in the propaganda battle between Protestants and Catholics during the early years of the Reformation. Although Nuremberg's artists produced

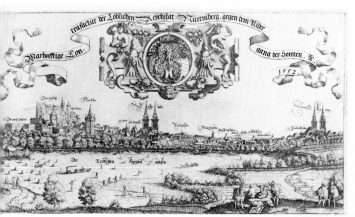

2. Hans Lautensack, *View of Nuremberg from the West*, etching, 1552, Washington, National Gallery of Art (Rosenwald Collection). (courtesy National Gallery of Art)

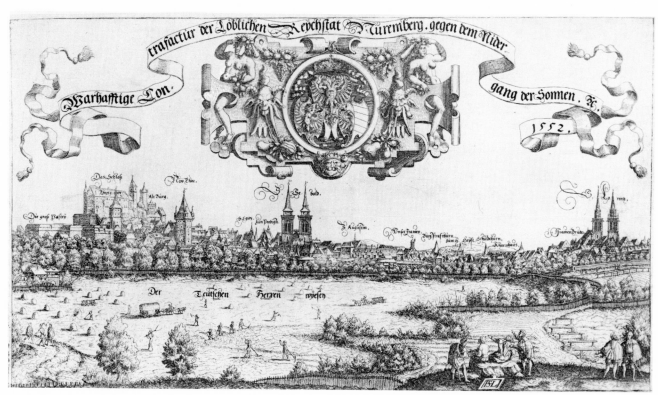

3. Hans Lautensack, *View of Nuremberg from the West*, detail.

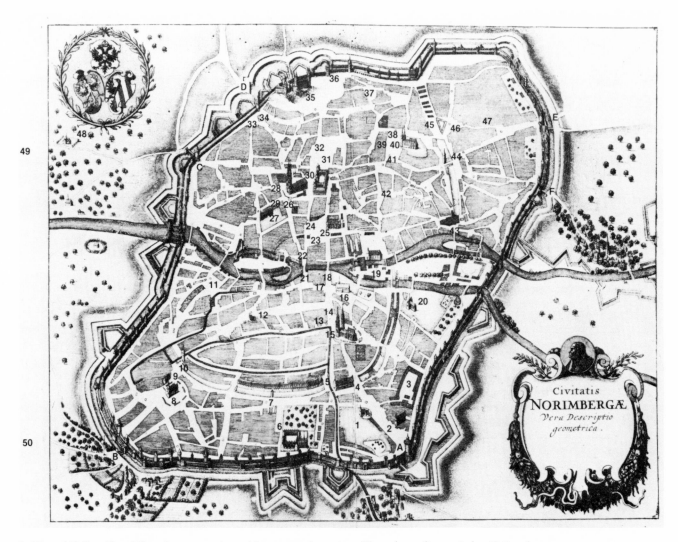

4. Wenzel Hollar, *Plan of Nuremberg*, engraving, mid-seventeenth century, Nuremberg, Germanisches Nationalmuseum. (courtesy Germanisches Nationalmuseum)

A. Frauentor
B. Spittlertor
C. Neutor
D. Tiergärtnertor
E. Laufertor
F. Wöhrder Torlein

1. St. Klara
2. St. Martha
3. Baumeisterhaus and Peunt
4. Kornhaus
5. Zeughaus
6. Kartäuserkloster
7. Mendel Zwölfbrüderhaus
8. St. Jakob
9. Enclave of the Deutsche Herren and St. Elisabeth
10. Weisser Turm
11. Unschlitthaus
12. Karmeliterkloster and Salvatorkirche

13. Nassauerhaus
14. Fountain of the Virtues
15. St. Lorenz
16. Franziskanerkloster (Barfüsserkloster)
17. Viatishaus
18. Barfüsserbrucke
19. Heilig-Geist-Spital
20. St. Katharinenkloster
21. Fleischbrücke
22. Fleischhaus
23. Hauptmarkt (fig. 5)
24. Schöner Brunnen
25. Frauenkirche
26. Waage
27. Augustinerkloster
28. St. Sebaldus
29. Sebalder Pfarrhof
30. Rathaus
31. Dominikanerkloster (Predigerkloster)
32. Burgstrasse and Fembohaus

33. Albrecht Dürerhaus
34. Pilatushaus
35. Burg
36. Kaiserstallung
37. Toplerhaus
38. Pellerhaus and Imhoffhaus
39. Kobergerhaus
40. St. Egidien
41. Egidien, or Melanchthon, Gymnasium
42. Veit Stosshaus
43. Herrenschiesshaus
44. Landauer Zwölfbrüderhaus
45. Sieben Zeilen
46. Tucherhaus
47. Hirschvogelhaus
48. Pilger-Spital Heilig Kreuz
49. Johannisfriedhof, Johanniskirche, and Holzschuherkapelle
50. Rochusfriedhof and Imhoffkapelle

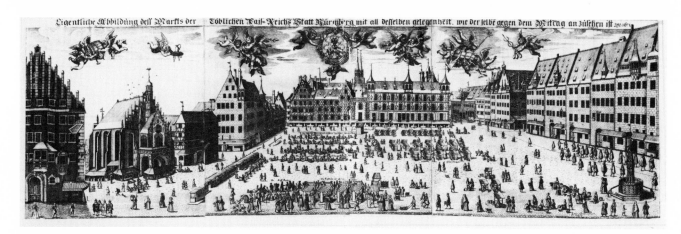

5. Lukas Schnitzer, *View of the Hauptmarkt to the South*, engraving, 1671, Nuremberg, Germanisches Nationalmuseum. (courtesy Germanisches Nationalmuseum)

more of these satirical woodcuts than did their counterparts in Wittenberg, Augsburg, or any other German city, their work is little known. Andersson identifies the basic categories of prints and then addresses their influence in shaping the attitudes of both literate and illiterate audiences.

Moxey, on the other hand, examines the secular woodcut. Using scenes of peasant festivals and mercenaries as a focus of his discussion, he challenges the traditional assumption that all popular prints merely transmit information. Instead he argues that the printmakers in Nuremberg used their art both to disseminate the attitudes of the ruling class and to influence the ideas of the lower classes. In this respect, Moxey's and Andersson's papers share a common thesis. Moxey contends that contemporary attitudes about the distinction between the civilized cities and the country, which was inhabited by uncouth, amoral peasants, are recounted in the prints of Erhard Schön, the Behams, and others. In the second part of his paper, he analyzes the ideal and the reality of the mercenary in literature and art.

My paper studies the activities of the Nuremberg patricians as patrons of the arts. The dynamics of this city differed somewhat from Augsburg, Bamberg, and its other principal rivals because its strong ruling merchant class controlled virtually all aspects of economic, political, social, and even religious life. Its outstanding community of artists was supported primarily by commissions from the patricians, who considered the enrichment of their churches, houses, and city as a matter of religious, family, and civic obligation. I chart the transformations of taste and the changing roles of art during the sixteenth and early seventeenth centuries. One particularly fascinating phenomenon is the rise of a new social ideal: the patrician connoisseur.

In the essays that follow, many of the buildings and monuments of Nuremberg are mentioned. To assist the reader, a list of the principal sites is given opposite. These are keyed to the letters and numbers that I have added to Wenzel Hollar's *Plan of Nuremberg*, a mid-seventeenth century engraving (fig. 4).

It is my hope that these five essays will stimulate the thoughts of other scholars and students of the Renaissance. This was the initial objective of the symposium on Nuremberg and the spirit in which the exhibition was conceived. I wish to thank Eric McCready and the staff of the Archer M. Huntington Art Gallery, notably Jessie Otto Hite, Ellie Francis, and Tanya Walker; my colleagues in the Department of Art at The University of Texas at Austin; my students; and the participants for contributing to the success of the original symposium. I also greatly appreciate the sympathetic support of my wife, Sandy, and my children, Spencer and Abby.

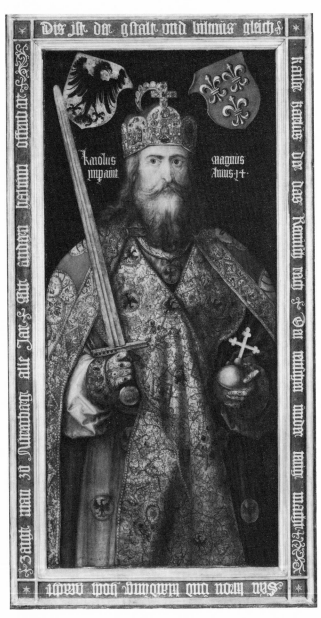

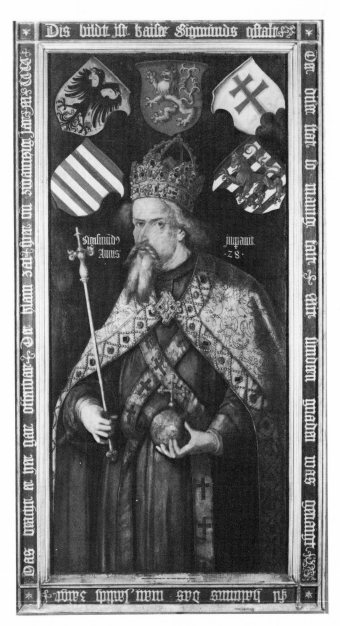

1. Albrecht Dürer, *Emperor Charlemagne*, painting, ca. 1510–1513, Nuremberg, Germanisches Nationalmuseum. (courtesy Germanisches Nationalmuseum)

2. Albrecht Dürer, *Emperor Sigismund*, painting, ca. 1510–1513, Nuremberg, Germanisches Nationalmuseum. (courtesy Germanisches Nationalmuseum)

Prints for a Prince: Maximilian, Nuremberg, and the Woodcut

by Larry Silver

The imperial city of Nuremberg held a special place in the Holy Roman Empire. After the promulgation of the Golden Bull by Emperor Charles IV in 1356 as a kind of constitution for the Empire, each new emperor was required to convene his first Diet in Nuremberg.[1] Charles IV had already adorned the city with the donation of the Schöne Brunnen on the market square and with the imperial construction of the neighboring Frauenkirche. But of even greater significance as a powerful link between Nuremberg and the Empire was Emperor Sigismund's 1424 decision to deposit within the city "in perpetuity" the official imperial insignia, regalia, and relics.[2] Every year for a two-week period these regalia were carried in procession and then put on public display at the time of the annual city fair, beginning on the second Friday after Easter. To commemorate this important custodianship, the Nuremberg city council commissioned the most famous local painter, Albrecht Dürer, to paint for the storage chamber a pair of life-sized figures of both Sigismund, donor of the regalia, and Charlemagne, the first Holy Roman Emperor (figs. 1–2).[3] These massive panels, now in the Germanisches Nationalmuseum in Nuremberg, were begun in 1510 with a compositional drawing (Seilern Collection, Courtauld Institute) and a series of careful studies of the individual items of the regalia: ceremonial sword, gloves, and imperial crown, in short, the objects conferring to the emperor the dignity and virtue of his office.[4] These panels were paid for in early 1513. Both pictures show the emperors, surrounded by the coats of arms of their dominions, dressed in ceremony, with Charlemagne wearing the items that were believed to have been his own. The inscriptions around the original frames proudly proclaim the city's ties to these famous emperors:

Charlemagne: This is the very portrait likeness
Of Emperor Charles, His Roman highness.
His crown and garments, painted here,
Are shown in Nuremberg every year.

Sigismund: Her is Emperor Sigismund's face
Who conferred on Nuremberg special grace.
In annual show are brought before
These precious relics since 1424.[5]

The portraitlike character of Dürer's *Sigismund* can

be confirmed by comparing it to Pisanello's early-fifteenth-century portrait of the same emperor.[6]

When the current emperor-elect, Maximilian I, made his last of six visits to the city of Nuremberg in the spring of 1512, he would surely have been aware of these massive images of his illustrious predecessors. It was on that 1512 visit that the Emperor entrusted Dürer with the supervision of his most elaborate and cherished artistic projects, the woodcuts *The Triumphal Arch* (fig. 9) and *Triumphal Procession* (fig. 12). Maximilian also made the contact that was to produce a third imperial portrait to add to the *Charlemagne* and *Sigismund* already in Dürer's oeuvre. Indeed, Dürer produced a pair of portraits of Maximilian, one on canvas (today in Nuremberg, Germanisches Nationalmuseum) (fig. 3), the other on limewood panel (Vienna, Kunsthistorisches Museum) (fig. 4), signed and dated 1519, the year of the emperor's death.[7] Both portraits are based on a beautiful chalk drawing (fig. 5), made from life in the summer of 1518 (28 June), when Dürer visited the emperor at the Diet of Augsburg; later, a study of hands holding a pomegranate, the personal emblem of Maximilian, was produced during the 1519 painting process.[8] Inasmuch as Maximilian died on January 12, 1519, both of these paintings were produced posthumously, and their rich inscriptions contain the vital statistics of the emperor as well as fulsome panegyrics. One inscription, in German, is written in the Gothic *Fraktur* script designed exclusively for Maximilian and employed lovingly in his printed books and woodcut projects.[9] The other inscription is written in Roman block letters as befits its Latin *laudatio*. In the paintings, once again, the ceremonial predominates. The upper-left corner shows the double-headed imperial eagle already found on *Sigismund* (Charlemagne carries only the single-headed, German eagle); around it runs the official chain-and-collar insignia of the prestigious Order of the Golden Fleece, whose sovereign Maximilian had been. Above it sits the distinctive "horned" personal imperial crown worn by Maximilian in most of his official portraits by the painter Bernhard Strigel.[10] In place of the crown, both the drawing and the two paintings present a soft, broad-brimmed hat bearing a religious badge on the head of the emperor. It is the addition of the inscriptions, the heraldry, and the poised hands before the half-length figure of the emperor that serves to remove him from our world, to distance and immortalize the lively and sketchy features of the drawing.[11] Like those on the *Charlemagne* and *Sigismund* panels, the Nuremberg figure is standing and dressed in imperial robes, and, although carefully copied from the drawing, the features of Maximilian are smaller in the picture, surrounded by the various impersonal devices and symbols. The fusion of the imperial with the personal is exemplified by the equation of Maximilian's private pomegranate device with the traditional orb of the Empire, as held by both Charlemagne and Sigismund, also in their left hands. The inscription in German in all probability was composed in Nuremberg by either Stabius or Pirckheimer, the programmers of the emperor's projects whom we shall meet below, and it was possibly penned by the renowned Nuremberg scribe, Johannes Neudörffer. That inscription is as formal in content as it is in appearance: "The most almighty, most invincible Emperor Maximilian, who in reason, wisdom, and manhood surpassed many and achieved noteworthy great deeds. . . . May the Almighty graciously bestow His divine mercy on his soul." The Vienna portrait presents an extended version of the same basic message in Latin stamped directly on the pictorial ground with the same iconlike permanence in its severe, crisp simplicity, beginning with the block letters. Now the reposing right hand on the lower edge of the picture—a pictorial motif originally derived from early Netherlandish portraits—suggests both an enthroned monarch and a barrier between the emperor and the observer, like a bust seen behind a balustrade. The study from life has become an epitaph picture as well as a final, painted instrument of Maximilian's artistic statecraft.

Dürer, however, created a fourth image of Maximilian even more suited to the emperor's own use of printing for propaganda purposes: a woodcut (fig. 6).[12] Even though this printed portrait is closer than either painting to the costume and the bust format of the original charcoal drawing, it nevertheless presents the most severe and august image of the emperor. Its honorific titles in the inscription are borrowed from ancient Roman coins, thus linking Maximilian in learned fashion with the continuous chain of emperors from Caesar Augustus through the Holy Roman Empire.[13] Also like the Roman *imperatores*, Maximilian is accorded quasi-divine status after his

3. Albrecht Dürer, *Portrait of Emperor Maximilian I*, painting, 1519, Nuremberg, Germanisches Nationalmuseum. (courtesy Germanisches Nationalmuseum)

4. Albrecht Dürer, *Portrait of Emperor Maximilian I*, painting, 1519, Vienna, Kunsthistorisches Museum. (courtesy Kunstistorisches Museum)

5. Albrecht Dürer, *Portrait of Emperor Maximilian I*, drawing, 1518, Vienna, Graphische Sammlung Albertina. (courtesy Graphische Sammlung Albertina)

6. Albrecht Dürer, *Portrait of Emperor Maximilian I*, woodcut, 1519.

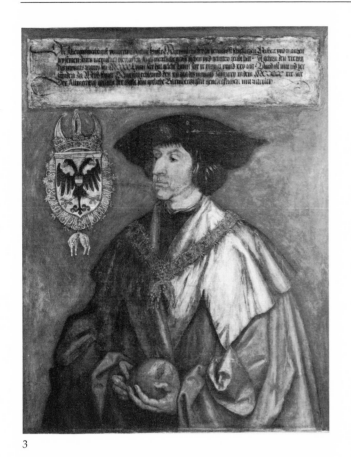

3

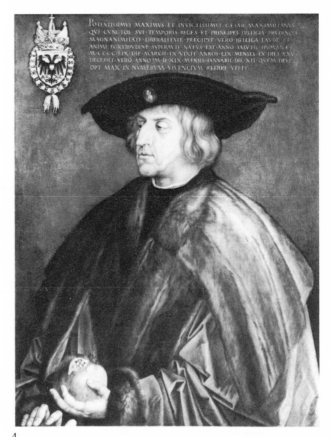

4

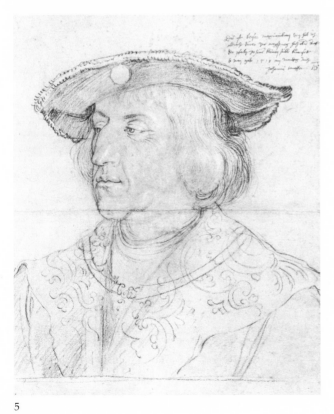

5

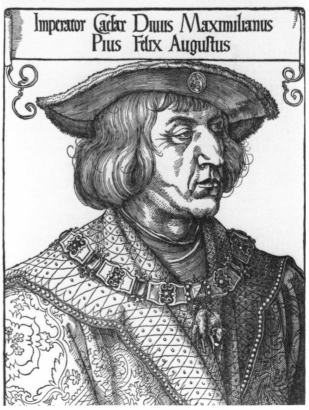

6

9

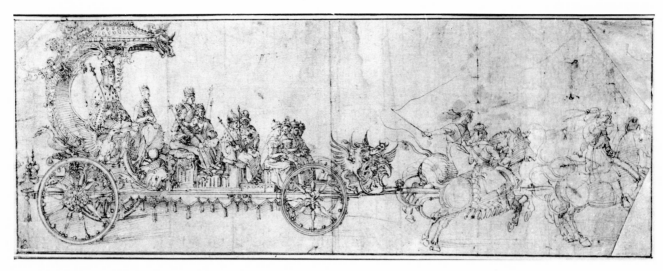

7. Albrecht Dürer, *The Small Triumphal Procession*, drawing, ca. 1512, Vienna, Graphische Sammlung Albertina. (courtesy Graphische Sammlung Albertina)

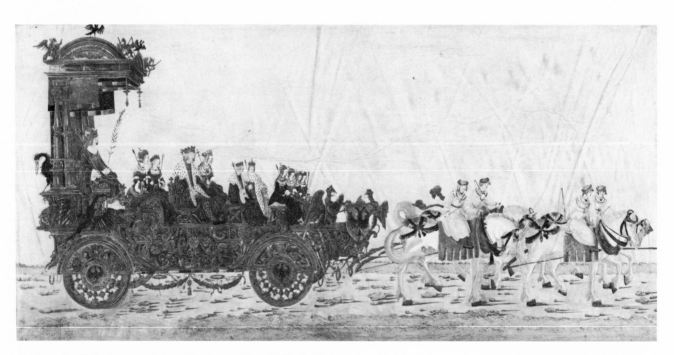

8. Albrecht Altdorfer or workshop (after Jörg Kölderer), *The Small Triumphal Procession*, drawing, ca. 1512, Vienna, Graphische Sammlung Albertina. (courtesy Graphische Sammlung Albertina)

death, with the designation "*divus*." We should try to remember that this commemorative woodcut portrait was the very first to be made by Dürer, though it was to be followed by eight other portrait prints in the next eight years. Here the powerful decorative patterns—of the Golden Fleece as well as of pomegranates on the emperor's brocade—set off against the blank white of the paper, serve to underscore fully his majesty as well as his distance behind the firm barrier of the framed border of the print.

Woodcut was the favored medium of Emperor Maximilian during this vital final decade of his life, when he requested Dürer to supervise his memorial projects. Around 1512, presumably in connection with Maximilian's visit to Nuremberg, we find Dürer's first involvement with these massive works on paper: an ink sketch (Vienna, Albertina; fig. 7) of the central chariot containing the emperor and his immediate family for the *Triumphal Procession* woodcut series.[14] This drawing was closely modeled on a previous design (fig. 8), either from a colored miniature (also now in the Albertina), completed after 1512 by the Altdorfer workshop in Regensburg, or its own lost prototype, documented as already completed by 1512 from the Innsbruck workshop of Maximilian's court artist, Jorg Kölderer.[15] It shows Maximilian under a baldachin accompanied by his first wife, Mary of Burgundy; before them sits their son, Philip the Fair, his bride, Joanna of Castile, and his sister, Mary of Austria. The six grandchildren of Maximilian, including future Emperors Charles V and Ferdinand I, sit at the front of the carriage. All of this arrangement accords perfectly with Maximilian's dictation for the "Emperor's Triumphal Car" in the 1512 instructions for the *Triumphal Procession*: "Then shall be brought the Emperor's triumphal car, depicted with the utmost richness; on this triumphal car shall be seated the Emperor in his Imperial dress and majesty. With him on the triumphal car shall be, in order: his first wife, also King Philip and his wife, and Margaret, and King Philip's children; Duke Charles shall be wearing a crown."[16]

At the same time, Dürer must also have begun designs for an even more massive project, the *Triumphal Arch* of Maximilian, whose woodcuts (fig. 9) were for the most part finished in 1515 but not printed until three years later owing to continual revisions by Maximilian of the section depicting his genealogy. The emperor's pleasure with Dürer's designs is clear from a letter he wrote to the Nuremberg town council in December of 1512: "Whereas our and the Empire's trusty Albrecht Dürer has devoted much zeal to the drawings he has made for us at our command and has

promised henceforth ever to do the like, whereat we have received particular pleasure, and whereas we are informed on all hands that the said Dürer is famous in the art of painting before all other masters, we have therefore felt ourselves moved to further him with our especial solicitude for the affection you bear us, to make the said Dürer free of all town imposts. . . ."[17] Such a departure from the ordinary closed-shop system of the crafts in Nuremberg smacked distinctly of favoritism and came to nothing. By 1515 Dürer was complaining about having received no remuneration at all to his Nuremberg compatriot, Christopher Kress, asking him to present the artist's petition at court: "Point out in particular to his Imperial Majesty that I have served his Majesty for three years, spending my own money in so doing and if I had not been diligent the ornamental work would have been nowise so successfully finished . . . You must know also that I made many other drawings for his Majesty besides the 'Triumph' . . ."[18] The problem was solved eventually, when in September 1515 Emperor Maximilian wrote a privilege from Innsbruck and settled a substantial annual pension of 100 florins on the artist, to be credited against Nuremberg's annual taxes to the emperor and paid to the artist from city revenues. The retainer was the equivalent, in Maximilian's far-flung empire, of making Dürer a court artist.

One of the other major projects Dürer undertook for Maximilian was the marginal decorations of his never-completed Prayerbook.[19] In the emperor's proof edition, printed on parchment in the *Fraktur* script with flourishes that simulated luxury manuscripts, Dürer provided about half of the elaborate monochrome marginal pen illustrations that would have completed the manuscript with illuminations. The remainder of the illustrations were divided among non-Nuremberg artists, including Lucas Cranach, Hans Baldung, Hans Burgkmair, and Albrecht Altdorfer.[20] The best evidence suggests that these drawings, too, would eventually have been reproduced in woodcuts and printed in a limited edition on parchment for the nobles in Maximilian's knightly order of St. George; however, as the calendar of saints was never completed, owing to Maximilian's futile attempts to have some of his ancestors canonized and included, the book remained only a fragment in proofs, so the question is moot. In all likelihood, Dürer worked on the Prayerbook decorations before his letter to Kress and at the same time as his drawings for the *Triumphal Arch*.

The Prayerbook offers us a good example of the kind of collaborative effort that went into most of

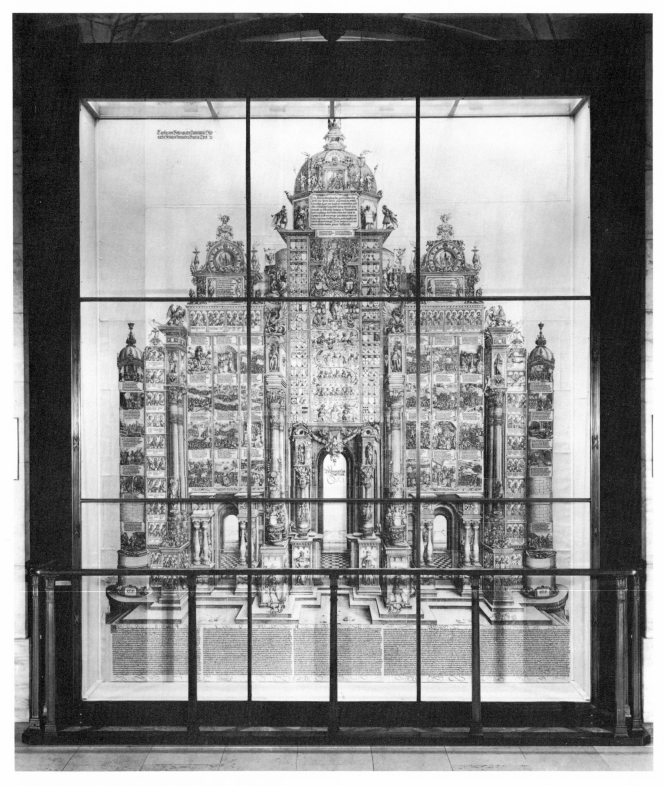

9. Albrecht Dürer and others, *The Triumphal Arch of Emperor
Maximilian I*, woodcut, 1512–1518. Photograph of the 1799 edition
on display at the New York Public Library. (courtesy New York
Public Library)

Maximilian's printed projects. The *Fraktur* script, known by its own uniqueness as "Prayerbook Fraktur," was designed in Augsburg for Maximilian by the city calligrapher, Leonhard Wagner, then cut and printed by New Year's Day 1514 by the Augsburg printer, Johannes Schoensperger. Schoensperger, like Dürer, received an annual pension from the emperor and in return was not allowed to use the new type for any other purposes. The supervision of the woodcutting of the letters and the invention of the calligraphic movable flourishes in print can be credited to Jost de Negker, who had recently moved to Augsburg from the Netherlands.[21] The entire project was supervised in Augsburg by the emperor's chief literary advisor, Conrad Peutinger, the learned Augsburg city secretary.[22] With this kind of teamwork and delegated executive administration, continually supervised from the top by Maximilian himself, we can hardly be surprised to find a team of artists, most of whom, like Dürer, were already notable for their achievements in the graphic arts, working successively on the border illustrations of the Prayerbook. It is for this reason that the progress of many of Maximilian's projects can be followed through his voluminous correspondence, especially to Peutinger.

The *Triumphal Arch* (fig. 9) was organized in much this same fashion, but, since here the pictures took precedence over the text, Dürer's supervisory role was correspondingly greater. In this project, as in all Maximilianic woodcut prints, the ultimate responsibility lay with an overall supervisor, in this case the court historian, Johannes Stabius, who devised the program and the texts, particularly the long explanatory collophon along the base of the arch. The collaborative production of this *Triumphal Arch* is acknowledged by the presence on the lower right of the arms of Stabius, Kölderer, and Dürer, respectively. In the case of the *Triumphal Arch*, as with the *Triumphal Procession*, Kölderer seems to have created the visual prototype, now lost, in the period between 1507 and 1511 under the supervision of Maximilian himself; indeed, the compositions of many of the scenes on the arch closely resemble Altdorfer's luxury miniatures for the *Triumphal Procession*, also produced after Kölderer's designs.[23] The Kölderer prototypes would be used first by Stabius in working out the details of the program and the illustrations, then later by the emperor to check and make corrections on his proof editions. A letter from Maximilian to Stabius in June 1517 makes clear how little got by the meticulous eye of the emperor: "The trial proof of the Arch of honor which we have now seen is not according to our instructions and does not correspond to the model in your hands.

We do not like it and are displeased . . . You will bring along the original design of the Arch of Honor which was given to you. We will then show you where it is lacking and how we wish it to be corrected."[24] Constant critical revisions of the emperor's genealogy in the center portal of the arch delayed the final printing of the arch for at least two full years, and then the project was only finally realized through a combination of Stabius's diplomacy and some visual vagueness at the bottom of the stem of the family tree.

Since this is a discussion of Maximilian's patronage and his ties to Nuremberg, a full analysis of the *Triumphal Arch* would be superfluous here, but the laudatory dedication of the collophon is worth spotlighting in connection with Dürer's subsequent portraits: "This Arch of honor with its several portals is erected in praise of the most serene, all powerful prince and sovereign Maximilian, Elected Roman Emperor and Head of Christendom . . . and in memory of his honorable reign, his gentility, generosity, and triumphal conquests."[25] So massive a project (174 woodcuts) could only have been a collaborative artistic effort within the large Dürer workshop. Only Albrecht Altdorfer of Regensburg, who had earlier completed the parchment miniatures of the *Triumphal Procession* and worked on the illustrations of the Prayerbook, participated from outside the city of Nuremberg. He is credited with the woodcuts in the outermost towers of the arch, showing scenes of the emperor that display his virtues and character. Dürer's own contribution seems to have been the bulk of the ornament as well as the crownbearer over the central door, the lower column figures, the four Habsburg ruler statues in tabernacles, the two Habsburg saints, one triad of Roman emperors, and a quintet of history pictures within the chronological cycle of the arch.[26] Besides Dürer, his student Hans Springinklee was entrusted with the remaining ornamental details, the central cupola, the frieze of busts, and the genealogy in the center, as well as half a dozen historical scenes; the remaining history pictures are ascribed to Wolf Traut. The wooden blocks were cut in the workshop of Hieronymus Andreae in Nuremberg; most of them survive today in the Albertina. In the inventory drawn up by Stabius after the emperor's death, a full 700 impressions of the arch are recorded.[27]

Springinklee also participated along with other artists, including Altdorfer and, especially, Hans Burgkmair, in the continuation of the massive *Triumphal Procession*. Even incomplete and published posthumously in 1526, the *Procession* comprises 137 woodcuts in a 54-meter-long row. Burgkmair's proofs, a series of 63 impressions, are preserved in Dresden,

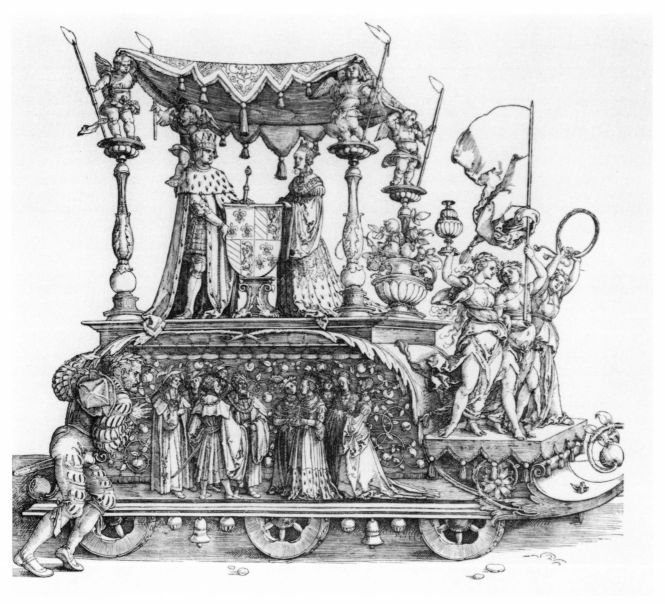

10. Albrecht Dürer, *The Small Triumphal Chariot*, woodcut, ca. 1516–1518.

inscribed with the date April 1, 1516.[28] The original program of the *Procession*, which we can imagine as complementing or even passing through the *Triumphal Arch*, was dictated by Maximilian to his private secretary, Marx Treitzsaurwein, as early as 1512; again Stabius assumed responsibility for the supervision of historical details, although no final text was ever devised. Here Dürer's own role was greatly reduced, though he still was in charge of the all-important chariot with the emperor, which was to be the climax of the *Procession*. His original image of the carriage with the larger royal family had in the meantime become condensed into an isolated image of Maximilian alone; a preparatory sketch (now in Dresden) of this

kind formed the basis for a wooden relief plaque in the Louvre commemorating the double state marriage in Vienna of 1515.[29] The eventual form of Dürer's *Large Triumphal Chariot* would appear shortly, but in the meantime, around 1516–1518, he placed the youthful Maximilian together with Mary of Burgundy in a separate woodcut carriage, usually now called the *Small Triumphal Chariot* (fig. 10), to appear as part of the *Procession*'s historical commemoration, akin to another chariot by Springinklee of the marriage of Maximilian's son Philip to Joanna of Castile. For the *Small Triumphal Chariot* Dürer designed two blocks, again cut by the redoubtable Hieronymus Andreae, one with the cart and the other with a team of four powerful

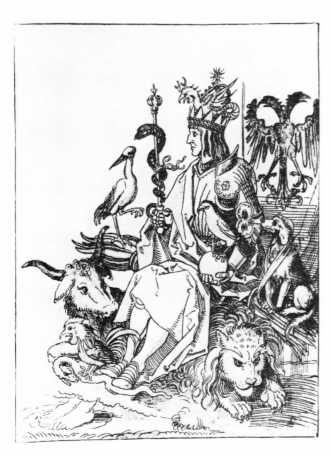

11. Albrecht Dürer (copy after), *Maximilian I Surrounded by His Hieroglyphic Symbols*, pen and wash drawing, ca. 1513–1518, design for the title page of Horapollo's *Hieroglyphica*, Vienna, Österreichische Nationalbibliothek, codex 3255. (courtesy Österreichische Nationalbibliothek)

rearing stallions reined in by a winged victory. A significant personal detail for Maximilian is the large vase of pomegranates at the foot of his nuptial chariot.

Up until now, we have seen Nuremberg artists, beginning with Dürer, producing commemorative or laudatory works of art in accord with prescriptions laid down by Maximilian himself and his circle of advisors and secretaries: Peutinger, Stabius, and Treitzsaurwein. We have seen relatively little independence or initiative from the artists themselves, who served the emperor chiefly in the guise of anonymous illustrators, part of a team who could realize his blueprints in fleshed-out forms. When, in a case like the *Triumphal Arch*, they strayed too far from the blueprint, these artists provoked the ire of the emperor on themselves and their program advisor, Stabius. We can understand better the particular attraction of Nuremberg by reflecting on how exceptional among Maximilian's monuments the painted portraits or his large bronze tomb sculptures actually were. Maxi-

milian had never really had a proper court center in the later sense of a palace like Versailles or even Fontainebleau. He spent much of his time in the saddle and was as likely to visit the independent imperial cities of Augsburg or Nuremberg as the Austrian lands that truly belonged to his family realm. Yet his desire to record his deeds and preserve his memory was as self-conscious and obsessive as that of any monarch. His solution, except for his tomb figures and a few other abortive sculpture projects, was to employ the graphic arts, then enjoying their greatest flowering in Germany. His sense of scale was still grand: the 54-meter *Procession* and the nearly-4-meter-high arch. His forms could also be luxurious, both in their *Fraktur* script and in their profusion of woodcut illustrations and ornamentation, not to mention the use of parchment rather than paper folios. What these graphic works of Dürer or of Burgkmair enabled was a reconstitution of imperial majesty throughout the German-speaking world and, through their particular replicable grandeur, perhaps even a greater consolidation of the revived Holy Roman Empire under the charismatic leadership and the dynamic imagery of Maximilian himself. Like the coinage that links a modern country or the sculptural surrogates sent by Roman emperors throughout their provinces,[30] Maximilian's woodcuts could serve not only as a personal monument, a *gedechtnus*, but also as instruments of statecraft. Unlike those of his father-in-law, Charles the Bold of Burgundy, who carried his insignia, tapestries, and treasury around with him as a kind of portable court, present alongside a peripatetic ruler, Maximilian's monuments could be present simultaneously at every center, even without him. Not being unique, they could not be lost or forfeited by being captured, like the Swiss army's capture of the Burgundian treasures as booty in war.[31] Not that prints need imply a "mass" medium in the modern sense or ought to seem cheap and disposable. In his projects, Maximilian took the "public" out of publication. His books and prints were the equivalent of the modern "limited edition," intended to appear unique and to be prized gifts distributed to favored nobles and court retainers, as both a reward for loyalty and a means to promote political cohesiveness. Neither the *Arch* nor the *Procession* nor Maximilian's luxury printed books on parchment were ever directed at the so-called common man. Instead, Maximilian's printed projects were able to achieve a Walter Benjamin paradox—mechanical reproducibility without the loss of an aura of both artistry and grandeur.[32]

If anything, the sense of privilege surrounding these prints of Maximilian grew stronger in his later

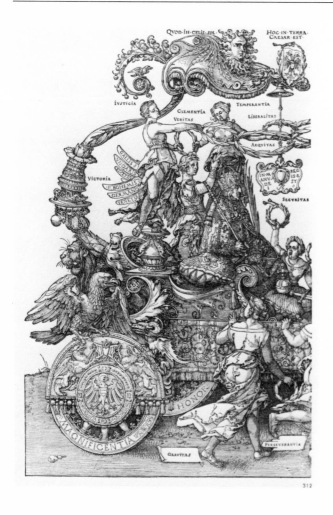

years with the increasing addition of allegory and esoteric learning. Here, too, Nuremberg played a major role, especially through the figure of Dürer's friend, the gentleman and scholar Willibald Pirckheimer.[33] Though he remained in Nuremberg, Pirckheimer was able to devise programs and imagery for Maximilian's projects that supplemented and eventually supplanted the more historical orientation of advisors like Peutinger and Stabius.

Around 1512, Pirckheimer began a Latin translation for Maximilian of the *Hieroglyphica*, an early Christian-era manuscript of hieroglyphic interpretation in Greek, ascribed to an Egyptian named Horus Apollo.[34] Dürer added illustrations to the copy presented to Maximilian in 1514. Modest in scale and in appearance, these hieroglyphics nevertheless had far-reaching consequences for Dürer's artistic contributions for the emperor, for this secret visual language appealed to Maximilian's serious interest in the occult. Hieroglyphs also served to link the emperor with the purported Egyptian forbears in his genealogy and the wisdom they once possessed. The fruits of Pirckheimer's translation can be observed already in the central cupola of the *Triumphal Arch*. There, a secret hieroglyphic rebus surrounds the seated figure of Maximilian (fig. 11). This elaborate panegyric was composed by Pirckheimer, using the proper animals

12. Albrecht Dürer, *The Large Triumphal Chariot*, woodcut, 1522 (Latin edition, 1523), Lawrence, Spencer Museum of Art, University of Kansas. (courtesy Spencer Museum of Art)

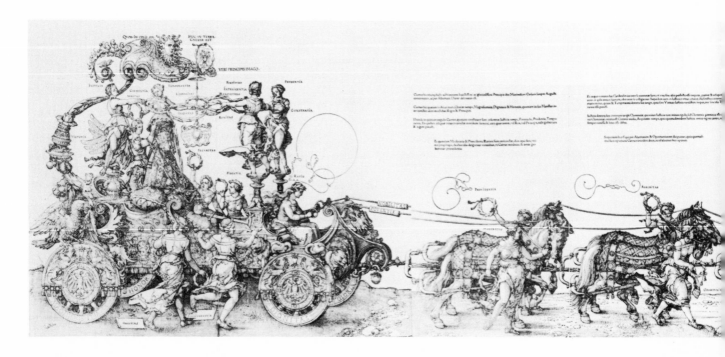

and attributes as described by Horapollo to serve as carriers of the message. As decoded by Stabius in the collophon below, the cupola reads:

The tabernacle above the title is a mysterium of ancient Egyptian letters deriving from King Osiris. It has been interpreted word by word to describe Maximilian as a most pious, generous, mighty, powerful, and prudent sovereign, a prince of unforgettable eternal and honorable blood, born of a lineage blessed with all gifts nature can bestow, endowed with the knowledge of art and wise teachings, Roman Emperor and Lord of a great portion of the earth. He has by force of arms and superb victory, yet with the greatest modesty, subdued the most powerful king, a thing all men had thought impossible and thereby has prudently guarded himself from further attack.[35]

Several of these animal emblems reappear within the decorations of the *Triumphal Arch*; for example, the crane with a foot lifted serves as a symbol of vigilance, and the skins of deer and lion as, respectively, longevity and strength.[36] Moreover, the *Arch* is also studded with antique references used symbolically and explained by Stabius, such as sirens, harpies, and cupids. Stabius goes on to explain Maximilian's own personal emblem, the pomegranate, as follows: "Although a pomegranate's exterior is neither very beautiful nor endowed with a pleasant scent, it is sweet on the inside and filled with a great many well-shaped seeds. Likewise, the Emperor is endowed with many hidden qualities which become more and more apparent each day and continue to bear fruit."[37] These hidden symbols, the hieroglyphs, are themselves like the pomegranate, revealing their qualities only to the learned and then only after careful study.

With this appeal to a kind of timeless, symbolic memorial and a restricted audience of *cognoscenti*, Maximilian eventually turned even the centerpiece of the *Triumphal Procession* into a learned allegory removed from all circumstances of history, what Pirckheimer described as "not an ordinary triumph, but also one of philosophy and morality." Pirckheimer and Dürer once again penned the program and design for what eventually appeared as the woodcut of the *Large Triumphal Chariot* (fig. 12), published posthumously with the full Pirckheimer text in 1522.[38] The drawing *modello* (fig. 13) of 1518 by Dürer (now in the Albertina)[39] already shows the allegorical elements that were applauded by Maximilian in a letter of March 1518 to Pirckheimer. Decorated "not with gold or precious stones . . . but only with virtues," the chariot has become, in effect, a personal apotheosis, where each of the six pairs of horses is led by an allegorical virtue, and the very wheels support the emperor with Gloria, Magnificentia, Dignitas, and Honor. Reason is the charioteer and Maximilian, crowned by a victory whose very wings recount the emperor's military conquests, is surrounded by the four cardinal virtues, linked and inseparable. In the canopy above, another

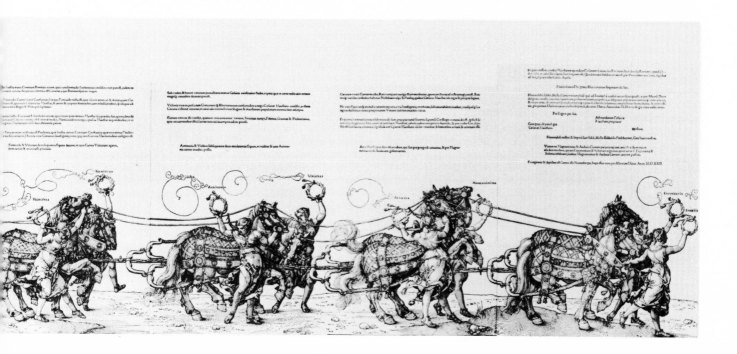

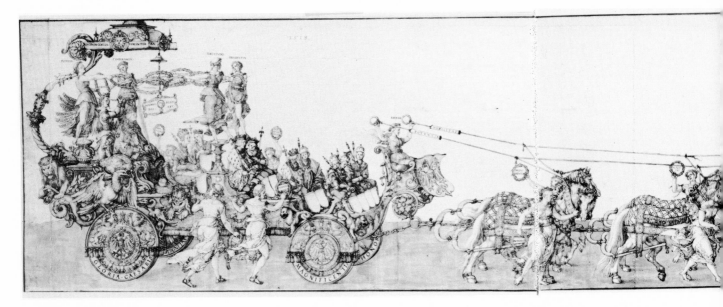

13. Albrecht Dürer, *The Large Triumphal Chariot*, drawing, 1518, Vienna, Graphische Sammlung Albertina. (courtesy Graphische Sammlung Albertina)

rebus equates the emperor with the sun itself: "Quod in celis sol, in terra Caesar est." Eagles, griffons, and dragons reinforce these kingly aspects in the decoration; and the personal emblems, the flints of the Golden Fleece and the pomegranates in a scroll ornament, fill the side of the chariot. Pirckheimer's program continues a *laurea*, or Wreath of Honor, that he had begun earlier for the *Triumphal Procession* and illustrated in a surviving Hans von Kulmbach drawing (in Berlin).[40] But in the *Large Triumphal Chariot* he blows up the panegyric into a personalized procession of 32 allegories proclaiming the virtues of this most supreme ruler, much in the manner of the contemporary Mirrors of Princes texts. The emperor's just rule, in accord with divine rule, proclaims itself in another rebus hanging from the canopy beside the figure of Maximilian: "In manu dei cor regis est" (The heart of the king is in the hand of God). However, in the posthumous edition of these woodcuts, this text could also serve a memorial function. As Pirckheimer's description says, this image of virtues pertains "not only to this present perishable life but also well and truly to adorn such a man after his mortal departure, being lasting and permanent."

The *Large Triumphal Chariot* takes on additional significance in a Nuremberg context because it was transcribed in paint onto the walls of the great hall of the Nuremberg Rathaus, the site of the meeting of the imperial Diet (fig. 14). Mende has seen in this painted Nuremberg tribute to Maximilian an indirect criticism of his grandson and successor, Charles V, who violated imperial tradition by calling his inaugural Diet in 1520 at Worms instead of at Nuremberg.[41] Mende, however, also calls attention to the significance of a passage in Book Nine of Alberti's *Ten Books of Architecture*, a work quite possibly known to Dürer, whose workshop painted the Rathaus walls. Alberti says that "in a free city, the House of the Senator or Chief Magistrate ought to be the first in Beauty and Magnificence. It is certain that the brave and memorable actions of one's countrymen and their effigies are ornaments extremely suitable to both porticoes and halls. For this Reason in some of the most conspicuous parts of the wall, I am for making handsome panels in stone in which we may place either statues or pictures, such as Pompey had carried along in his Triumph."[42]

A more literal Nuremberg memorial to Maximilian can be seen in the woodcut (fig. 15) by Dürer's pupil Springinklee after a program by Stabius.[43] Here the scene is laid in heaven, where a standing God the Father appears before a triumphal arch adorned with all the regalia of a ruler: jeweled robes held by angels and an orb. Before Him in prayer kneels Maximilian in his own imperial raiment, including sword, scepter, and orb on the ground. The emperor is accompanied by patron saints and saints of special imperial devotion (most of whom appeared within his Prayerbook), led by the Virgin and Child. The other saints include his name saint, the bishop Maximilian; the patron saint of Burgundy and the Order of the Golden Fleece, St. Andrew; a sainted Austrian an-

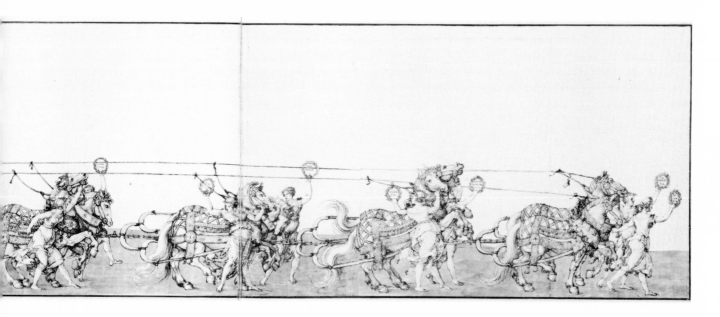

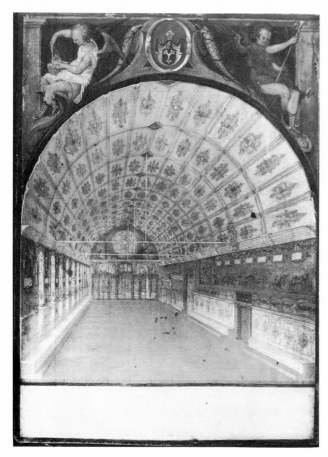

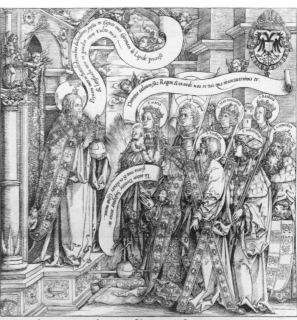

Imperator Cæsar divus Maximilianus pius felix augustus Christianitatis supremus Princeps Germaniæ Hungariæ Dalmatiæ Croaciæ Bosnæq Rex Angliæ Portugalliæ & Boemæ heres &c. Archidux Austriæ Dux Burgundiæ Lotharingæ Brabantiæ Stiriæ Carinthiæ Carniolæ Lymburgæ Lucemburgiæ & Gheldriæ Comes Princeps in Habspurg & Tirolis Lantgrauius Alsatiæ Princeps Sueuiæ Palatinus Hannoniæ Princeps & Comes Burgundiæ Flandriæ Goriciæ Arthesiæ Holandiæ & Comes Seelandiæ Phirretis in Kyburg Namurci & Zutphaniæ Marchio super Anasum Burgouiæ & sacri Imperij Dominus Phrysiæ Marchiæ Sclauoniæ Mechliniæ Portusnaonis & Salinarum &c. Princeps potentissimus transijt. Anno Christi Domini M·D·XIX· Die XII Mensis Ianuarij· Regni Romani xxxiij· Hungariæ uero xxix·
Vixit annis Lix· Mensibus· ix· Diebus·x·ix

14. Paul Juvenel the Elder, *View of the Interior of the Great Hall of the Nuremberg Rathaus*, painting, ca. 1614, Nuremberg, Germanisches Nationalmuseum. (courtesy Germanisches Nationalmuseum)

15. Hans Springinklee, *Emperor Maximilian I Presented by His Patron Saints to the Almighty*, woodcut, 1519, Ann Arbor, University of Michigan Museum of Art. (courtesy University of Michigan Museum of Art)

cestor, St. Leopold; and a triad of military saints: George, the patron of knights and crusaders as well as of Maximilian's own Order of St. George; Sebastian, the patron of archers; and Barbara, the patron of artillery. Mary's Latin inscription is an intercession for the ruler by all of his patron saints, while Maximilian pays homage to God as his *susceptor*, or support. God replies with a blessing and the bequest of a crown and a joyous welcome for the petitioner. A quatrain above celebrates the emperor's change from an earthly to a heavenly empire, while below he is addressed by all of his formal titles, along with the significant phrases that we have seen already on the Dürer portraits: "Imperator Caesar divus Maximilianus, pius, felix, augustus, Christianitatis supremus Princeps . . ." This scene is nothing less than an imperial apotheosis, according to Roman traditions, where the deceased emperor is welcomed into heaven. Here we have the reversal of the early Christian assimilation of Roman imperial iconography, for the Christian heaven is now the site of the reception, and the imperial sphere is revived, to be grafted onto a religious hierarchy of God and His saints. In the process, the cosmic order is maintained, as the worthy but worldly emperor takes his place within the elite circle of the saints before the truly universal throne of God. No longer are the deeds and worldly accomplishments of the emperor celebrated, as in the case of the *Triumphal Arch*, but rather the dignity of his office and his personal virtues, so fully enumerated elsewhere in Pirckheimer's allegorical program for the *Large Triumphal Chariot*.

Herein lies the ultimate significance of the placement of the *Large Triumphal Chariot* in Nuremberg's town hall. Placed on the wall alongside a classical subject symbolizing Justice, the Alberti-inspired Calumny of Apelles, this image of the emperor proclaims both the city's allegiance to the late emperor himself and its special status as an independent imperial city, singled out as keeper of the regalia of Empire. But with the elaborate Pirckheimer allegory, it was no longer only the person of Maximilian himself that the city honored. Rather it was the office of emperor in all its perfection and virtue that was given a permanent memorial in Nuremberg. Because of their closeness to the emperor in his final years and their own influence on his artmaking, Dürer and Pirckheimer captured the spirit and ambition of Maximilian's creations for their native city as well. After the model of the ancients, whose emperors achieved godlike status through apotheosis, the humanists and historians around Maximilian created for him an ideal and timeless imagery of the emperor himself, akin to

Spenser's ideals for Queen Elizabeth of King Arthur and the Faerie Queene. Here we see allegory, whether in the *Large Triumphal Chariot* or in the hieroglyphics of the *Triumphal Arch*, used like a monstrance (to paraphrase Sebastian Franck) in order to "figure forth" a deeper moral significance: the glory and transcendence of the Holy Roman Emperor. History through poetry thus becomes myth. The flesh-and-blood Emperor Maximilian becomes emperor incarnate, largely through the artistic programs devised by his Nuremberg associates. By these pictorial means, Maximilian achieves the immortal status of "*divus*" accorded him on Dürer's posthumous, iconlike portrait woodcut, as well as in the wall painting of the *Large Triumphal Chariot*, in the very heart of Nuremberg.

NOTES

1. *Albrecht Dürer, 1471–1971*, exh. cat. (Nuremberg, 1971), p. 134, no. 239 (hereafter cited as Nuremberg, 1971).

2. Nuremberg, 1971, pp. 134–138, nos. 240–249. Also J. Schnelbögel, "Die Reichskleinodien in Nürnberg, 1424–1523," *Mitteilungen der Verein für Geschichte der Stadt Nürnberg* 51 (1962): 77–159; A. Weixlgärtner, "Weisung der Heiltümer zu Nürnberg," *Kunsthistorisk Tidskrift* 4 (1955): 79–84; J. C. Smith, *Nuremberg, A Renaissance City, 1500–1618* (Austin, 1983), pp. 28–30.

3. Nuremberg, 1971, pp. 138–139, nos. 251–257. Also H. Th. Musper, *Dürers Kaiserbildnisse* (Cologne, 1969); F. Anzelewsky, *Albrecht Dürer, Das malerische Werk* (Berlin, 1971), pp. 233–236, nos. 123–124; Smith, *Nuremberg*, p. 29, no. 31.

4. Nuremberg, 1971, pp. 138–139, nos. 253–257 (W. 503–506). Also W. Koschatzky and A. Strobl, *Dürer Drawings: The Albertina Collection* (Greenwich, Ct., 1972), pp. 194–195, no. 74. For the Seilern sketch, see *Mantegna to Cezanne: Master Drawings from the Courtauld*, exh. cat. (London: British Museum, 1983), p. 10, no. 2.

5. Author's translations. Nuremberg, 1971, p. 138, nos. 251–252.

6. G. Paccagnini, *Pisanello* (New York, 1973), pp. 152–153, figs. 121–123.

7. Nuremberg, 1971, pp. 139–141, no. 258; Anzelewsky, *Albrecht Dürer*, pp. 250–254, nos. 145–146. Also V. Oberhammer, "Die vier Bildnisse Kaiser Maximilians I. von Albrecht Dürer," *Alte und Moderne Kunst* 14 (1969): pp. 2–14.

8. Koschatzky and Strobl, *Dürer Drawings*, pp. 276–277, no. 113 (W. 567), pp. 282–283, no. 115 (W. 635).

9. C. Wehmer, "Mit Gemäld und Schrift: Kaiser Maximilian und der Buchdruck," *In Libro humanitas Festschrift für W. Hoffman* (Stuttgart, 1962), pp. 244–275.

10. See the Strigel portrait (after 1508; private collection) in *Maximilian I*, exh. cat. (Innsbruck, 1969), p. 148, no. 550, fig. 106. On the variety of "imperial" crowns, see E. Rosenthal, "Die 'Reichskrone,' die 'Wiener Krone,' und die 'Krone Karls des Grossen' um 1520," *Jahrbuch der Kunsthistorischen Sammlungen in Wien* (*JKSW*) 66 (1970): 7–48, esp. pp. 19, 45–47, for the miter crown of the Habsburgs. Also H. Fillitz, "Die Insignien und Ornate des Kaisertums Österreich," *JKSW* 52 (1956): 124–126.

11. On the bust portrait in its connection with devotional images, see S. Ringbom, *Icon to Narrative* (Abo, 1965), pp. 39–45.

For related problems of cultic images as sources for a later Italian context, see I. Lavin, "On the Sources and Meaning of the Renaissance Portrait Bust," *Art Quarterly* 33 (1970): 207–226.

12. Nuremberg, 1971, p. 141, no. 259; Oberhammer, "Kaiser Maximilian."

13. Maximilian's advisor, Conrad Peutinger of Augsburg, not only possessed an extensive collection of antique coins himself but was also preparing a *Kaiserbuch*, a chronicle of the continuity of rulers from Julius Caesar to Maximilian. See T. Falk, *Hans Burgkmair*, (Munich, 1968), pp. 46–47; *Hans Burgkmair: Das graphische Werk*, exh. cat. (Stuttgart, 1973), no. 77. The sequence of Roman emperors, beginning with Caesar and extending through Charlemagne to Henry VII and Ludwig IV, runs down the left tower of Maximilian's *Triumphal Arch*.

14. Koschatzky and Strobl, *Dürer Drawings*, pp. 212–213, no. 83.

15. F. Winzinger, *Albrecht Altdorfer. Die Gemälde* (Munich, 1975), pp. 107–119, nos. 56–79; F. Winzinger, *Die Miniaturen zum Triumphzug Kaiser Maximilians I* (facsimile: Graz, 1972–1973); F. Winzinger, "Albrecht Altdorfer und die Miniaturen des Triumphzuges Kaiser Maximilians I," *JKSW* 62 (1966): 157–172.

16. S. Applebaum, *The Triumph of Maximilian I* (New York, 1964), p. 16.

17. M. Conway, *The Writings of Albrecht Dürer*, (New York, 1958), pp. 81–82; H. Rupprich, *Dürer Schriftlicher Nachlass* (Berlin, 1956), 1: 77, no. 24.

18. Conway, *Writings*, p. 82; Rupprich, *Dürer*, 1: 77–78, no. 25; Nuremberg, 1971, p. 148, no. 266.

19. W. Strauss, *The Book of Hours of the Emperor Maximilian the First* (New York, 1974); D. Strickland, "Maximilian as Patron: The Prayerbook," Ph.D. dissertation, University of Iowa, 1980.

20. Attributions summarized in Strauss, *Book of Hours*, pp. 324–326, based principally on the pioneering studies of Chmelarz, Giehlow, Röttinger, and Flechsig, there cited.

21. Wehmer, "Mit Gemäld," pp. 254–257; C. Dodgson, "Zu Jost de Negker," *Repertorium für Kunstwissenschaft* 21 (1898): 377–381.

22. On Peutinger, see most recently J. Bellot, "Konrad Peutinger und die literarisch-künstlerischen Unternehmungen Kaiser Maximilians," *Philobiblon* 11 (1967): 171–190, and C. M. Horn, "Doctor Conrad Peutingers Beziehungen zu Kaiser Maximilian I," Ph.D. dissertation, Graz, 1977. The classic studies remain T. Herberger, *Conrad Peutinger in seinem Verhältnisse zum Kaiser Maximilian I* (Augsburg, 1851), and E. König, *Peutingerstudien* (Freiburg, 1919).

23. K. Giehlow, "Urkundenexegese zur Ehrenpforte Maximilians I," in *Beiträge zur Kunstgeschichte Franz Wickhoff gewidmet* (Vienna, 1907), pp. 91–110; K. Fischnaler, "Jörg Kölderer und die Ehrenpforte Kaiser Maximilians," in *Ausgewählte Schriften* (Innsbruck, 1936), 2: 22–41; P. Strieder, "Zur Entstehungsgeschichte von Dürers Ehrenpforte für Kaiser Maximilian," *Anzeiger des Germanischen Nationalmuseum* (1954–1959), pp. 128–142.

24. Quoted by W. Strauss, *Albrecht Dürer Woodcuts and Woodblocks* (New York, 1980), pp. 500–502, no. 175.

25. Ibid., p. 726.

26. Nuremberg, 1971, pp. 144–145, no. 261; E. Chmelarz, "Die Ehrenpforte des Kaisers Maximilian I," *Jahrbuch der Kunsthistorischen Sammlungen des Allerhöchsten Kaiserhauses* (*JKSAK*) 4 (1886): 289–319; Smith, *Nuremberg*, pp. 12–13, no. 20.

27. K. Giehlow, Dürers Entwürfe für das Triumphrelief Kaiser Maximilians im Louvre," *JKSAK* 29 (1910): 14–15, n. 1. Strauss, *Woodcuts*, p. 504, tallies only five hundred sets in the first two editions.

28. *Hans Burgkmair: Das graphische Werk*, exh. cat. (Stuttgart, 1973), nos. 204–219; K. Woermann, "Dresdener Burgkmair-Studien," *Zeitschrift für Bildende Kunst* n.f. 1 (1890): 40.

29. Giehlow, "Dürers Entwürfe," pp. 14–84.

30. H. Rand, "The Modes and Recent Art," *Arts* 55, no. 4 (December 1980): 78–83.

31. F. Deuchler, *Die Burgunderbeute* (Bern, 1963).

32. W. Benjamin, "The Work of Art in the Age of Mechanical Reproduction," *Illuminations*, trans. H. Zohn (New York, 1969), pp. 217–257.

33. W. P. Eckert and C. von Imhoff, *Willibald Pirckheimer, Dürers Freund* (Cologne, 1971).

34. K. Haupt, "Die Renaissance-Hieroglyphik in Kaiser Maximilians Ehrenpforte," *Philobiblon* 11 (1967): 253–267; K. Giehlow, "Die Hieroglyphenkunde des Humanismus in der Allegorie der Renaissance, besonders der Ehrenpforte Kaisers Maximilian I," *JKSAK* 32 (1915): 1–232.

35. Strauss, *Woodcuts*, p. 726.

36. Giehlow, "Hieroglyphenkunde"; E. Panofsky, *The Life and Art of Albrecht Dürer* (Princeton, 1955), pp. 177–178.

37. Strauss, *Woodcuts*, p. 731.

38. Nuremberg, 1971, pp. 147–148, no. 264; Panofsky, *Life and Art*, pp. 180–181; Strauss, *Woodcuts*, pp. 536–537, no. 188; Eckert and von Imhoff, *Pirckheimer*, pp. 109–115, 173–177. Smith, *Nuremberg*, pp. 120–121, no. 26.

39. Koschatzky and Strobl, *Dürer Drawings*, pp. 278–281, no. 114.

40. Guklow, "Dürers Entwurfe," pp. 43–46; F. Winkler, *Hans von Kulmbach* (Plassenburg, 1959), p. 92, pl. 72. Some sixty virtues and qualities would have adorned the leaves of this Wreath of Honor held by two riders on standards.

41. M. Mende, *Das alte Nürnberger Rathaus I*, exh. cat. (Nuremberg, 1979), p. 226. On the *View of the Interior of the Great Hall of the Nuremberg Rathaus* (Nuremberg, Germanisches Nationalmuseum), attributed to Paul Juvenel the Elder and dated about 1614, see ibid. pp. 178–181, no. 110, and Smith, *Nuremberg*, pp. 301–302, no. 213.

42. Mende, *Rathaus*, pp. 227–228.

43. C. Dodgson, *Catalogue of Early German and Flemish Woodcuts in the British Museum* (London, 1903; reprinted 1980) 1: 407–409, no. 78; Smith, *Nuremberg*, p. 157, no. 57.

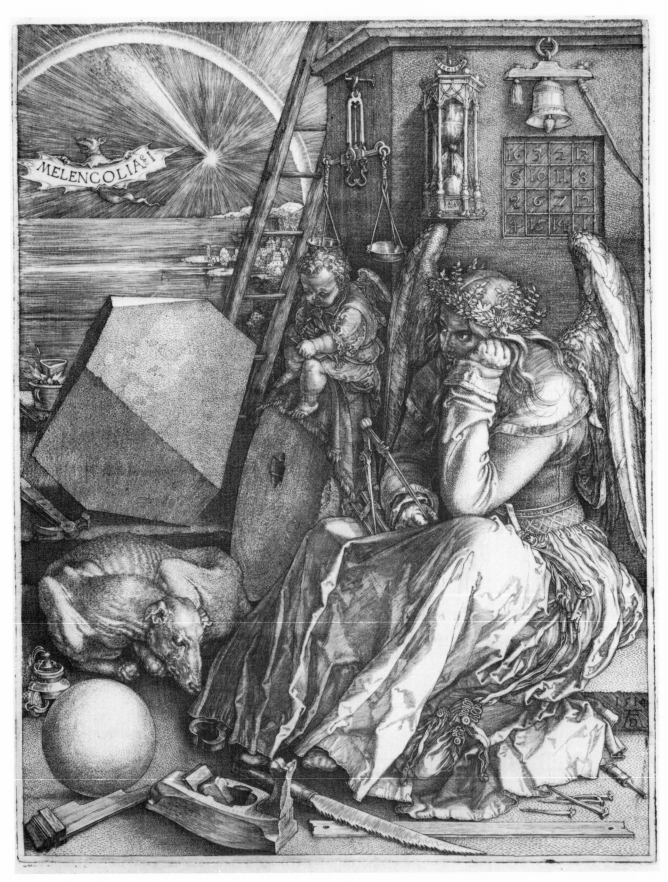

1. Albrecht Dürer, *Melencolia I*, engraving, 1514, Fort Worth, Kimbell Art Museum. (courtesy Kimbell Art Museum)

Hermeneutics in the History of Art: Remarks on the Reception of Dürer in the Sixteenth and Early Seventeenth Centuries

by Thomas DaCosta Kaufmann

This paper presents an approach to the problem of interpreting the work of Albrecht Dürer, the artist who was best represented in the exhibition "Nuremberg, A Renaissance City, 1500–1618" and who indeed is most discussed in this collection of essays. The attention given here to Dürer seems appropriate, because Dürer still enjoys the reputation of being the most representative artist of the Renaissance both in Nuremberg and in Germany as a whole. This famous Nuremberger has accordingly evoked a huge, if often contradictory, literature. A bibliography of writings on the artist that was compiled for the "Dürer year" of 1971 listed over 10,000 items, and many more studies, including several large books, have swelled this number during the past twelve years.[1]

As differences among the contributions to the present volume indicate, however, within this vast literature there exist not only numerous but also varying and even conflicting interpretations of the artist. It is this situation I would like to discuss. The recent history of interpretation of a well-known engraving, such as Dürer's *Melencolia I*, may be seen as characteristic of the problem. Some years ago it might have appeared as if the learned exegesis that Raymond Klibansky, Erwin Panofsky, and Fritz Saxl offered in *Saturn and Melancholy*, and that Panofsky also elaborated in his monograph of Dürer, had solved the enigma of the print (fig. 1). To recapitulate briefly, Panofsky concluded that *Melencolia* was a spiritual self-portrait in Neo-platonic guise, a vision of a frustrated genius.[2] In 1971 the authors of the exhibition catalogue *Dürer in America* could tellingly call this a "matchless elucidation."[3] Yet interpretations of *Melencolia* continue to pour forth, and this view has been challenged recently on several grounds. On the one hand, the print has been interpreted as redolent of astrological and prophetic themes or of magic and cabala, and Panofsky's interpretation has been seen as "romantic."[4] On the other hand, the "erudition of iconography" and "geometrical knowledge" that *Melencolia* supposedly reveals have led to what might be called a more rationalized interpretation, which regards the print as a summary of Dürer's intellectual achievements rather than as a self-portrait.[5]

The conflict of interpretations raised in response to the *Melencolia* points to a general problem of validation that provokes some theoretical reflection. Within the maze of conflicting arguments, how can we determine what is a plausible hypothesis not only about individual works by the artist but also of Dürer's significance for the Renaissance in Nuremberg and Germany?

I cannot hope to answer these questions fully, nor

indeed do I intend to address them directly in this paper. Instead, I intend to take the problem situation that is presented by the variety and conflict found in the history of interpretation of Dürer as the point of departure for another approach. Because of the difficulty and complexity of the issues involved, I can only adumbrate certain ideas, and raise some questions within the limits of this short essay. Nevertheless, I would like to suggest how what I will describe as one kind of interpretation of Dürer's art, namely its use by other artists, can help us to understand his own work. By ultimately revealing the reception that Dürer could relay on in his time, borrowings by artists who constituted some of the most perceptive elements in his audience may help us to determine the meaning of Dürer's art itself. From the vast store of works, from his age continuing to our own era, that borrow from Dürer, I would thus like to re-examine but a few familiar examples of the reception of Dürer in art during the time frame that was provided by the exhibition "Nuremberg, A Renaissance City, 1500–1618." I will concentrate on what I will call their interpretative aspects.

Even though the historiography of writings on Dürer has hardly been neglected—a large book-length study of the subject by Jan Białostocki is now in press[6]—I think that past interpretations of the artist, particularly as seen in later works of art, have not hitherto been thoroughly utilized for the explication of Dürer's work itself. Earlier interpretations do more than allow us insights into the attitudes of previous interpreters and the art or culture of their time, although it is as such that they have mainly been studied. The meaning of a past work also comes alive through its subsequent interpretations, as some writings on hermeneutic theory have suggested.[7] In this sense borrowings from Dürer by other artists, which I will explain as interpretations, may give clues to his own work. If we trace back the history of earlier interpretations, as we move closer to Dürer's own time and milieu the attitudes we find they reveal may indeed begin to approximate his own. Interpretations in the visual arts may be especially helpful here, given the lack of a rich body of contemporary writings directly on or related to Dürer. In addition to the more standard strategies aimed at establishing the set of conventions, expectations, and beliefs that existed at the time a work of art was created, its horizon of expectations, I would thus like to suggest considering past interpretations, especially those found in the visual arts themselves.[8]

Of course not all later uses of an artist's work can be considered in the same light as interpretations, nor are they all equally informative as such. Obviously, not all copies can be considered in this way, for copying is an artistic process with an ancient history and may result from many different motivations. For instance, students' copies, which aim at effacing the copyists' difference from the original, may not be interpretations, although their choice of model may be revealing.[9] My paper will therefore touch instead on instances in which Dürer's images or motifs have been transformed either in scale, or in medium, or in some other visual aspects that make clear that an artist has considered questions of design or function or meaning.

I should explain why I emphasize the quality of this active process of assimilation that is often encountered in transformations of Dürer's art in later borrowings as a kind of intra-artistic interpretation. While imitative procedures in the visual arts are usually categorized as examples of artistic influence, influence as it is generally understood accounts for only part of the story with which I am concerned. When used in reference to works of art created in an era before originality replaced origin as a ground for artistic creation, the word *influence* seems to be either to describe a neutral process of transmission or to imply a passive one, in which artistic reception is conceived as if it were a flow from a source to its recipient.[10] As scholars of Renaissance literature have however often reminded us, there are many kinds of borrowing and imitation. An artist may choose to imitate only some of the elements of his or her model, or to transform them, or even in so doing apparently to reject certain aspects of the source.[11] For these reasons artistic reception must be considered to have an active side as well. It might be noted in this regard that this history of "influence" has itself been described as revealing a productive as well as a reproductive attitude.[12]

By considering the process of interpretation involved in artistic reception, we may also see how earlier artistic borrowings form part of the tradition that provides the background to our own particular problem situation, namely the interpretation of Dürer. It is admittedly from our own vantage point that we can regard later transformations or imitations as interpretations. But our own conjectures about history may be altered by views of Dürer that have been expressed in later works of art, just as indeed our own understanding of Dürer may be preformed or affected by the way in which the artist has been previously understood.[13] Thus, I hope that earlier interpretations of Dürer in art may enrich not only our view of those artists who used Dürer's work, and our conjectures about the situation in which Dürer's own art was cre-

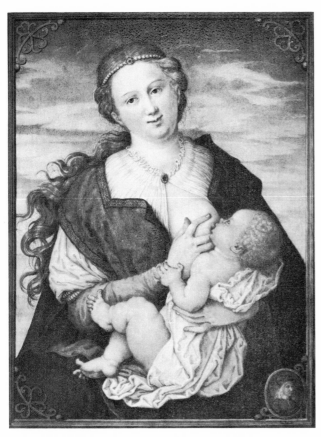

2. Daniel Fröschl, *Virgin and Child*, painting, Vienna, Kunstistorisches Museum. (courtesy Kunsthistorisches Museum)

ated, but also our understanding of the origins or validity of our own interpretations.

Let us first consider but a few of the many images that can be associated with the interest in Dürer around 1600.[14] These images illuminate their artists' attitudes and inform our own. They also serve as a foil for borrowings from Dürer from the earlier sixteenth century, from which something of Dürer's own meaning may be gained more immediately. Let us take for example a painting in miniature by Daniel Fröschl (fig. 2). Like the Nuremberg Dürer imitator Hans Hoffmann, the Augsburg-born Fröschl came to Prague to serve at the court of the Holy Roman Emperor Rudolf II Habsburg (reigned 1576–1612), where he was active from 1603. In his miniature Fröschl has translated a drawing of 1512 by Dürer into paint. The absence of Dürer's monogram and indeed the presence of another image in the lower-right corner that is in fact a copy of another drawing by Dürer, his earlier self-portrait of 1484, indicate that this is neither a direct copy of a single work nor made to deceive. The insertion of the portrait instead seems to make a historical reference to the artist who provided the source for the original works. By combining copies or imitations of two drawings of different dates by Dürer in a single image, Fröschl has transformed Dürer's works and at the same time called attention to his source. Moreover, Fröschl has in a way completed an invention found in drawings by giving them color and body in paint. Dürer's work might be considered to have been treated here in a way similar to that in which Renaissance artists regarded ancient works of art, as historically distant, yet imitable, even in other media. Revealing its source and combining works of two different dates by Dürer, Fröschl's imitation also reveals its own distance in time from him and may thus be interpreted in relation to is own mileau. On the other hand, through its form of imitation it manifests an attitude that has informed our interpretation of the artist as well.

Fröschl's imitation of Dürer may be set, first, in the specific milieu of Rudolf II's Prague and, in general, in an era in which Dürer was especially appreciated.[15] The transformation in form of execution to the technique of the miniature, recalling the appearance of precious illuminated manuscripts, as well as the small size of the composition suggest that it was made for a collector; and, in fact, the work can be found in an inventory of paintings in the imperial collections in Vienna that was compiled between 1610 and 1619.[16] Rudolf II was of course a great collector. Among other objects in his *kunstkammer* was one of the largest assemblages of works by Dürer that had been gathered

at a time in which the artist's works were avidly sought throughout Germany, by Duke Maximilian I of Bavaria, Archduke Ferdinand of the Tyrol, and Nuremberg patricians, such as Willibald Imhoff, Melchior Ayrer, and Paulus Praun.[17] Rudolf owned many examples of Dürer's prints, many of his drawings, and such paintings as the *Allerheiligenbild* and *Rosenkranzmadonna*. Since Fröschl served as *antiquarius*, or keeper, of this collection from 1604 and compiled an inventory of it in the years 1607–1611, he would have been intimately familiar with these holdings.[18] Furthermore, because the emperor had collected them, Dürer's works would in themselves have formed a set of models for artists at the imperial court.[19]

The desire for Dürer's art was linked closely with the high regard for his work that is to be found in late-sixteenth- and early seventeenth-century literature on art. Giorgio Vasari, Ludovico Dolce, Gian Paolo Lomazzo, Romano Alberti, Cardinal Paleotti, and Karel van Mander in one way or another all praised aspects of the Nuremberger's art.[20] Their comments also provide the intellectual background for Fröschl, who had also worked in Florence, and theoretical bases for his form of imitation. In the words of another Florentine Cinquecento theorist, to imitate (*imitare*) was a higher function than to portray (*ritrarre*).[21] Through the imitation of another, valued artist's work, something could be seen represented as if through a previously selected screen of beauty or perfection: imitation of the greatest masters was a way of imitating nature at its highest and most characteristic.[22] In this view, to paraphrase Hans Kauffmann, *imitatio* involved both a receptive as well as a productive process.[23] Thus, Fröschl's imitation of Dürer can tell us something about the changing forms of interpretation of Dürer's art around 1600. Rather than being used merely as a source for specific motifs or copied in a similar medium, as had occurred frequently earlier in the sixteenth century, Dürer's art has been made into a component of a consciously historical canon for art, distant yet assimilable.[24] This has been done in a way similar to that in which contemporaries around 1600 used the work of Italian Renaissance painters, such as Raphael, whose works Fröschl indeed also adapted to the miniature format.[25]

The canonization of Dürer's art around 1600 was moreover subject to other ideas about imitation that would have affected forms of artistic interpretation in Prague.[26] The artists at Rudolf II's court also asserted that painting was one of the liberal arts. Accordingly, the visual arts could claim to follow the same principles as did the other arts, including, most pertinently for questions of style, rhetoric. Artists aimed

3. Hans von Aachen, *Minerva Presents Painting to the Liberal Arts*, drawing, Brno, Moravská Galerie. (courtesy Moravská Galerie)

4. Bartholomäus Spranger, *Mercury Leads a Young Artist to be Crowned by Minerva*, drawing, Vienna, Graphische Sammlung Albertina. (courtesy Graphische Sammlung Albertina)

at effects similar to the ends that educators sought in the liberal arts. In several works Hans von Aachen makes these claims for the visual arts by, for instance, showing Minerva, goddess of Wisdom, presenting painting to the Liberal Arts (fig. 3). On the other hand, Bartholomäus Spranger suggests that painting pursues the same goals as does education—traditionally the production of learned or wise eloquence—when he shows the god of eloquence (Mercury or Hermes) presenting a young painter to Minerva (or Athena) or, assuming the role of a painter himself, bowing to be crowned by her (fig. 4). The conjunction of Mercury/Hermes with Minerva/Athena is related to the image of Hermathena, the symbol of the academy since Cicero, and, to summarize an argument that I have made elsewhere, their appearance in many contemporary allegories on the arts supports other evidence suggesting that the Prague court painters adhered to the academic ideal in pursuing the processes and ends of Renaissance education (and poetics) in their art.[27]

One way to obtain the requisite eloquence that had been taught in schools since antiquity was to imitate selected models. In this way of thinking there was thus yet a further significance to the use of Dürer's art as a model around 1600. Like the art of antiquity or that of the Italian Renaissance, Dürer's could provide model images to be emulated.[28] When artists like Spranger, who cannot be regarded as belonging to the same direct historical tradition as does Dürer, borrow from him, I believe that such borrowings may often be considered in this light as examples of emulative imitation and not simply the result of artistic copying, a well-established process for educating artists. Spranger was born in Antwerp in the mid-sixteenth century and also formed as an artist in Italy during the 1570s, and I know of no early copies of Dürer by him. Yet Spranger emulated the Nuremberger's designs when he later came to paint panels with patron saints of Bohemia (fig. 5–6). In two pictures that probably formed parts of an altarpiece for some church in Prague, Spranger does not in fact directly copy Dürer's woodcut of the patron saints of Austria for his designs but adopts its general types for his images of the Bohemian saints Vitus, Wenzel, Adalbert, and Sigismund. It has also been observed that the visage of St. Wenzel is even generally patterned on the male type presented by Dürer's features in his Prado *Self-Portrait*.[29] The Prague court painters thus suggest that toward 1600 Dürer's work had become part of an international European canon and could serve as a model not only for imitation but also for emulation—and this was true of artistic centers besides Prague.[30]

We, of course, no longer share what other art historians and I have called the "academic" premises that determined some forms of imitation of Dürer around 1600. Nevertheless, I would argue that the self-conscious and articulate canonization of Dürer that had occurred by that time in art as well as in literature still informs the way we see the artist. Because Dürer had become an ideal for artists and a paragon for writers at least by the end of the sixteenth century, it is hard to see him otherwise today. Indeed when we look back beyond the later sixteenth century I would suggest that it seems to be difficult for historians to distinguish between those academic and historicizing attitudes that we find operative around 1600 and a different approach that seems present in earlier borrowings.[31] But not all borrowings from Dürer can be interpreted in the light of the same Renaissance ideas about imitation. I will argue that what might be termed an orthodox use of Dürer's art around 1600 in fact provides a useful foil to some earlier reactions to his work that I will describe as problematic, since in their differences with his presentation they might even be regarded as offering criticism of certain values that are implicit in his work. I find this kind of response in borrowings from Dürer by such artists as Hans Baldung Grien and Lucas Cranach the Elder. I think that the refiguration of Dürer's art in their work, moreover, also illuminates the way in which problems of art historical interpretation can also open up more general questions of our understanding of the Renaissance in Germany.

A consideration of the relation of Dürer to Baldung touches on complicated issues of the meaning of Baldung's work and has also been extensively studied, most recently by Linda Hults.[32] But I believe that we need neither to resolve the extremely complex issues raised by the interpretation of Baldung nor to follow Hults's arguments about Baldung and northern "mannerism"—a conception with which I have repeatedly taken issue—in order to consider certain obvious aspects of Baldung's response to Dürer.[33] If we examine even briefly the use of motifs and themes taken from Dürer as they appear in several important images by Baldung, they point in a consistent enough direction. Where in the late sixteenth century Dürer's work provided a canonical ideal, in the art of Baldung, who had probably served directly in the master's shop for some years from about 1503, Dürer's images are often transformed in an apparently negative fashion. And where later emulations of Dürer can be fit into a familiar pattern of understanding of Renaissance culture based on an Italian model, the significance of Bal-

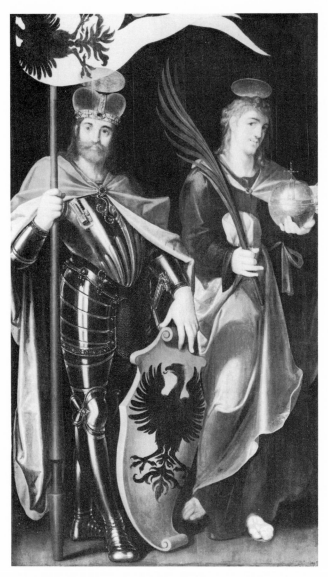

5. Bartholomäus Spranger, *Saints Wenzel and Veit*, paintings, Duchcov, Zámecká Galerie (on loan, Prague, Národní Galerie). (courtesy Národní Galerie)

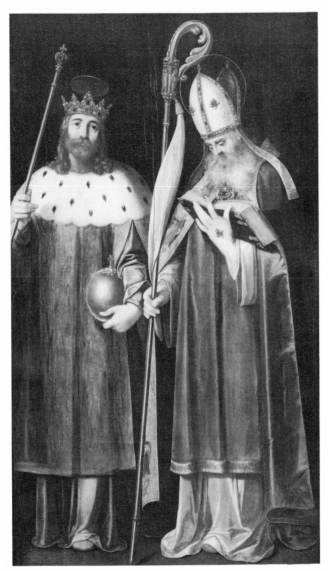

6. Bartholomäus Spranger, *Saints Sigismund and Adalbert*, paintings, Duchcov, Zámecká Galerie (on loan, Prague, Národní Galerie). (courtesy Národní Galerie)

dung's borrowing challenges us to re-examine our interpretation of the reception of the Renaissance.

Let me review some aspects of a familiar comparison, Baldung's version of the *Fall of Man* from 1511 versus Dürer's engraving of the same theme (his famed *Adam and Eve*) from 1504 (figs. 7–8). Baldung's print takes over the proportions and to some degree the stance of Dürer's Eve, although as was noted in the catalogue of a recent Baldung exhibition, the sinuous contrapposto gesture and position of the left hand of Baldung's Eve also depend from Dürer's Prado paintings of the theme from 1507.[34] Yet Baldung's composition can certainly not be regarded as a simple adaptation of Dürer. Baldung's Eve looks out directly from the woodcut. She is given a more prominent position than in Dürer's print, overlapping Adam rather than standing in balance with him in the composition. And where Dürer's Eve seems to be on the point of taking the forbidden fruit from the serpent, Baldung's Eve has already grasped it and holds it forth. In turn, Baldung's Adam lustfully grasps Eve. Baldung also changes the vision of nature found in Dürer. In place of a luxuriant vision of Eden, with an abundance of natural creatures, including cat and mouse, ox, stag, and single rabbit inhabiting the foreground and middle ground, Baldung's Paradise is pared down. His woodcut gives prominence to the large Satanic snake but otherwise presents only two rabbits.

If in Dürer's Eden Adam and Eve are still the perfect man and woman before the Fall, in Baldung's vision sexual appetite is already present. Baldung's print must therefore be seen to do more than merely borrow from Dürer: as in other paintings and prints of the subject by the artist, it transforms the Original Sin into an image of carnal lust.[35]

These obvious contrasts between Baldung's and Dürer's images are mutually elucidating. They help first of all to support other interpretations of these works that have been based on different interpretative strategies. Baldung's presentation of the first parents, for instance, coincides with what has been found in several other images by the artist, namely the visual presentation of the theme that the cause of the Fall was lasciviousness. Baldung's woodcut would seem to support the (scholarly) argument that the artist created a visual image of a traditionally Augustinian interpretation. He thus suggests that the Fall was caused by sexual desire.[36] On the other hand, the contrast with Dürer that is to be found in the presentation of the natural world would seem to support Panofsky's interpretation of Dürer's Adam and Eve as beings ideal both in their beautiful forms, which are

derived from classical canons, and in their happy pre-lapsarian balance of the four humors. To recall Panofsky's arguments, the animals in the foreground stand for the four humors that were held in perfect balance in Eden.[37] As only the rabbits, traditional symbols of lust, are to be seen in the Baldung, no such happy balance appears to hold.[38]

I think that the points of this comparison, however familiar they may be, are worth emphasizing because they illuminate a contrast with Dürer that may be found in many of Baldung's borrowings. Baldung echoes Dürer's Eve in a number of images that present the first mother as lustful or even worse. As Hults, among others, has noted, Baldung even uses ideal female figures resembling Dürer's Eve for his depiction of a witch.[39] In such instances it would seem that Baldung is doing more than simply borrowing. Can Baldung then also be regarded as drawing on Dürer's imagery to present a different view of Adam and Eve? Can he not in fact be seen to be questioning and even rejecting the type of female ideal that Dürer embodied in Eve?

Similar thematic contrasts that can be found in other well-known adaptations of Dürer by Baldung would indeed seem to support the suggestions that Baldung is responding to Dürer's ideas. In their depictions of similar images of horses, for example, what appears in the guise of perfect proportion or rational control in Dürer becomes suspect as subject to the urges of sensuality or unreason—even with a tinge of sorcery—in Baldung. Hults has already mentioned several aspects of Baldung's transformation of Dürer's *Small Horse* of 1505 (figs. 9–10), the idealized equine companion piece to the *Adam and Eve*.[40] Baldung discards the lamp, classical garb, and architectural setting of Dürer's engraving. Where Dürer's horse seems under control, at rest, Baldung's is charged with motion, strides forward, and can hardly be constrained by the groom. If Dürer's creature represents the perfectly proportioned horse and reflects Italianate canons in a way similar to that in which Adam and Eve presented a human ideal, Baldung's beast changes these proportions and by moving calls into question the possibility of considering proportionality as a static phenomenon. To Hults's observations one might add that the ordered view with its suggestion of perspective which Dürer imposes upon the world, implying that proportional relationships also exist in space, is replaced by an unbalanced composition in Baldung. The focus on the light in the Dürer —which Panofsky saw as the light of reason that holds the irrational in check—is also absent.[41] Instead, Baldung presents a view of untrammeled nature, with a rocky

7. Hans Baldung Grien, *Adam and Eve (The Fall of Man)*, woodcut, 1511, Washington, National Gallery of Art (Rosenwald Collection). (courtesy National Gallery of Art)

8. Albrecht Dürer, *Adam and Eve*, (engraving, 1504, Los Angeles County Museum of Art (Art Museum Council Fund). (courtesy Los Angeles County Museum of Art)

landscape with a castle that is perhaps derived from the landscape in Dürer's *St. Eustace* engraving, as is, by the way, a similar landscape in Johann Ladenspelder's copy of the *Small Horse*.[42] The fierce glow and bulging strain of the eye of Baldung's horse resemble similar features in Baldung's images of horses made prey to sexual passion. As Jay Levenson has noted, this detail may also perhaps be related to stories of demonic possession.[43]

The negative transformation of Dürer is taken one step further in Baldung's adaptation of Dürer's *Large Horse* (figs. 11–12). Regardless of our full interpretation of the "meaning" of Baldung's own image, it can be seen as a radical and indeed ultimately terrifying reinterpretation of Dürer's subject, from which in the end it may even seem to depend but loosely.[44] Instead of standing next to the horse or holding him in check, as in Dürer's image, the groom now lies prostrate. The horse in Baldung glowers with a fierce demonic expression. Where the horse and man had been compositionally conjoined in Dürer's print, in Baldung's woodcut they are separated, the horse has been turned and presents its hindquarters—has it kicked the groom or is it about to? The transformation of the composition, from the tight control of interlocking forms in Dürer to the separate aggregation of masses in Baldung, from outdoors to the constraints of an interior, also brings home the difference. Yet the compressed physical space of the Dürer has been psychologically extended in Baldung. In Baldung's woodcut the tipping of the ground plane and the use of exaggerated foreshortening, a device often employed for expressive effect,[45] increase the uneasy and odd feeling. Nature and man can no longer be seen to exist in happy conjunction; they are uneasily out of joint. Finally, and most significantly, a hag has been added to the right of Baldung's image. While she has previously been identified as a witch, her action and consequently the full terror of her presence have not yet been completely elucidated. I think that her gesture—she is holding up a torch in her hand—suggests not that she is casting a spell but that she may be about to set fire to the barn. Arson was regarded during the early modern era as a specific malefic act, attributable at times to witches. As Keith Thomas has reiterated, arson and sorcery were often overlapping charges made of witches. In the sixteenth and seventeenth centuries fires were especially feared, since, as Thomas has suggested, they formed perhaps the greatest threat to security next to the plague, because contemporaries were much less well equipped to deal with them.[46] While Thomas's evidence is drawn from England, the point can most likely be extended to

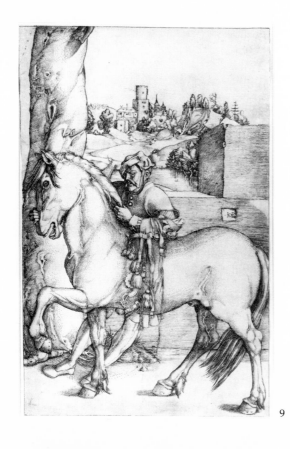

9

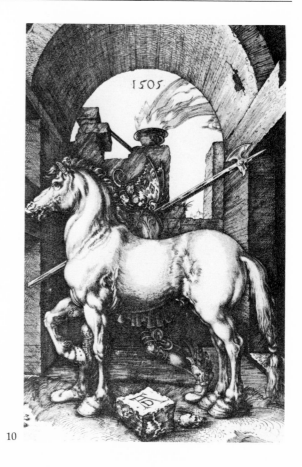

10

11

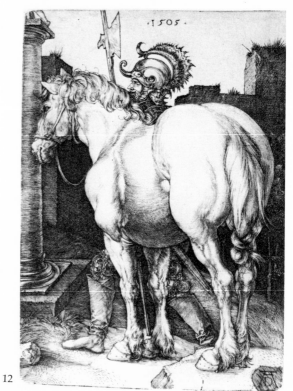

12

Germany: surely for the still predominantly agricultural society that existed in Central Europe the burning of a barn would have added to the horror of a witch's malevolence.

The transformation of Dürer's image into this frightening scene should inform us about Baldung's interpretation of Dürer. Far from being part of a canonical vision, Dürer's forms are recast in a context where they have become problematic and, finally, terrifying. I think this may be revealing both of Dürer and of Baldung. Can we see this process as an indication of a problematic reception of the ideals that lay behind Dürer's images as well? Does the contrast with Fröschl's or Spranger's use of Dürer in effect not help us to see Baldung's adaption of Dürer as a form of comment on the ideals in his art? Is Baldung suggesting that the ideals of harmonic proportion, perfect form, the harmony of man and nature, and their

9. Hans Baldung Grien, *Groom Bridling a Horse*, engraving, ca. 1510–1512, Boston, Museum of Fine Arts (Samuel P. Avery and Special Print Funds). (courtesy Museum of Fine Arts)

10. Albrecht Dürer, *Small Horse*, engraving, 1505.

11. Hans Baldung Grien, *Bewitched Groom*, woodcut, ca. 1544.

12. Albrecht Dürer, *Large Horse*, engraving, 1505.

manifestation in the ordering of the world in perspective are norms that are to be questioned with the Fall? In our imperfect world, are such images of perfection possible? Indeed, for the pious man is the uncontrolled search for order and hidden correspondences underlying the world in itself not open to sin, and perhaps even demonic interference?

The turning of Renaissance imagery in occult directions and an attack on it as sorcery indeed seem to be at stake in the final images I would like to discuss. In Cranach's depictions of witches the transformation of Renaissance imagery found in Dürer into something evil has been completed. Several of Cranach's paintings directly transfigure Dürer's female figure in *Melencolia* into witches (fig. 13).[47] As in Baldung's treatment of Dürer's *Adam and Eve*, many of the accessories are eliminated; these include the mysterious polyhedron and, significantly, the magic square, which has been explicated as a talisman against Saturnine influences. Dürer's sleeping dog is awake, his restful putti frolic about, either playing with the dog or (in other images) rolling the sphere or swinging. Instead of holding a compass, the female figure in Cranach whittles her stick. Seemingly lost in a trance, she has presumably joined, or is about to join, the legion of creatures riding their familiars in the sky. In some interpretations of this detail, these figures have

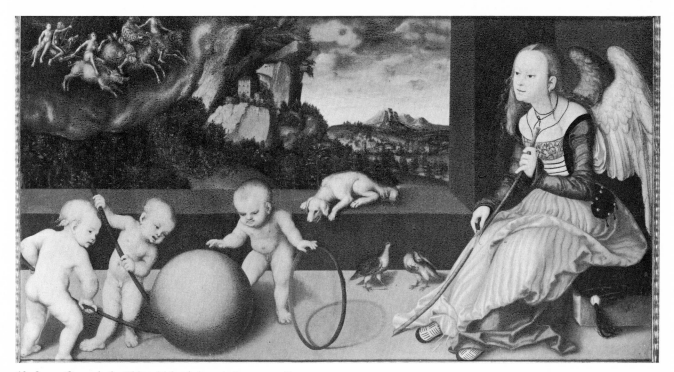

13. Lucas Cranach the Elder, *Melancholy*, painting, 1532, Copenhagen, Statens Museum for Kunst. (courtesy Statens Museum for Kunst)

been regarded as a procession to a witches' sabbath.[48] But the presence of putti and the assembled cohort of night riders evokes an even more horrifying vision. If these putti are seen as unbaptised dead infants and the riders whom the witch joins are the dead, then they may represent the *Wütischend* (or *Wütend*) *Herr* (raging army) or *Wilde Jagd* (wild hunt), beliefs which brought fear throughout Europe. These terrible visions were the subject of folk tales and learned disquisitions, such as that of Johann Geiler von Kaisersberg, with whose writings Baldung was certainly and Cranach possibly familiar.[49]

In their magisterial study *Saturn and Melancholy*, Panofsky, Saxl, and Klibansky were aware of Cranach's echo of Dürer's print, and other scholars have offered interpretations of this borrowing.[50] But there remains a problem if attention is not paid to the particular quality of Cranach's response to Dürer, or if Cranach's witches be seen only as links in the chain of an iconographic tradition that passively or "associatively" receives the impulse of Dürer's invention. The horrifying vision in Cranach's paintings would seem in any event to rule against the idea that Cranach is simply drawing on a recently established iconographic type. The logic of Panofsky's own argument speaks against this. Whatever the intricacies of their exegesis, for Panofsky, Saxl, and Klibansky the significance of Dürer's print of melancholy lies in its adherence to a particular Renaissance revaluation of what had formerly been regarded as something negative. In Cranach, however, this valorization has again been reversed. The trance of the figure is specifically evil, and not the gaze of a melancholic frustrated genius. It would thus appear that in using Dürer's image in a negative context, his contemporary Cranach would have to be regarded as making some kind of comment on Dürer's ideas.

Cranach's reading of Dürer may here again point to something about Dürer's meaning and, consequently, about the reception of the Renaissance. If Cranach is making a comment on the *Melencolia*, what could he be saying? What is there in Dürer's work, beyond the earlier iconographic tradition that portrayed melancholy as having ill effects, that lends itself to the peculiar form of reversal found in Cranach's paintings? Cranach's differences with Dürer, like Baldung's, focus on a particular problem, and this problem in Cranach seems to revolve around the magical or occult implications of Dürer's print. By being alert to this problem in Cranach's image, we may thus add to the results of other interpretative strategies. Among these are arguments by Konrad Hoffmann and, most pertinent for my purposes, by Frances Yates in her last book, *The Occult Philosophy in the Elizabethan Age*.[51] By paying closer attention to H. C. Agrippa's *De Occulta Philosophia*, a Renaissance handbook for much occult and cabalistic lore, which Panofsky and his colleagues themselves recognized as the source for much of Dürer's imagery without fully considering these aspects of the text, Yates came to challenge Panofsky's interpretation of *Melencolia*. Yates instead argued that if Dürer had used Agrippa's text, which indeed he must have consulted in manuscript, he must have been aware of its presentation of a philosophized combination of white magic and the cabala. Dürer's Melancholy is not to be seen as subject to a state of depression—she is not the frustrated genius Panofsky finds in her—but is wrapped in an intense trance, an occult vision protected by the angel of Saturn. Yates also noticed that Dürer's vision breaks down in Cranach's imagery. Yates wonders if Cranach does not suggest that suspicion of witchcraft and of the occult go hand in hand. There is also the question if indeed any possibility exists for any kind of white magic, for theurgic practice within the limits set by a correct theology, as seen by a committed adherent of Luther's Reform, such as Cranach—and here we approach another issue that has been raised by Dieter Koepplin, who saw a Lutheran message in Cranach's versions of *Melencolia*.[52]

Whatever the answer to these questions, or our judgment of the validity of Yates's (or Hoffmann's) theses, the problematic use of Dürer's art that is found in Cranach's imagery cannot be equated with the types of imitation that were conceived by Renaissance art and literary theory and exemplified in the art of Fröschl or Spranger. Cranach and Baldung seem instead to pose questions about some of the values embodied in Dürer's work, values that may be associated with the advent of the Renaissance. They thus raise questions not only about the reception of Dürer, but also about the reception of the Renaissance in the north in general.

The evocation of the occult and of witchcraft in their images recalls that the rhetorical and philological aspects of humanism, and its philosophy of art and beauty, represent only one side of what the Renaissance revived. It was in fact in relation to Dürer's *Melencolia* that Aby Warburg postulated his own famous interpretation of the duality of the classical tradition in general and, accordingly, of the Renaissance: "Athen will eben immer wieder neu aus Alexandrien züruckerobert sein."[53] We may interpret this as suggesting that the rational heritage of antiquity, including its educational ideals and notions of beauty, had to be recovered from what might be called its more

irrational elements, including traditions of magic and astrology. Within the intellectual tradition that Warburg himself established, Panofsky, Saxl, and Klibansky countered Warburg's thesis of the conflict expressed in Dürer's *Melencolia* with another vision of this image as a philosophic message related to artistic creation, and in turn Yates turned some of Panofsky's insights into the importance of Agrippa to stress an interpretation of the cabalistic, or magical, elements of the *Melencolia*, reminding us of Warburg's view. Cranach's and Baldung's responses to Dürer may thus ultimately be seen to open up perspectives on the dialectic of interpretations of Dürer and of the Renaissance.

The dialectic of interpretations of the Renaissance in the north has developed since art historians, most notably Heinrich Wölfflin, posed the era of the German masters of Dürer's time as comparable to but different from the Italian Renaissance, and many subsequent historians and art historians have challenged the unique or normative view of the Italian Renaissance. In turn the mixture of the native and the Italianate, what another scholar associated with the Warburg Institute, Michael Baxandall, has discussed as the *Deutsch* and the *Welsch* has come to characterize German Renaissance art.[54] But, as I have argued elsewhere, the view of the *Dürerzeit* as the norm for the Renaissance in Central Europe—and indeed for German art in general—rests on questionable and often nationalistic assumptions.[55] The arguments about Dürer's reception advanced above instead remind us that toward 1600 a model can be found that approximates Italian humanist and academic ideas; to make the early sixteenth century the norm is to ignore this evidence. In the works by Fröschl and Spranger discussed above it is of course Dürer, not the antique, that determines the canon. Thus, the reception of Dürer becomes a key not only to the question of the reception of specifically Italianate values in the north but also to their particular adaptation in the alien culture.

In conclusion, I would like to suggest that interpretations found in works of art may complement other strategies in helping not only to validate our understanding of earlier images but also to direct our approach to larger issues of historial interpretation. To return to the art historical problem with which I began, in the instances I have discussed, through their differences with Dürer, some earlier interpretations in art intimate what Dürer's meaning may be. I realize that in calling attention to the mutual interdependence of past and present interpretations I have been able to touch only superficially on some of the most difficult problems that exist both in hermeneutic theory and in art historical practice. Yet I hope that, by concentrating just on the way in which interpretations in a few selected examples within the history of art may enrich our understanding both of historiography and of past works, I have pointed to a line of approach that may prove fruitful in future art historical investigations.

NOTES

For purposes of publication I have limited the number of illustrations. References (in works cited in the notes) will be given for those images illustrated in the lecture on which this paper is based but not reproduced here. Because of the vast scope of several of the issues addressed here, I have also deemed it wise to restrict annotation to sources consulted, and to other key works.

1. See Matthias Mende, *Dürer Bibliographie zur 500. Wiederkehr des Geburtstages von Albrecht Dürer* (Wiesbaden, 1971). The commemorations of Dürer in 1971 provoked an outpouring of literature, which is surveyed in H. J. Berbig, "Sammelbericht über die Literatur zum Dürer-Jahr 1971," *Archiv für Kulturgeschichte* 55 (1973): 35–53; P. Vaisse, "Albrecht Dürer, écrits récents et états des questions," *Revue de l'art* 19 (1973): 116–124; G. Bräutigam and M. Mende, "Mähen mit Dürer. Literatur und Ereignisse im Umkreis des Dürer-Jahres 1971," *Mitteilungen des Vereins für Geschichte der Stadt Nürnberg* 61 (1974): 204–282; Wolfgang Stechow, "State of Research. Recent Dürer Studies," *Art Bulletin* 56 (1974): 259–270.

Since 1974 there have been several exhibitions devoted to Dürer and his influence, as well as a number of books on the artist, including comprehensive monographs by Fejda Anzelewsky, *Dürer: His Art and Life*, trans. Heide Grieve (London, 1982), and Peter Strieder, *Albrecht Dürer. Paintings. Prints. Drawings*, trans. Nancy M. Gordon and Walter L. Strauss (New York, 1982). Among the ever-growing body of articles and essays on the artist two contributions (in English) in F. Baron, ed., *Joachim Camerarius (1500–1574). Beiträge zur Geschichte des Humanismus im Zeitalter der Reformation. Essays on the History of Humanism during the Reformation*, Munich, 1978, may be singled out: Peter W. Parshall, "Camerarius on Dürer: Humanist Biography as Art Criticism," pp. 11–29, and William S. Heckscher, "Melancholia (1541): An Essay in the Rhetoric of Description by Joachim Camerarius," pp. 31–120.

2. Raymond Kilbansky, Erwin Panofsky, and Fritz Saxl, *Saturn and Melancholy. Studies in the History of Natural Philosophy, Religion and Art* (London, 1964), pp. 275–373; Erwin Panofsky, *Albrecht Dürer*, 2d ed. (Princeton, 1945) pp. 156–171. See also Erwin Panofsky and Fritz Saxl, *Dürer's "Melencolia I," ein quellen- und typengeschichtliche Untersuchung* (Berlin and Leipzig, 1923).

3. Charles W. Talbot, ed., *Dürer in America. His Graphic Work*, notes by Gaillard F. Ravenal and Jay A. Levenson, essay by Wolfgang Stechow (New York and London, 1972), p. 145. Jeffrey Chipps Smith, *Nuremberg, A Renaissance City, 1500–1618* (Austin, 1983), p. 111 (cat. no. 19), also seems to accept Panofsky's reading.

4. Among the newer interpretations of Dürer's engraving, specific reference is made here to Konrad Hoffmann, "Dürer's 'Melencolia'," in Werner Busch, Reiner Hausherr and Eduard Trier, eds., *Kunst als Bedeutungsträger* (Berlin, 1978), pp. 251–288, and Frances A. Yates, *The Occult Philosophy in the Elizabethan Age*

(London, Boston and Henley, 1979), pp. 49–59. Yates, p. 54, calls Panofsky's a "romantic interpretation."

5. Terence Lynch, "The Geometric Body in Dürer's Engraving *Melencolia I*," *Journal of the Warburg and Courtauld Institutes* 45 (1982): 226–232; Lynch specifically takes issue with Panofsky on p. 230.

6. The works listed in the first note, particularly the review essay by Stechow, evince some of this historiographic concern and point to further literature. At the time of writing, Białostocki's book was in press for the series Saecula Spiritualia (ed. Dieter Wuttke), Baden-Baden.

7. I am referring here to arguments that may be characterized as the theories of *Rezeptionsästhetik,* such as are associated with the teachings of the "Constance School" of literary theory and philosophy. Rainer Warning, ed., *Rezeptionsästhetik, Theorie und Praxis* (Munich, 1975), provides a convenient selection of texts related to these theories. The writings of the principal figures in the "Constance School," Wolfgang Iser and Hans Robert Jauss, are also becoming increasingly available in English; see, for example, especially Wolfgang Iser, *The Act of Reading: A Theory of Aestetic Response* (Baltimore and London, 1978); and Hans Robert Jauss, *Toward an Aesthetic of Reception,* trans. Timothy Bahti, intro. Paul de Man (Minneapolis, 1982). I have also profited much from Jauss's *Literaturgeschichte als Provokation der Literaturwissenschaft* (Frankfurt am Main, 1970).

It should be clear, however, that my own arguments in this paper do not strictly follow the lines of either Iser's or Jauss's theory. I am arguing for another effort to establish historical "meaning"—as well as the "significance" of Dürer's work. (For the distinction between these terms, see E. D. Hirsch, *Validity in Interpretation* [New Haven and London, 1967], which also, pp. 245–264, contains a trenchant critique of H.-G. Gadamer's hermeneutics, pertinent here [see the next note]. See, however, also the remarks on Hirsch's critique by Frank Lentricchia, *After the New Criticism* [Chicago, 1980], pp. 260–263.) It should be noted that these writings represent only some aspects of the vast and important literature on hermeneutics.

Earlier efforts to apply a hermeneutic approach, roughly speaking, to art history include H. R. Jauss, "Geschichte der Kunst und Historie," in *Literaturgeschichte als Provokation,* pp. 208–251 (in English as "History of Art and Pragmatic History," in *Toward an Aesthetic of Reception,* pp. 46–75), and Gottfried Boehm, "Zu einer Hermeneutik des Bildes," in *Seminar: Die Hermeneutik und die Wissenschaften,* ed. Hans-Georg Gadamer and Gottfried Boehm, (Frankfurt am Main, 1978). See also Götz Pochat, "August Wilhelm Schlegel als vorläuffer einer hermeneutischen Kunstgechichte" [*sic*] in *Problemi di Metodo: Condizioni di Esistenza di una Storia dell'Arte, Atti del XXIV Congresso di Storia dell'Arte,* 10, ed. Lajos Vayer, (Bologna 1982).

8. The notion of a "horizon of expectations," to which reference is made here, is drawn from the work of Jauss, as he has developed it from the writings of Hans-Georg Gadamer, in particular *Wahrheit und Methode,* now available as *Truth and Method* (New York, 1982).

9. The subject of artists' copies is again vast: an excellent introduction to drawn copies is provided by Joseph Meder, *The Mastery of Drawing,* trans. and rev. Winslow Ames (New York, 1978), pp. 217–231.

10. I am alluding here to David Quint, *Origins and Originality in Renaissance Literature* (New Haven and London, 1983), which discusses (p. 1) the problem of how Renaissance culture was to define its own individual creativity with respect to a classi-cal tradition that it at once posited and sought to displace as a source of authority and value.

In general I think that, in contrast with the situation I find in art history, students of literature have been much more reflective about, and have analyzed more thoroughly, questions of "influence," in particular its relation to imitation in the Renaissance. For an illuminating recent discussion of these issues, see, for example, Thomas M. Greene, *The Light in Troy: Imitation and Discovery in Renaissance Poetry* (New Haven and London, 1982), with many further references.

11. Helpful introductions to the extensive literature on the subject of imitation, with citations of further studies, are provided by Greene, *Light in Troy,* and by G. W. Pigman III, "Imitation and the Renaissance Sense of the Past, the Reception of Erasmus' *Ciceronianus,*" *Journal of Medieval and Renaissance Studies* 9 (1979): 155–177, and "Versions of Imitation in the Renaissance," *Renaissance Quarterly* 33 (1980): 1–32.

12. I have adapted this idea from H. R. Jauss's reading of H.-G. Gadamer; see Jauss, *Toward an Aesthetic of Reception,* p. 31. It should be noted that the passage in *Truth and Method,* p. 264, to which Jauss refers does not strictly speaking apply to the history of "influence," with which I am concerned here, but to the historicity of understanding. I should also reiterate that, while I find Jauss's description of the history of influence useful, I do not subscribe completely either to his hermeneutic approach to the problem or to that of Gadamer. As will be seen, my approach to the problem of establishing the historical meaning of a work of art is somewhat different.

13. I am deliberately recalling some of the conceptions of Gadamer, *Truth and Method,* p. 245, without, however, intending to imply that I believe in the notion of the "authority of tradition," according to Gadamer's discussion. The phenomenon to which I refer is of course just that of the historicity, or historic situation, of all interpretations.

14. For this phenomenon, see Gustav Glück, "Fälschungen auf Dürer's Namen aus der Sammlung Erzherzog Leopold Wilhelms," *Jahrbuch der Kunsthistorischen Sammlungen des Allerhöchsten Kaiserhauses* 28 (1909–1910): 1–35; Hans Kauffmann, "Dürer in der Kunst und Kunsturteil um 1600," *Anzeiger des Germanischen National-Museums* (1940–1953): 18–60; *Dürer-Renaissance,* exh. cat. (Munich, 1971); Hans Georg Gmelin, "Dürerrenaissance um 1600," *Im Blickpunkt* 7 (Hanover, 1979); Gisela Goldberg, "Dürer-Renaissance am Münchener Hof," in *Um Glauben und Reich Kurfürst Maximilian I,* 2: pt. 1, *Beiträge zur Bayerischen Geschichte und Kunst 1573–1657* (Munich, 1980), pp. 318–323, and "Zur Ausprägung der Dürer-Renaissance in München," *Münchener Jahrbuch der bildenden Kunst* 31 (1980): 129–176; *Dürers Verwandlung in der Skulptur zwischen Renaissance und Barock,* exh. cat., ed. H. Beck (Frankfurt am Main, 1981–1982) (including important essays by Bernhard Decker); see also note 24 below.

The examples in this paper are, however, drawn directly from Eliška Fučíková, "Umělci na Dvoře Rudolfa II a jejich vztah k tvorbě Albrechta Dürera," *Umění* 20 (1972): 149–162, who also provides more information on Hoffmann and Fröschl. For an overview of Hoffmann's and Fröschl's work in Prague, see the catalogue of paintings in my *L'Ecole de Prague. La peinture à la cour de Rodolphe II* (Paris: Flammarion, 1985). For Dürer's 1502 *Madonna,* see Fučíková, fig. 2; Dürer's 1484 self-portrait can be found illustrated in Strieder, *Dürer,* fig. 5, p. 10.

15. For art in Rudolfine Prague, see my *L'Ecole de Prague,* with an extensive bibliography on painting at the court of Rudolf II.

16. In the 1610–1619 Vienna inventory, which contains many works with a provenance probably from the collection of Rudolf II, it is already described as a work by Dürer; see the "Inventarium und verzaichnus ihrer römischen kaiserlichen majestät gemäld und conterfähten, so in Neuenburg zu Wien liegen," in W. Köhler, ed., "Aktenstücke zur Geschichte der Wiener Kunstkammer in der herzoglichen Bibliothek zu Wolfenbüttel" *Jahrbuch der Kunsthistorischen Sammlungen des Allerhöchsten Kaiserhauses* 26 (1906–1907): vii. Fučíková, "Umělcı na Dvoře," pp. 154, 163 no. 30, first pointed out this reference.

17. For Rudolf II as a collector of Dürer, see Josef Neuwirth, "Rudolf II als Dürer-Sammler," *Xenia Austriaca* (Vienna, 1893); for Elector Maximilian, see Anton Ernstberger, "Kurfürst Maximilian und Albrecht Dürer," *Anzeiger des Germanischen National-Museums* (1940–1953), pp. 163–183; for Ferdinand of the Tyrol, see Peter W. Parshall, "The Print Collection of Ferdinand, Archduke of Tyrol," *Jahrbuch der Kunsthistorischen Sammlungen in Wien* 78 (1982): 139–184 (with much information on other contemporary collections); for the Nuremberg collectors, see W. Schwemmer, "Aus der Geschichte der Kunstsammlungen der Stadt Nürnberg," *Mitteilungen des Vereins für Geschichte der Stadt Nürnberg* 40 (1949): 123–125 (as cited by Parshall); for Praun the basic source is Christophe Theophile de Murr, *Description du cabinet de Monsieur Paul de Praun à Nuremberg* (Nuremberg, 1797). Dissertations on the Praun and Imhoff collections are currently being written by K. Achilles and H. Budde at the Technische Universität in Berlin. (Editor—see below, Smith, "The Transformations of Patrician Tastes in Renaissance Nuremberg.")

18. For the 1607–1611 inventory of Rudolf II's Kunstkammer, and the role of Fröschl in its compilation, see Rotraud Bauer, "Die Kunstkammer Kaiser Rudolfs II in Prag, ein Inventar aus den Jahren 1607–1611," in Bauer, and Herbert Haupt, ed., "Das Kunstkammer-inventar Kaiser Rudolfs II, 1607–1611," *Jahrbuch der Kunsthistorischen Sammlungen in Wien* 72 (1976): esp. xxiiff.

19. This idea is developed in my *L'Ecole de Prague* (pp. 71–75), and in forthcoming papers by E. Fučíková that were delivered originally at the International Congress of the History of Art in Vienna in 1983 and at an exhibition (see note 24 below) held in Vienna in 1985.

20. For Vasari, see Gaetano Milanesi, ed., *G. Vasari: Le Vite de' più eccellenti pittori scultori ed architettori* (Florence, 1880), 5: 399–403; for Ludovico Dolce, see Mark W. Roskill, *Dolce's Aretino and Venetian Art Theory of the Cinquecento* (New York, 1968), pp. 120–121. Lomazzo mentions Dürer favorably at many points in his writings. See, most accessibly, Gian Paolo Lomazzo, *Scritti sulle arti*, ed. Roberto Paolo Ciardi (Florence, 1973), 1: 150; (Florence, 1974), 2: 163, 250, 400, 159, 410, 161, and passim. For Palcotti, see P. Barocchi, ed., *Trattati d'arte del cinquecento* (Bari, 1961), 2: 167; for Alberti, see ibid: (Bari, 1962), 3: 220, 232. For Van Mander on Dürer, see *Het Schilder-Boek* . . . (Haarlem, 1604), fols. 207v–210r. The comments of Italian critics, such as Dolce, are also of course made with the demurral that if Dürer had been born in Italy he would have been second to none.

21. This distinction is drawn by Vincenzo Danti, *Trattato delle perfette proporzioni, di tutte cose che imitare si possono con l'arte di disegno*, in *Trattati*, ed. Barocchi, 2: 264ff. For ideas of imitation in relation to sixteenth- and seventeenth-century art in general, see E. Battisti, "Il Concetto d'imitazione nel cinquecento da Rafaello a Michelangelo," *Commentari* 7 (1956): 86–101, and "Il concetto d'imitazione nel cinquecento dai Veneziani a Caravaggio," pp. 249–262.

22. For an explication of this notion, see Erwin Panofsky, *Idea: A Concept in Art Theory*, trans. Joseph J. S. Peake (Columbia, S.C., 1968), esp. pp. 107ff. To be sure, Panofsky associates the attitude described here most closely with G. P. Bellori and "classicist" art theory, but, as Rensselaer W. Lee, *Ut Pictura Poesis: The Humanistic Theory of Painting* (New York, 1967), pp. 9–16, has demonstrated, this issue is a current in art theory through the Renaissance.

23. Kauffmann, "Dürer in der Kunst." p. 30; in this passage Kauffmann also first connected the imitation of Dürer ca. 1600 with Danti's notions of imitation. Although Kauffmann does not refer to any aspect of hermeneutic theory, echoes of its language in his account seem quite striking.

24. For a good overview of the phenomenon of printed copies of Dürer in the sixteenth century, see the catalogue of the exhibition held in Nuremberg, *Vorbild Dürer: Kupferstiche und Holzschnitte Albrecht Dürers im Spiegel der europäischen Druckgraphik des 16. Jahrhunderts* (Munich, 1978); several examples of interpretations of Dürer's *Adam and Eve* were also included in the exhibition *Nuremberg, A Renaissance City* (see Smith, *Nuremberg*, cat. nos. 53, 93, 114). The subject of borrowings from Dürer was also touched upon by Richard Field in his unpublished contribution to the symposium at which an earlier version of this paper was given, and also in his *The Spread of Dürer's Woodcut Style*, exh. cat. (New Haven, 1981). See also in general *Dürers Verwandlung*. The general subject of copies and forgeries of Dürer is also treated in *Dürer Through Other Eyes: His Graphic Work Mirrored in Copies and Forgeries of Three Centuries*, exh. cat. (Williamstown, Mass., 1975). See also the important exhibition catalogue by Fritz Koreny, *Dürer und die Tier und Pflanzenstudien der Renaissance* (Vienna: Graphische Sammlung Albertina, 1985).

25. Fröschl's (once) signed copy of Raphael's *Canigiani Holy Family* (Munich, Alte Pinakothek) is illustrated, p. 198, and discussed along with other works of his Florentine period in *Firenze e la Toscana dei Medici nell'Europa del Cinquecento: Palazzo Vecchio committenza e collezionismo medicei*, exh. cat. (Florence, 1980), nos. 376–380. See also Alessandro Conti, "The Reliquary Chapel," *Apollo* 106 (1977): 208 and n. 20.

26. For ideas and forms of artistic imitation in Rudolf II's Prague, see Jürgen Zimmer, "Zum Stil in der Rudolfinischen Kunst," *Umění* 18 (1970): 112–120, and my "The Eloquent Artist: Towards an Understanding of the Stylistics of Painting at the Court of Rudolf II" [sic], *Leids Kunsthistorisch Jaarboek* 1 (1982): esp. 136–137.

27. I am here summarizing "The Eloquent Artist," with many further references. For the subject of such allegories on the arts in this time and region, see in general Hanna Peter-Raupp, "Zum Thema 'Kunst und Künstler' in Deutschen Zeichnungen von 1540–1640," *Zeichnung in Deutschland: Deutsch Zeichner 1540–1640*, exh. cat. (Stuttgart, 1980), 2: 223–230.

28. For this process of emulation in Prague, see chap. 2 of my *L'Ecole de Prague*, as well as Zimmer, "Zum Stil," and Fučíková, "Umělci na Dvoře," pp. 162, 163 n. 62. In contrast with the arguments made here and in my "The Eloquent Artist," and also by Hans Kauffmann and others, Bernhard Decker, "Dürer Nachahmungen und Kunstgeschichte—ein Problem am Rande," p. 388, in *Dürers Verwandlung*, in response to Kauffmann's (*Dürer in der Kunst*), p. 30, says: "[Imitation] . . . ist ein Leitgedanke der Akademie, der damaligen wie der späteren. . . . Welche Kunst aber wäre in diesem Sinne nicht 'imitatio?' Vielleicht sagt diese Erklärung etwas über den italienischen Akademiebetrieb—sie sagt aber nichts aus über die Dürer Nachahmungen, die sich auf keine akademische Lehrmeinung stützen konnten." In my "Draw-

ings from the Holy Roman Empire, 1540–1680: An Essay toward Historical Understanding," in *Drawings from the Holy Roman Empire, 1540–1680: A Selection from North American Collections* (Princeton, 1982), pp. 20–25, I have, however, extended some of my theses about Prague to other areas of the Empire as well; I thus wish here again to point out my disagreement with Decker's argument. I have also elaborated the arguments I have made here in a paper delivered at a symposium held in connection with the exhibition in Vienna mentioned in footnote 24, now being prepared for publication. The paper, "The Nature of Imitation: Hoefnagel on Dürer," proceeds from an explication of two unpublished Latin poems on Dürer by Georg Hoefnagel, who copied at least two of Dürer's nature studies.

29. I have again taken these images from Fučíková, "Umělci na Dvoře," where they are discussed (p. 158) and illustrated (figs. 9, 10, 11); Dürer, *Patron Saints of Austria* (Bartsch 116), and fig. 13, *Self-portrait*.

30. Telling examples here are Goltzius' *Meisterstiche*, including his emulation of Dürer's graphic style. For the *Meisterstiche* as forms of emulation, see E. K. J. Reznicek, *Die Zeichnungen von Hendrick Goltzius* (Utrecht, 1961), pp. 98–99; and E. De Jongh, "The Spur of Wit: Rembrandt's Response to an Italian Challenge." *Delta* 12 (1969–1970): esp. 54–60.

31. For a discussion of the historiographic problem in relation to the canonization of Dürer and his contemporaries, see "Drawings from the Holy Roman Empire," pp. 4–8.

32. Linda Hults Boudreau, "Hans Baldung Grien and Albrecht Dürer: A Problem in Northern Mannerism," Ph.D. dissertation, University of North Carolina, 1978. J. E. von Borries has addressed many of the same issues in his lecture, now being prepared for publication, at the 1985 Vienna symposium mentioned in notes 24 and 28.

33. My critiques of "mannerism"—which I usually deliberately choose to leave in lower case—can be found in "The Problem of 'Northern Mannerism': A Critical Review," in *Essays on Mannerism in Art and Music*, ed. S. E. Murray and R. I. Weidner, (West Chester, Pa., 1980), pp. 89–115; "The Eloquent Artist," pp. 119–122; "Drawings from the Holy Roman Empire," pp. 19–20; *L'Ecole de Prague*, chap. 4.

34. See *Hans Baldung Grien: Prints and Drawings*, exh. cat., ed. James H. Marrow and Alan Shestack, with three essays on Baldung and his art by Alan Shestack, Charles W. Talbot, and Linda C. Hults (Washington and New Haven, 1981), cat. no. 19, pp. 121ff. The contrast between Baldung's and Dürer's images of Adam and Eve is drawn out by Robert A. Koch, *Hans Baldung Grien, Eve, the Serpent and Death / Eve, le serpent et la Mort* (Ottawa, 1974), pp. 10–14, and Hults Boudreau, "Baldung Grien and Dürer," pp. 100–110. For copies (as opposed to Baldung's form of adaption) of Dürer's print, see in general Peter Strieder, "Copies et interprétations du cuivre d'Albrecht Dürer 'Adam et Eve,'" *Revue de l'art* 21 (1973): 44–47; for adaptions, including Baldung's, see Craig Harbison, ed., *Symbols in Transformation: Iconographic Themes at the Time of the Reformation*, exh. cat. (Princeton, 1968), pp. 16–18.

35. For this point, in addition to the sources cited in the previous note, see Larry Silver and Susan Smith, "Carnal Knowledge: The Late Engravings of Lucas van Leyden," *Nederlands Kunsthistorisch Jaarboek* 29 (1978): 247–249; and A. Kent Hieatt, "Hans Baldung Grien's Ottawa *Eve* and Its Context," *Art Bulletin* 65 (1983): 290–304. E. M. Vetter, "Necessarium Adae Peccatum," *Ruperto-Carola* 18 (1966): 144–181 (cited in *Hans Baldung Grien: Prints and Drawings*, pp. 122–123), was not available to me at the time of writing.

36. This interpretation is advanced by Hieatt, "Baldung's Ottawa *Eve*," in regard to images other than those directly under consideration in this paper.

37. Panofsky, *Dürer*, pp. 84–85.

38. This particular elucidation of the rabbits in Baldung is brought out by Silver and Smith, "Carnal Knowledge," pp. 248, 285 n. 39; *Hans Baldung Grien: Prints and Drawings*, p. 121; Harbison, *Symbols in Transformation*, p. 40.

39. For Baldung's adaptations of Dürer's *Eve* and ideal female nudes, see Charles W. Talbot, "Baldung and the Female Nude," in *Hans Baldung Grien: Prints and Drawings*, pp. 19–37, with further references; Koch, *Hans Baldung Grien*; Hults Boudreau, "Baldung Grien and Dürer." Baldung's transformation of Dürer's ideal types into witches is mentioned in Linda C. Hults, "Hans Baldung's Weather Witches in Frankfurt," *Pantheon* 40 (1982): 124–130.

40. Hults Boudreau, "Baldung Grien and Dürer," pp. 121–122.

41. Panofsky, *Dürer*, p. 88; noted by Hults Boudreau, "Baldung Grien and Dürer," p. 121.

42. For Ladenspelder's version, see *Vorbild Dürer*, no. 123, p. 115. It has been pointed out that Dürer's *St. Eustace*, which employs geometrical forms for the construction of parts of the horse, occupies an important place in the development of Dürer's constructional methods: *Albrecht Dürer, 1471–1971*, exh. cat. Nuremberg (Munich, 1971), no. 496, p. 254. Could Baldung's use of the landscape from this print be deliberate—a recollection of the context from which it is derived? If so, does it then reinforce the associations with the proportionality of the horse and underline Baldung's rejection of Dürer's ideas?

43. Levenson's interpretation is presented in *Hans Baldung Grien: Prints and Drawings*, nos. 83–85, pp. 264–266 (with ills. on pp. 267–269); no. 34, p. 164, connects the eye of Baldung's *Groom Bridling a Horse* with these other images. Levenson's observation (p. 164) that "Baldung's print is surely meant as a mildly satiric reworking of Dürer's *Small Horse*" does not seem to go far enough, however.

44. On Baldung's print known as the *Bewitched Groom*, see *Hans Baldung Grien: Prints and Drawings*, no. 87, p. 273. Though the comparison between Dürer's horse and Baldung's in this particular print does not seem to have been frequently made, the dependence of Baldung's animal in both pose and proportion from Dürer's seems obvious.

45. For this device, see Kurt Rathe, *Die Ausdrucksfunktion extrem verkürzter Figuren* (London, 1938).

46. Hults Boudreau, "Baldung Grien and Dürer," p. 137, says, "The touch is undoubtedly the source of this bewitching." See, however, for arson and witches, Keith Thomas, *Religion and the Decline of Magic* (New York, 1971), pp. 531–534, 559, and for the problems and dangers of fire, pp. 15–16. I am grateful to Anthony Grafton for recalling these references to me.

47. Cranach's images of witches, derived from the *Melencolia*, are illustrated in Dieter Koepplin and Tilman Falk, *Lukas Cranach. Gemälde. Zeichnungen. Druckgraphik*, exh. cat. (Basel, 1974), 1: plate 13 (p. 225), ill. 133 (p. 273); and Max J. Friedländer and Jakob Rosenberg, *The Paintings of Lucas Cranach* (Ithaca, N.Y., 1978), figs. 276, 277; see also Werner Schade, *Cranach: A Family of Master Painters*, trans. Helen Sebba (New York, 1980), ill. 181.

48. See, for example, Yates, *Occult Philosophy*, p. 59.

49. For these beliefs, see Carlo Ginzburg, *I Benandanti: ricerche sulla Stregoneria e sui culti agrari tra Cinquecento e Seicento*, (Turin, 1966), pp. 67ff. (I am again grateful to Anthony Grafton for bringing Ginzburg's book to my attention.) See also E. Hoffmann-

Krager, founder, and Hanns Bächtold-Stäuber, ed., *Handwörterbuch des Deutschen Aberglaubens*, Berlin, 9 [Nachtrag] (1938/41), col. 488; 8 (1936/37), col. 736, 1475. Ginzburg, pp. 68ff., discusses Geiler von Kaisersberg's treatment of these subjects in *Die Emeis*. For Baldung and Geiler, see, most recently, Gert von der Osten, *Hans Baldung Grien: Gemälde und Dokumente* (Berlin, 1983), pp. 22, 31–39, and passim.

50. *Saturn and Melancholy*, pp. 382–384; see also Falk and Koepplin, *Cranach*, p. 292; Yates, *Occult Philosophy*; Konrad Hoffmann, "Dürer's 'Melencolia I' und Cranach," in *Akten des Kolloquiums zur Basler Cranach Ausstellung 1974* (Basel, 1978), pp. 24–25.

51. I refer here to Hoffmann, "Dürer's 'Melencolia,'" in *Kunst als Bedeutungsträger*, ed., Hausherr and Trier, as well as to Yates, *Occult Philosophy*, pp. 49–59. I do not think it is necessary to concur with Hoffmann in rejecting the import of Agrippa for Dürer because Dürer would have had to have read Agrippa's text in manuscript. As Panofsky et al., *Saturn and Melancholy*, pp. 351–352, point out, and Yates, p. 52, reiterates, the work was circulated in many copies and was available in the circles in which Dürer moved. Dürer's consultation of this text in manuscript might even be interpreted to mean that it had special import for him.

52. Koepplin, in *Cranach*, p. 192, and also modified in response to Hoffmann's criticism in *Akten des Kolloquiums*, p. 25.

53. Aby Warburg, *Heidnisch-antike Weissagung in Wort und Bild zu Luthers Zeiten, Sitzungsberichte der Heidelberger Akademie der Wissenschaften, Philosophisch-historische Klasse* 26 (1919), reprinted in *Aby M. Warburg. Ausgewählte Schriften und Wurdigungen, Saecula Spiritualia*, ed., Dieter Wuttke (Baden-Baden, 1979), 2: 199–304. Warburg's famed remarks can be found on p. 267.

Wuttke's edition also contains a comprehensive bibliography on Warburg. For an interpretation of Warburg's reading of these themes, see E. H. Gombrich, *Aby Warburg: An Intellectual Biography (with a Manuscript on the History of the Library by F. Saxl)* (London, 1970), pp. 206–215. I in turn am reading these lines somewhat differently, in the context of the history of interpretation of Dürer.

54. Michael Baxandall, *The Limewood Sculptors of Renaissance Germany*, (New Haven and London, 1980), esp. pp. 135–142.

55. "Drawings from the Holy Roman Empire," pp. 4–10.

My thanks to Margaret Carroll for a helpful reading of a draft of this paper. After this essay was in press I learned of a related article on Dürer's *Melencolia I*; see P. K. Schuster, "Das Bild der Bilder - zur Wirkungsgeschichte von Dürers Melancholiekupferstich," *Idea – Jahrbuch der Hamburger Kunsthalle* 1 (1982):72–134.

1. Anonymous, *The Meteor of Ensisheim*, broadsheet with text by Sebastian Brant, 1492, Basel, Universitätsbibliothek. (courtesy author)

Polemical Prints in Reformation Nuremberg

by Christiane Andersson

One of the most striking developments in the early history of the graphic arts is the extraordinary efflorescence of the popular woodcut in Nuremberg during the first half of the sixteenth century. Especially the single-sheet woodcut—generally accompanied by an explanatory text and disseminated in the form of a broadsheet—benefited from a timely confluence of artistic, literary, and commercial factors in Nuremberg. The ground-breaking esthetic and technical advances of Albrecht Dürer's woodcuts at the beginning of the century and, by the 1520s, the availability of a substantial number of fine graphic artists, some of them trained by Dürer himself, had a considerable impact on the visual quality of popular prints. In addition, during these years there was ample literary talent to draw upon, the prime exponent of popular verses composed in the vernacular being of course Hans Sachs. But the remarkable achievements brought forth by Nuremberg's graphic artists and writers were made possible primarily by the commercial strength and versatility of the local publishing and printing industry, which by 1500 already enjoyed an international reputation. Nuremberg claims both the oldest verifiable operation of a paper mill in Germany in the year 1390 and the earliest identifiable woodcutters and *Briefmaler*,[1] known from their works dating from the second half of the fifteenth century. Small-time publishers (*Briefmaler, Kartenmaler, Formschneider*) were usually the initiators in the creations of broadsheets; they commissioned other craftsmen, who produced the woodcuts and texts and who often did the printing as well.

These publishers proliferated in Nuremberg during the late fifteenth and sixteenth centuries due to the absence of restrictive guild regulations of the type that "protected" other crafts. Competition was so fierce that numerous *Briefmaler* and *Kartenmaler* were obliged to pursue a second trade for additional income. For instance, around 1490 the *Kartenmaler* Schürstab is recorded also dealing in rags, which he presumably sold to paper mills and related industries. In 1477 the *Briefmaler* and *Kartenmaler* asked the Nuremberg town council to establish a guild ordinance to regulate their trade and thus diminish competition, but the request was denied, as it was consistently on at least six subsequent occassions between 1482 and 1746. In 1623 the council was at least willing to apply the principle of attrition to shrink the ranks of the local *Kartenmaler*, but actual guild regulations were not instituted until 1746. The councilors consciously encouraged variety and quantity in the products of the printing industry, which they regarded as a "free trade." Within the limits of their own powers of

censorship, they valued broadsheets and pamphlets for their informative function and especially for the moral precepts they reinforced among Nuremberg's citizenry. Broadsheets reported on a wide array of current events, such as celebrations, wars, crimes, famines, and natural catastrophes. Since many such occurrences—earthquakes, floods, typhoons, eclipses, and the like—were understood as divine warnings, the dissemination of news regarding such events in the form of illustrated broadsheets, intended to elicit repentence and thus avert disaster, was a mainstay of moral rectitude in Nuremberg society.

Another factor that enhanced the development of the illustrated broadsheet in Nuremberg was the popular nature of its imagery. Local artists, such as the Behams, Erhard Schön, Peter Flötner, Leonhard Beck, and others, were especially adept at transforming aspects of contemporary culture and folklore into pictures comprehensible to all facets of society, literate and illiterate alike. A remarkable tradition of satirical imagery, illustrations of proverbs, popular customs, and local observances, had been established in Nuremberg by 1520. Thus when Luther's evangelical theology was introduced there, the stage was already set for a lively propaganda campaign of illustrated broadsheet and pamphlets issued in rapid reaction to the course of events. Small-time publishers expanded their output in order to cater to the new demand for reportage and commentary on Reformation-related issues. They quickly learned tactics allowing their wares to slip past the local censors, sometimes employing "disguised" polemical symbolism during periods of heightened conflict with Germany's Catholic emperor. The particularly advantageous circumstances of art and commerce in Nuremberg enabled the free imperial city to become a far more active center of production of visual propaganda than Wittenberg, where this might reasonably be expected due to Luther's presence. As a university town and residence of the Saxon electors, Wittenberg had cultivated a tradition of scholarly publication and of court art rather than of popular woodcuts. Thus, during the early years of the evangelical movement, even the Cranach workshop was less well prepared to initiate a large-scale campaign of visual propaganda in the popular mode.

Prior to the Reformation a major category of images illustrated and commented upon in broadsheets comprised unnatural or fearful events, such as comets and meteors (fig. 1), strange celestial formations, pestilence, misbirths, floods (fig. 2), and the like. In a highly superstitious, prescientific age, such incidents took on supernatural significance in the popular imag-

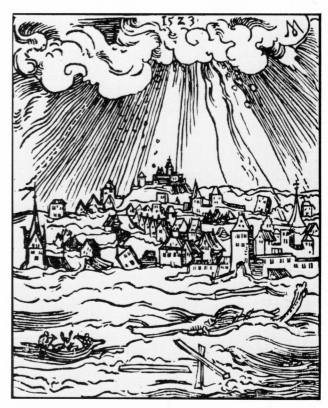

2. Anonymous, title page, Joseph Grünback, *Warnungen*, 1523, Frankfurt, Stadt- und Universitätsbibliothek. (courtesy author)

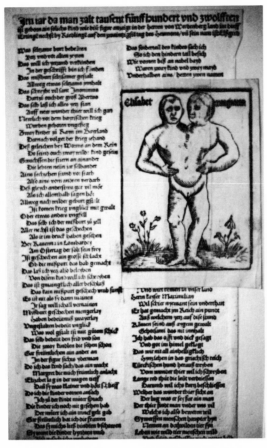

3. Anonymous, *Birth of Siamese Twins*, broadsheet with anonymous text, 1512, London, British Museum, Department of Prints and Drawings. (courtesy British Museum)

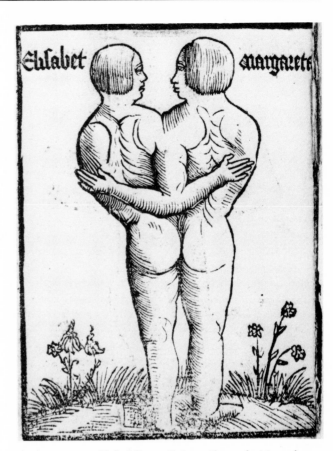

4. Anonymous, *Birth of Siamese Twins*, with woodcut turned over.

ination and were interpreted as omens and portents of divine displeasure over the sinful deeds of mankind. Owing to the great attention such events commanded and the irrational fears they elicited in common people, omens lent themselves well to political exploitation. German publicists were very adept at capitalizing on this polemical potential. Their diatribes, published in the form of broadsheets and pamphlets, had an especially profound effect during two critical periods when the imminent end of the established social order and even of the world itself had been predicted, as occurred for the years 1500 and 1524. Contemporary commentaries issued to publicize these dire events demonstrate the prevailing atmosphere of catastrophe. For example, the falling of a large meteor on the Alsatian hamlet of Ensisheim in 1492[2] was described and given a political interpretation by Sebastian Brant (fig. 1), the publicist and author of the famous *Ship of Fools*, published in Basel in 1494. In the text of his broadsheet, Brant subverts a

natural event, transforming it polemically into a divine reprimand against current imperial policies in Germany. Numerous prognostics for the fateful year 1524 (fig. 2) predicted torrential rains, which were said eventually to flood the entire world, a retribution analogous to the biblical flood survived only by Noah and the animals.

Among the many types of omens and disasters publicized in broadsheets, misbirths, and monsters seem to have held a particular fascination for the German people. Judging from the examples preserved, they must have been among the most common themes in broadsheets even before the Reformation. One of the more technically imaginative ones recounts the birth of Siamese twins named Elizabeth and Margarete in the village of Ertingen near Werdenberg in the year 1512 (fig. 3).[3] The broadsheet, now belonging to the British Museum, is illustrated with two woodcuts, printed on both sides of a separate sheet, which is pasted vertically onto the broadsheet between the

columns of text. The image can be turned over, allowing the viewer to inspect these unfortunate creatures from the rear as well (fig. 4), in effect offering the viewer the assembled evidence of the anonymous author's own inspection of the misbegotten twins. As described in the text, he had requested their mother to turn them over in their crib so that he could also study their peculiar anatomy from behind. Establishing the reliability of the author's report through both text and images was essential in broadsheets in order to give credibility to the political interpretation that he gave to the misbirth. Here he urges Emperor Maximilian to defend Christendom by mounting a campaign against the Turks in Greece.

It was in the service of the Protestant Reformation, however, that the misbirths as a propaganda tool truly came into their own. Physical deformity was interpreted as a sign of spiritual corruption. The first and most famous pamphlet that capitalized on this belief for polemical purposes was the tract of 1523 by Luther and Melanchthon, *Deuttung der zwo grewlichen / Figuren Bapstesels zu Rom vnd Munchkalbs / zu freyberg jn Meyssen funden*, published by Johannes Rau-Grunenberg in Wittenberg.[4] The theologians themselves composed the texts and determined the configuration of the images. The woodcuts were designed in the workshop of Luther's friend and supporter Lucas Cranach the Elder. The pamphlet consists of polemical interpretations of two alleged misbirths: a calf born near Freiberg in Saxony in 1522, which came to be called the Monk Calf (fig. 5), and a fantasy creature supposedly discovered in the Tiber at Rome in 1496, called the Papal Ass (fig. 6).

The Papal Ass, which appears in the pamphlet with an allegorical explanation written by Melanchthon, consists of an ass's head attached to a female torso, with one human hand and an animal limb. Its legs end in a hoof and a claw. It is almost entirely covered with scales and its tail resembles that of a dragon. This outlandish creature originated in Italy at the end of the fifteenth century and was already then associated with an antipapal polemical campaign. The appearance of this monster, allegedly dredged out of the Tiber after a flood, had been publicized in Rome as a portent reflecting on the sinful deeds of the then reigning pontiff, Pope Alexander VI. Its specific characteristics were recorded and transmitted to Germany by an engraving dated 1496 by the Bohemian artist Wenzel von Olmütz (fig. 7). Olmütz's composition in turn seems to have been based on an Italian precedent, perhaps a print or broadsheet circulated in Rome at that time, but no impressions of this are known. Presumably, the Bohemian artist's satirical en-

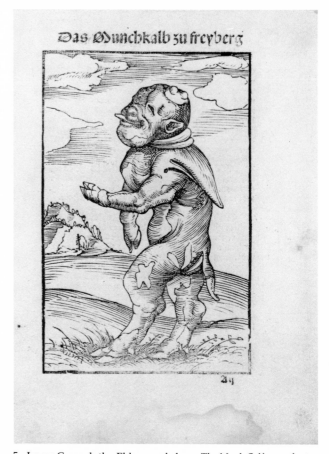

5. Lucas Cranach the Elder, workshop, *The Monk Calf*, woodcut, 1523, Nuremberg, Germanisches Nationalmuseum. (courtesy Germanisches Nationalmuseum)

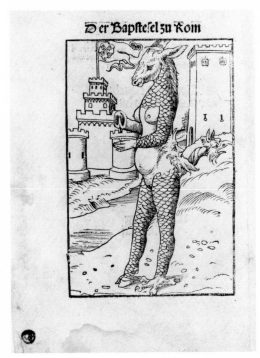

6. Lucas Cranach the Elder, workshop, *The Papal Ass*, woodcut, 1523, Nuremberg, Germanisches Nationalmuseum. (courtesy Germanisches Nationalmuseum)

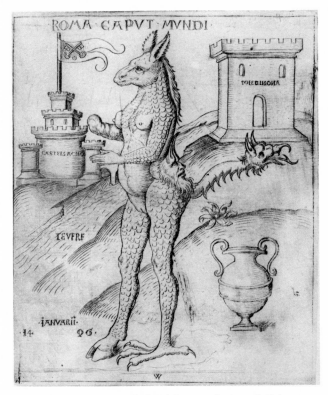

7. Wenzel von Olmütz, *The Papal Ass*, woodcut, 1496, Coburg, Kunstsammlungen der Veste Coburg. (courtesy Kunstsammlungen der Veste Coburg)

graving was created as an expression of the Bohemian Brethren's opposition to the papacy. Both the Bohemian engraving and its German counterpart in the Lutheran tract link the monster to the papacy by association: the monster is discovered in Rome (*ROMA•CAPVT•MVNDI*), capital of Christendom, and the surrounding buildings are papal structures. Olmütz identifies the one flying the papal flag in the left background as the Castel Sant'Angelo, which Alexander VI had refurbished as a fortification. The square tower at the right (fig. 6) represents the Torre di nona, a building across the Tiber that Alexander VI used as the papal prison.

As for the Monk Calf of Saxony, this freak of nature was allegedly born with a large flap of skin on its back resembling a cowl and a bald spot on its head similar to a tonsure, hence offering analogies to the appearance of a monk (fig. 5). It thus became known as the Monk Calf. This misbirth occurred in 1522 and led to at least two polemical interpretations criticizing the clergy prior to Luther's pamphlet,[5] which was published the following year. Like the Papal Ass with its Bohemian precedent, here again Luther was not the first to exploit the misbirth for polemical purposes. But almost overnight, Luther's became the definitive version, whose satirical success is attested to by the enormous number of copies and adaptations it engendered. As illustrated in Luther's tract, the Monk Calf seems to extend one front leg out like a hand, a gesture that Luther understood as preaching. The protruding tongue was seen as evidence that monkish teaching amounts to nothing more than nonsensical gossip. Luther explained the flaps of skin resembling ears as signifying Catholic subjection to the practice of confession.

By expressing their polemical message in terms of divine portents, Luther and Melanchthon in essence gave divine sanction to their theology. They cleverly captured the attention of a wide audience through the exploitation of the popular obsession with omens. As we have seen, neither the Papal Ass nor the Monk Calf can be considered their own invention, but effectiveness rather than originality was the crucial factor. Though Luther and Melanchthon may have lobbed the opening salvos in the polemical campaign, publicists from the Catholic camp shortly followed suit, often returning the fire with the same type of images. Thus monsters and misbirths, which had already played an important role in popular culture before the Reformation, became one of the most common forms of propaganda, used by Protestants and Catholics alike in support of theological arguments as well as for character assassination.

The polemical tradition of publicizing misbirths, so expertly exploited by Luther and Melanchthon in Wittenberg, was eagerly embraced and imitated by artists and publishers in other areas of Germany sympathetic to the Reformation, such as Nuremberg. For example, a widely circulated broadsheet illustrated by an anonymous Nuremberg artists and published by Steffan Hamer in 1546 (fig. 8) reports the discovery of a mishapen monk-like fish, whose torso resembled a cowl and chasuble but who had the negroid features of a Moor and a fishtail and fins rather than human limbs. Allegedly caught by fishermen in the sea near Copenhagen, this bizarre creature with its amphibious characteristics is clearly a direct descendant of the scaly Papal Ass dredged out of the Tiber some fifty years earlier. But its resemblance to a monk in clerical garb equally recalls to mind Luther's Monk Calf. Likewise, the Monk Fish was surely intended to publicize once again the Lutheran view of monks as demonic freaks. Just as the report of the birth of Siamese twins (fig. 3–4) scrupulously identifies the source of the author's information, here again the accuracy of the account is underscored: the "reliable source" cited is no less than the king of Denmark himself, who had the monster, while still alive, brought before him to be sketched by an artist, as we know from variants of the broadsheet having thirty-two additional verses (fig. 9). The existence of impressions from four separate editions, printed from different woodblocks and all issued in 1546, as well as numerous later copies,[6] attests to the Monk Fish's considerable popularity. It remained in demand perhaps partly due to its similarity to the famous Wittenberg prototypes (figs. 5–6), later editions of which continued to circulate.[7] In addition to impressions of the Monk Fish at Gotha[8] and Nuremberg issued from Steffan Hamer's shop in Nuremberg, two impressions preserved at Zurich[9] and bearing the longer text appear to have both been printed by Jakob Frölich in Strasbourg. Hamer's conspicuous omission of the more extensive text suggests that the tale of the Monk Fish was possibly already so well known in Nuremberg as to obviate the necessity for a detailed account.

Three years later, in 1549, Hamer's broadsheet seems still to have been in such demand that he contemplated a new edition. But the town councilors evidently denied permission to reissue it,[10] a typical case of stricter censorship[11] during politically more precarious times. Following the defeat of the Schmalkaldic League by the Catholics in 1547, the councilors—having to answer to the emperor whenever Protestant propaganda slipped past local censors—steered a consistently more restrictive course. Contrary to their

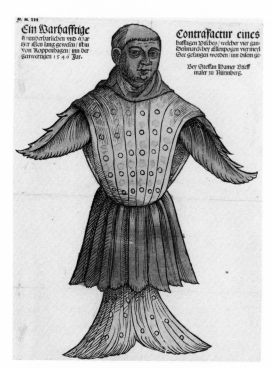

8. Anonymous, *The Monk Fish*, broadsheet with anonymous text published by Steffan Hamer, Nuremberg, 1546, Nuremberg, Germanisches Nationalmuseum. (courtesy Germanisches Nationalmuseum)

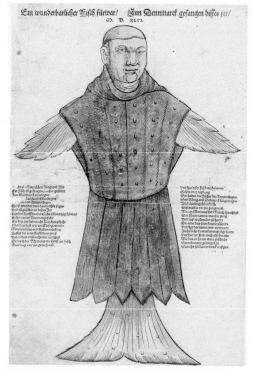

9. Anonymous, *The Monk Fish*, with 32 verses, Zürich, Zentralbibliothek. (courtesy Zentralbibliothek)

earlier practice, after 1547 they must have regarded leniency as too great a luxury. Indeed, in 1550, Hamer was imprisoned for having unlawfully published a broadsheet reporting a miraculous celestial formation, and the offending woodblocks were confiscated.[12] The object of the council's displeasure may be deduced from a later decision to allow Hamer to publish a text announcing the miraculous appearance of five suns over Leipzig: the councilors stipulated that he might merely describe the event, not interpret its significance.[13] The polemical explications of omens were to be avoided.

The popular fascination with monsters and misbirths was not due to idle curiosity or sensationalism, as we might assume today, but rather to the religious convictions of the age. Nature was believed to reflect God's will. Being perversions of God's creation, misbirths and monsters were understood as manifestations of sin on earth, and even of the devil in disguise. The latter idea naturally made the association

of the Catholic camp with monsters a perennially attractive polemical strategy for Protestant publicists. Indeed, during the early 1520s, once Luther had come to identify the pope with the Antichrist, they consistently cast their papist opponents in the role of monsters to reveal their demonic nature. This tactic is evident in the animal heads of Luther's opponents as illustrated in Reformation broadsheets and pamphlets.

In an anonymously published example from Nuremberg created not later than 1521 (fig. 10), the pope and his entourage have been transformed into hybrid beasts, each in a way corresponding to his name or to aspects of his biography. Assembled on a loggia, or balcony, surrounding Pope Leo X in the guise of a lion are Thomas Murner as a cat, Jerome Emser as a goat, Johannes Eck as a sow, and Jakob Lemp as a dog. That Pope Leo should be represented as a lion was an inevitable consequence of his name. The illustration of Murner as a cat is an onomatopoetic parody of his

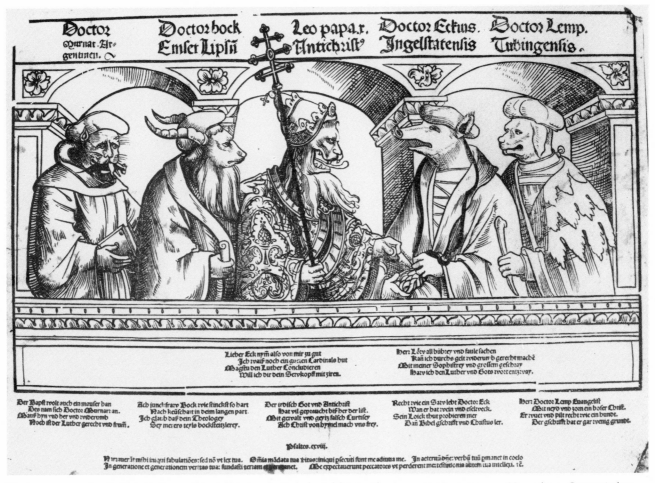

10. Anonymous, *Leo X, Murner, Emser, Eck, and Lemp as Animals*, broadsheet with anonymous text, ca. 1521, Nuremberg, Germanisches Nationalmuseum. (courtesy Germanisches Nationalmuseum)

name as well, which in German suggests the sound of meowing. Emser's goat head alludes to the lecherous nature ascribed to this animal and derives from the heraldic device used in his coat of arms. Johannes Eck of Ingolstadt, shown holding an acorn, is accused in the text of leading the life of a sow, nuzzling in the dirt in search of food. Lemp is portrayed as a growling dog, wrangling over the bone he holds and querulous after his defeat at the Zurich disputation, which the text below blames on his poor knowledge of the Bible.

These hybrid creatures with animal heads quickly became the canonical means of representing Luther's antagonists in antipapal propaganda, with only minor variations in response to changing circumstances. A similar cast of demonic characters, for example, is assembled in the title-page illustration of a polemical pamphlet published in 1522 in Augsburg (fig. 11),[14] with the notable distinction that the anonymous artist ventured beyond mere monstrous heads to include the entire figures, beastly limbs, paws, hooves, and all. Again Murner appears as a cat in Franciscan habit, and Eck again as a goat. In this instance, however, the lion's head is no longer given to Pope Leo, who had died in 1521, but is handed down to the most prominent Vatican representative in Germany, the papal nuncio Aleander. Eck is not shown as a sow—since here this coveted role is reserved for Wedel[15]—but Eck can nonetheless be recognized as the prelate with donkey's ears at far left by the acorn branch he holds. This demonic band of theologians is accompanied by an ass in monk's clothing, who perhaps represents Alfeld, the "ass of Leipzig."[16] He plays a fiddle, symbolically revealing his wordly inclinations, and tramples on Scripture, displaying his contempt for God's word. Hovering above them all is a swarm of insects,[17] who show that they all have bees in their bonnets.

The spectacle of Catholic theologians metaphorically transformed into beasts by the power of the devil predictably aroused papist wrath. The Catholic camp counterattacked in kind, likewise adopting the imagery of monsters to castigate what they considered the demonic nature of Luther. In 1529, the Catholic publicist Johannes Cochlaeus published his anti-Lutheran tract, *The Seven-Headed Martin Luther* (*Martinus Lutherus Septiceps*), in simultaneous Latin and German editions, illustrated with a title-page woodcut generally ascribed to the Nuremberg artist Hans Brosamer (fig. 12). Cochlaeus's strategy in the text was to fight Luther with his own words, using quotations from his writings to demonstrate that his theology was full of contradictions. He assembled a compendium of "errors"—statements taken out of

11. Anonymous, *Eyn kurtze anred zu allen missgünstigen Doctor Luthters*, title page, Augsburg, 1522, Wittenberg, Lutherhalle. (courtesy author)

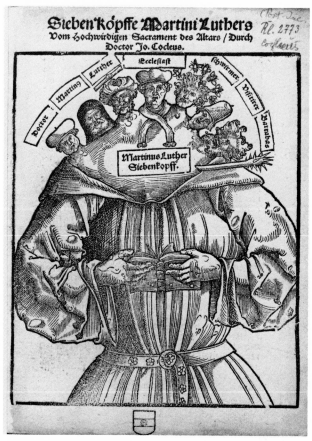

12. Hans Brosamer (attributed), *The Seven-Headed Martin Luther*, title page to Johannes Cochlaeus's tract, Leipzig, Valentin Schumann, 1529, Nuremberg, Germanisches Nationalmuseum. (courtesy Germanisches Nationalmuseum)

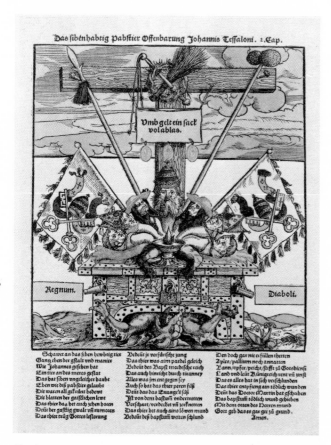

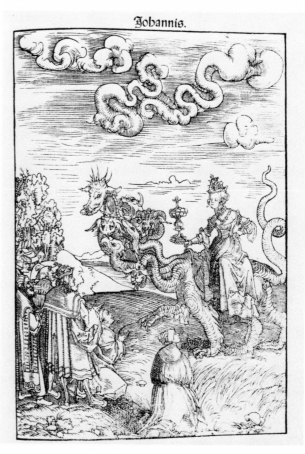

13. Anonymous, *The Seven-Headed Papal Beast*, broadsheet with text by Hans Sachs, ca. 1530, Berlin (West), Staatliche Museen Preussischer Kulturbesitz, Kupferstichkabinett. (courtesy Staatliche Museen Preussischer Kulturbesitz, Kupferstichkabinett)

14. Lucas Cranach the Elder, *The Whore of Babylon*, illustration to Luther's *September Bible*, 1522, Berlin (West), Kunstbibliothek. (courtesy Kunstbibliothek)

context and juxtaposed without reference to the development of Luther's thought over many years—that amounted to a handbook of attacks against Luther. It conveniently obviated Catholic priests having to read the reformer's own "poisonous" texts themselves. In Brosamer's illustration on the title page, Luther is presented as a multicephalic charlatan, in obvious analogy to the seven-headed dragon described in Chapter 13 of the Apocalypse, which to anyone familiar with the Bible signified the devil. The seven-headed "portrait" was certainly intended as a rebuttal to Luther's identification of the pope as the Antichrist, the major polemical message contained in the *Passional Christi et Antichristi*, published with illustrations from the Cranach workshop in 1521.[18] The polemical exchange on that issue was already in full swing by 1522, as we can see in an illustration by Cranach to Luther's *September Bible*, his German translation of the New Testament in which the Whore of Babylon riding the seven-headed apocalyptic beast wears a papal tiara (fig. 14).

To show that Luther speaks with "seven tongues,"

Brosamer's woodcut ironically transforms the standard Protestant manner of portraying the reformer, as a monk piously clutching his Bible, into a monster with seven heads representing his sevenfold contradictory and diabolical nature. Reading the heads from left to right, we see, first, a spoof on Luther's academic credentials, the oversized doctor's hat (i.e., the German *Doktorhut*), poking fun at his rank as doctor of theology. Next is an image of him as St. Martin, one of the saints whose veneration Luther had forbidden. The following head casts doubt on Luther's faith by showing him as an infidel sporting a turban.[19] The central head shows Luther posing as an ecclesiast, a renegade now defrocked since the bull of excommunication of 1520 and thus only masquerading as a clergyman. The ridiculous priest's crossed stole of Lilliputian proportions is a commentary on the validity of his office. The following head, superscribed *Suermerus* (*Schwärmer*), identifies the reformer as a radical sectarian, whose folly is suggested by the hovering hornets (ch. fig. 11). Luther as *Visitator* re-

fers to his leading role during the first Saxon Visitation, or visits to congregations, relevant here because Cochlaeus' quotations are derived largely from Luther's texts in the Saxon visitation book,[20] completed just a year earlier. Finally, Luther is equated with Barabbas, the thief who was set free in Christ's stead by Pontius Pilate. The story goes that upon seeing this image Joachim II, Elector of Brandenburg, exclaimed: "If Dr. Luther has seven heads, he will be invincible, since heretofore, as long as he only had one, they have not been able to defeat him!"[21]

Barely a year later, the Protestants returned the fire. The response to the seven-headed Luther was *The Seven-Headed Papal Beast* (*Das sibenhabtig Papstier*), a broadsheet illustrated by an anonymous Nuremberg artist, with a text composed by Hans Sachs (fig. 13). The image is far more complex in its pictorial language and more biting in its satirical humor than was its Catholic antecedent (fig. 12). The Nuremberg broadsheet reverses the attack launched in Cochlaeus's tract: not Luther but the Catholic hierarchy is identified as the multicephalic dragon of the Apocalypse,[22] its various heads, attached to serpentlike necks, being those of monks, bishops, cardinals, and the pope himself.

The woodcut makes a second, more original visual reference to the late medieval devotional image of the Mass of St. Gregory, that is, to the miraculous appearance of Christ himself, offering his real body and blood during Pope Gregory's celebration of the mass. As one of the most common images associated with the sale of indulgences before the Reformation in Germany (fig. 15), the miraculous mass was an ideal motif for an attack on the Catholic indulgence trade, allowing the Catholics' own imagery to be turned against them. In the Nuremberg broadsheet, St. Gregory's altar has become a huge money chest, while the instruments of Christ's Passion—the cross, crown of thorns, whip, flail, spear, sponge, and nails—have been reduced to mere inducements for the financial transaction advertised by the indulgence prominently displayed on the cross: "A bag full of indulgences if you've got the money" (*Umb gelt ein sack vol ablass*). By playing off Christ's promise of forgiveness during the mass against the cynical sale of salvation by the pope, the image delivers a radical indictment of the venal motives of the Catholic hierarchy.

The polemical impact of the broadsheet is thus achieved largely by its emphasis on the enormous discrepancy between the Church's spiritual responsibility and its actual practice. The reference to 2 Thessalonians 2 and 4 in the broadsheet's title reiterates the accusation against the pope as a demonic impostor

15. Anonymous, *Mass of St. Gregory*, illustration to Johann Bäumler, *Chronicle*, Augsburg, 1476. (courtesy author)

16. Anonymous, *The Changing Faces of the Catholic Church*, view 1: Fool with Goiter, trick woodcut, 1556, Vienna, Graphische Sammlung Albertina. (courtesy Graphische Sammlung Albertina)

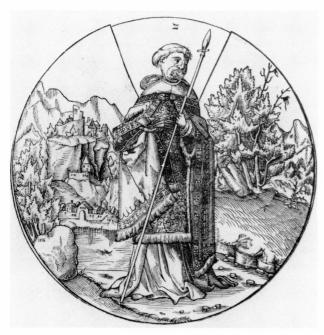

17. Anonymous, *The Changing Faces of the Catholic Church*, view 2: Monk Devouring a House.

who has set himself up in the place of God, his seven heads lolling on an ersatz altar, while the inscriptions below characterize the status quo as the reign of the devil (*Regnum Diaboli*). The identity of this devil as the Medici pope Clement VII (1523–1534) is spelled out by the coat of arms on the central seal attached to the indulgence.[23]

The broadsheets and pamphlets discussed thus far are representative of the polemical use of the imagery of monsters during the Reformation. The polemical tactics were initiated by Protestant publicists, and the Catholic camp merely jumped on an already moving train. The Protestants initially exploited for their own propagandistic purposes the already well established pre-Reformation fascination with misbirths, interpreting the omens from a Lutheran perspective. But Luther's growing conviction that the pope was in fact the Antichrist, whose coming is predicted in the Book of Revelations, gave rise to a host of polemical renderings of the pope as the seven-headed monster of the Apocalypse. Artists in Nuremberg generally followed the lead of the polemical images issued from Wittenberg, most of which were created in the Cranach workshop in consultation with Luther himself. We can see this relationship, for instance, in the Nuremberg *Monk Fish*'s dependence on the Wittenberg *Papal Ass* and *Monk Calf*. Luther's belief that the alleged vicar of Christ was actually the Antichrist in pope's clothing and that the Catholic prelates were really beasts transformed by the devil into his instruments called for an imagery of revelation, one that would look behind appearances to reveal the opponent's true nature.

A number of south German artists devised an ingenious method whereby such revelations could be made to occur mechanically—"unmasking" the culprits before our very eyes—by moving the woodcut to change the image. Again they merely updated a much older tradition. These broadsheets with movable parts either functioned like the round volvelles, which had long been used to illustrate the movement of the planets in astronomical treatises, or employed a fold-over technique by which a second image could cover and replace part of the first. As noted earlier, a similar arrangement had already been used before the Reformation, as in the broadsheet about the Siamese twins, in which turning the woodcut over revealed a second one (figs. 3–4).

A round volvelle dated 1556 consists of two superimposed woodcuts attached in pin-wheel fashion in the center (figs. 16–17). The uppermost image shows the pope's body and the background landscape, while the lower woodcut is visible only in the wedge-shaped

18 19 20

18. Hans Rudolph Manuel Deutsch, trick woodcut, view 1: Monk Plundering a Widow, ca. 1540, Bern, Universitätsbibliothek. (courtesy New York, Columbia University, Photography Collection)

19. Manuel Deutsch, trick woodcut, view 2: Wolf in Monk's Clothing Devouring a Lamb.

20. Manuel Deutsch, trick woodcut, view 3: The Monk Devouring the Widow's House.

area at the top center of the image, where it provides the interchangeable heads. When the woodcut is turned clockwise, its appearance changes sequentially to display the various members of the Catholic hierarchy, from an assortment of monsters to the familiar animal heads and including a fool. Although manifestly a distant descendant of the *Seven-Headed Luther* of 1529 (fig. 12), by contrast the volvelle attacks not just a single opponent, such as the pope, but like the *Seven-Headed Papal Beast* (fig. 14) takes on the entire Church. Standing before a landscape, wearing vestments and holding a breviary, the Catholic hierarchy passes in review in a series of eight images as the woodcut is turned. First we see a fool clad in his cap and bells and made to look more ridiculous by the goiter on his chin.[24] Then follows a cleric devouring the house of a parishioner, by 1556 a standard motif used to attack the clergy who fleeced their congregations via prebends. The motif occurs, for instance, in an earlier fold-over woodcut by Hans Rudolph Manuel Deutsch (figs. 18–20). The third transformation in the series is puzzling, because the animal shown,

a goose holding a rosary in its beak (fig. 21), is customarily included among the victims of the Catholic clergy rather than among their cronies. Such rosary-holding geese about to be disemboweled at the papal court appear, for example, in the title-page illustration of *The Song of the Wolves* (*Das Wolffgesang*) of 1522 (fig. 22). The fourth creature in the volvelle is a wolf in bishop's clothing devouring one of the sheep in his flock, quite the opposite of a "good shepherd" (fig. 23). The fifth shows a cardinal transformed into an owl, symbol of evil and doom (fig. 24), followed by the pope himself, his face paunchy from overindulgence (fig. 25). The last two are death and the devil (figs. 26–27), both copied from Albrecht Dürer's famous engraving of 1513, *Knight, Death, and the Devil*.[25] Dürer's renderings of these frightful heads had become canonical by mid-century and the Lutheran connotations[26] of the engraving itself made the source all the more appropriate.

A much earlier trick woodcut from Nuremberg, created by an unknown artist about 1535 and printed on two sides of a postcard-sized sheet with two smaller flaps, accomplishes the metamorphosis of the image by the fold-over method seen earlier (figs. 18–20). By folding the paper in different configurations, producing a kind of "before and after" approach to the subjects, four different figures in two views each can be seen. The polemical stance here is in opposition to Luther's, which at the time the trick woodcut was first circulated was the minority view in Nuremberg. The

21. Anonymous, *The Changing Faces of the Catholic Church*, view 3: The Goose with a Rosary in Its Beak.

Das Wolffgesang.

Eyn ander herz/ein ander kleid/Tragē falsche wölff in d' heyd
Do mit sy den gēsen lupffen/Den pflum ab dē kröpffen rupffen
Mägstu hie by gar wol verston/Wo du lisest die büchlin schon

22. Anonymous, *Das Wolffgesang*, title page, Augsburg, 1522, Washington, Folger Shakespeare Library. (courtesy author)

23. Anonymous, *The Changing Faces of the Catholic Church*, View 5: Wolf in Bishop's Clothing Devouring a Sheep.

24. Anonymous, *The Changing Faces of the Catholic Church*, view 5: Cardinal with an Owl's Face.

25. Anonymous, *The Changing Faces of the Catholic Church*, view 6: The Pope.

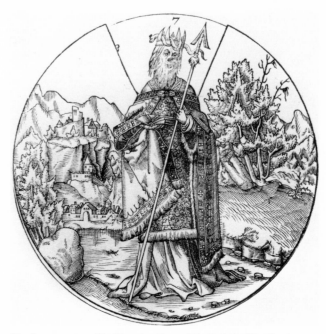

26. Anonymous, *The Changing Faces of the Catholic Church*, view 7: The Prelate as Death.

images operate on a not uncommon, low level of attack via character assassination: the process of revelation is achieved by indecent exposure, not a matter taken lightly in sixteenth-century Nuremberg.

The trick woodcut shows two sequences of thematically related images back to back. First we see a quack holding up a urine sample (fig. 28). When the lower flap is lifted, his baser instincts are revealed (fig. 29). Now, replacing the lower flap but lifting the upper one, we see an image of Martin Luther (fig. 30) shown in the type of dress, pose, and gesture of clutching the Bible that had become the standard formula for portraits of the evangelical reformers (fig. 32). After lifting the lower flap (fig. 31), the second view of Luther allows the propagandist to focus on the all too human aspects of the reformer's character, who in this juxtaposition is accused of both lechery and spiritual quackery. The polemical implications of these acts of exhibitionism become clear when the trick woodcut is turned over to display the figure of a mendicant friar (fig. 33) whose baser nature is subsequently exposed (fig. 34), followed by a nun in identical circumstances (figs. 35–36). The emphasis on lechery suggests that the nun probably represents Katharina von Bora, whom Luther married in 1525, and that the woodcuts aim to characterize Luther's opposition to Catholic laws on celibacy as the result of his own carnal inclinations. In addition, the reformer is ridiculed by wearing eyeglasses, a standard attribute of the fool.[27]

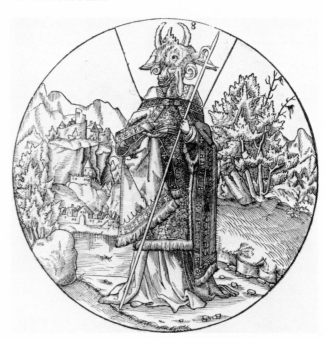

27. Anonymous, *The Changing Faces of the Catholic Church*, view 8: The Prelate as the Devil.

28. Anonymous, trick woodcut, view 1: The Quack, ca. 1535, Nuremberg, Germanisches Nationalmuseum. (courtesy Germanisches Nationalmuseum)

29. Anonymous, trick woodcut, view 2: The Quack Exposing Himself.

30. Anonymous, trick woodcut, view 3: Martin Luther.

31. Anonymous, trick woodcut, view 4: Martin Luther Exposing Himself.

32. Lucas Cranach the Younger, *Philipp Melanchthon*, woodcut, 1561, Chicago, The Art Institute. (courtesy The Art Institute of Chicago)

33. Anonymous, trick woodcut, view 5: The Friar.

34. Anonymous, trick woodcut, view 6: The Friar Exposing Himself.

35. Anonymous, trick woodcut, view 7: The Nun [Katharina von Bora?].

36. Anonymous, trick woodcut, view 8: The Nun Exposing Herself [Katharina von Bora?].

As noted above, the political circumstances of the moment dictated the degree of official tolerance of Reformation propaganda in Nuremberg, as elsewhere. But a distinction was also made between different types of polemical attacks. Character assassination as expressed in the fold-over images of Martin Luther and Katharina von Bora (figs. 28–36) was considered less offensive than inferences that one's opponent was in fact the devil in disguise, the *leitmotif* of the imagery of monsters. Greater caution was therefore exercised with regard to misbirths and monsters. When radical attacks were inadvisable, Protestant publicists retreated to less blatant forms of animal symbolism, in which the polemical barbs were no less obvious to the initiated public but whose primary meaning as mundane creatures helped avoid problems with the local censors. Here we may appropriately apply Erwin Panofsky's overworked concept of "disguised symbolism," a misnomer betraying an overly modern viewpoint as he applied it to certain image conventions in fifteenth-century Flemish painting, since to its original audience such symbolism was overtly understood and in no way "disguised." In Nuremberg then, the double levels of meaning of certain polemical broadsheets were sometimes intentionally calculated to throw all but the initiated off the scent, thus making their interpretation more difficult for the twentieth-century observer as well.

A previously unrecognized instance of such superficially "inoffensive" but actually highly polemical animal symbolism is the association of Catholic monks with magpies.[28] The constant, useless chatter of this species of bird and its black-and-white plumage, recalling the white monastic habit covered by a black cloak, must have suggested the analogy. In Nuremberg Hans Sachs incorporated the symbolic magpie into *The Twelve Pure and the Twelve Sinful Birds* during the crisis year 1524,[29] but no copies of the first printing are known. About 1538 the text, somewhat expanded, was issued as a broadsheet by Albrecht Glockendon, illustrated with twenty-seven woodcuts of different birds designed by Erhard Schön (fig. 37). Although any polemical implications of the broadsheet have been denied,[30] the appearance of the magpie (*Agerlaster*)—shown as number 2 among the sinful birds on the right—conspicuously corresponding to the nightingale (*Nachtigal*)—number 2 among virtuous birds on the left—reveals the Protestant slant unambiguously. Ever since Hans Sachs published *The Wittenberg Nightingale*,[31] his paean to Luther, in 1523, this bird was irrevocably associated with the reformer. The nightingale in the broadsheet is shown singing, proclaiming Christ the True Light, as the text says. It

addresses its song defiantly toward the magpie (that is, toward the chattering monk), who is said in the text to rely on the false teachings of man rather than of God, but who will not prevail on Judgment Day. The text and images are arranged along a central axis to emphasize the opposition between the pure birds and the damned, alluding to Last Judgment scenes, with Christ symbolically present above the other birds in the figure of the pelican, symbol of Christ's sacrifice. As for other birds, predictably the peaceful dove (*Turteltaub*) is placed among the righteous at the left, while the evil owl (*Nachtewl*, cf. fig. 24) joins the damned at the right. The various good and bad characteristics of the birds themselves are based on the medieval tradition of animal allegories, such as the *Physiologus* and Konrad von Megenberg's *Book of Nature*.[32]

In his introductory remarks, Sachs justifies the choice of birds as symbols to populate his animal allegory by referring to biblical passages, such as the parable of the "birds of the sky: they do not sow, neither do they reap." But Sachs is also referring to his own writings; certainly, the allusion to his earlier allegory on the Wittenberg nightingale was not lost on his fellow citizens in Nuremberg. Nor would they have missed recognizing the accusations Sachs makes against the "sinful birds" as the Protestant litany of habitual transgressions allegedly committed by the Catholic clergy: blindness to God's word, faith in human rather than divine teachings, robbing the poor, gruesome persecution of the adherents to the new Lutheran theology, excessive self-indulgence, and so forth. As the ranks of the Protestants in Nuremberg grew and Sachs's broadsheet spread, the antipapal connotations of the magpie and the nightingale must have become an "open secret," eventually acquiring equal importance with the denotations in the popular mind. In time such animal symbolism took on the heightened polemical impact of the imagery of monsters and thus was also censored. On 26 February 1541, the city councilors of Nuremberg warned all local printers not to reissue or copy Glockendon's "illustrated birds."[33]

Sachs's polemical juxtaposition of the pure nightingale and the sinful magpie was used again a few years later in nearby Augsburg. An illustrated broadsheet published by Johann Prüss (fig. 38) focuses entirely on these two birds, excluding Sachs's menagerie. The anonymous author praises the song of the nightingale (Luther) and condemns the magpies' chatter (Catholic accusations against Luther), in which he says no one has any further interest.[34] Below the title, *Ein klein erklerung ettlicher Atzeln oder geferbten Hetzen*, three simple woodcuts make the symbolic

37. Erhard Schön, *The Twelve Pure and the Twelve Sinful Birds*, broadsheet with text by Hans Sachs, published by Albrecht Glockendon, Nuremberg, ca. 1538, Austin, The University of Texas at Austin (Humanities Research Center). (courtesy Humanities Research Center)

38. Anonymous, *Ein klein erklerung ettlicher Atzeln oder geferbten Hetzen*, broadsheet with anonymous text, Augsburg, ca. 1525, Gotha, Schlossmuseum. (courtesy author)

39. Erhard Schön, *The Devil Playing a Bagpipe*, broadsheet with anonymous text, ca. 1530, Gotha, Schlossmuseum. (courtesy author)

identity of magpies and Catholic monks quite clear: monks are shown holding magpies like pets, and in the center is a close-up view of the birds themselves—"magpies in monk's clothing"[35] as the text describes them—complete with tonsure and cowl. Known only in a single impression at Gotha,[36] the broadsheet was probably issued around 1525, since the text mentions both the recent death of Reuchlin in June 1522 and Sachs's *The Twelve Pure and the Twelve Sinful Birds* of 1524 (fig. 37). Regarding the latter, the anonymous author of the Gotha broadsheet asserts that the magpies' excessive chatter (or constant accusations) was the motivating factor behind Sachs's decision to compose his *Twelve Birds* text.[37] The Gotha broadsheet dwells at length on the divisive effects of the shrill diatribes launched by the Catholics, exhorting them to cease such unchristian conduct. It also provides an unusually detailed account of contemporary propaganda tactics: one tract generally followed hard on the heels of the previous one, which was often alluded to but not named, so as not to give it additional publicity.[38]

Having recognized the polemical significance of magpies in the two preceding broadsheets, we must refer to a woodcut discussed earlier, the title-page illustration to *A Short Address to all Opponents of Luther and Christian Freedom* (fig. 11), in which two black-and-white birds occupy the lower foreground of the image. They bear a strong resemblance to the magpie illustrated by Erhard Schön in Sachs's broadsheet (fig. 37) and are shown in their customary activity of incessant chatter. In the company of Eck, Emser, Aleander, Murner, and other Catholic notables, the presence of magpies in their symbolic function as gossiping monks seems appropriate. The date of publication of this pamphlet, 1522, however, suggests that Sachs's polemical text of 1524 was not the first instance of the magpie's use in Protestant propaganda.

In the course of time the type of monster imagery employed in this title-page illustration (fig. 11) was to prevail. After the critical years leading up to the establishment of Luther's theology as the official religion in Nuremberg in 1525, the degree of caution displayed, for instance, in Hans Sachs's animal symbolism gave way to a more ferocious form of polemical picture during the 1530s. This development in propaganda reflected the widespread confidence in the eventual triumph of the evangelical movement (one that was to be utterly shattered by 1547). In an illustrated broadsheet of about 1530, *The Devil Playing a Bagpipe* (fig. 39), Erhard Schön breathes new life into the old polemical notion that Catholic prelates were instruments of the devil. In this case the instrument is a bagpipe

fashioned from the head of a tonsured monk. The demon is blowing into his ear, an action that customarily symbolized the devil's influence on humans in early German prints.[39] Visible under the demon's right forearm is a large goiter,[40] the same satirical attribute already seen in a previous example (fig. 16), added here to render the monk more grotesque. As was customary throughout the Middle Ages, the devil has a monstrous face and a second grimace on his belly.

Of at least three known versions[41] of Schön's broadsheet, the earlier one at Gotha (fig. 39) includes four rhyming couplets conveying the devil's words, rather like the "bubble" in a cartoon: he boasts that formerly simple Christian souls used to dance to any fantastic tune he played, but he laments that now they no longer follow his lead. Pinning his hopes on the pervasiveness of human folly, however, he remains confident that his former deceitful power over the faithful will soon be restored. The longer text on a later impression at London recounts how the devil infiltrated all the monastic orders. Searching for an utterly unscrupulous cleric, he finally came across "Friar Nose" (*Bruder Nasen*), as he is called here, and transforms him into his instrument, through which he seduces and corrupts innocent souls.

The choice of musical instrument is of course significant, since during this period bagpipes were habitually associated with merrymaking, passion, and lust, forms of sensual indulgence condemned by the Catholic church but all too common among the Catholic clergy. Bagpipe-playing had already been included among the dubious practices of the papal court in the *Song of the Wolves* (fig. 22), with the same polemical implications as in the Nuremberg broadsheet of lulling the ignorant into submission while revealing the monk's lecherous nature. In his large-format, simplified image, Erhard Schön has transformed the monk into the disembodied symbol of his own vice.

The Reformation broadsheets and pamphlets discussed here, though only a small selection, are nonetheless representative of this form of mass communication, which played such a critical role in the rapid dissemination and propagandistic reinforcement of evangelical theology and of a critical stance toward the Catholic church, tactics that were soon employed by the Catholic camp as well. Protestant polemics sought to construct and solidify an ideological relationship between Luther and his followers by providing powerful arguments to justify Luther's break with the church, ones that ideally would also induce potential new converts to do likewise. Reformation publicists generally did not aim at moral improvement in their adversaries but rather at discrediting or even destroying them in effigy. Polemical attack always required the simplification and vulgarization of issues and an arbitrary accentuation of certain characteristics over all others. Not infrequently, the first casualty in this process was truth itself, a factor evidently of secondary importance, especially in later years as the polemical exchange grew more heated and the stakes ever higher. Effectiveness was paramount. Successful examples, such as Luther's and Melanchthon's *Papal Ass* and *Monk Calf* of 1523, engendered the imitations, adaptations, parodies, or reverse parodies on all sides of the political spectrum.

Reformation propagandists communicated by means of the culture they shared with their presumed audience, relying heavily on prior familiarity with aspects of popular belief, local customs, and the like, one that we today can only laboriously piece together from the fragmentary remains of historical evidence. Protestant publicists invented few new images. Instead they adapted old ones to new polemical purposes, capitalizing on the recognition factor of familiar ideas in new contexts. They instinctively focused on those themes which already before the Reformation had elicited the greatest fascination among common folk. Like the Abominable Snowman a generation ago, the sixteenth century cultivated an obsessive interest in monsters and misbirths, with the notable distinction that the earlier period—in the expectation of apocalyptic events—gave such freaks of nature a moral significance, interpreting them as messages from heaven. Since the physiological processes of conception and birth were then only imperfectly understood and even the normal appearance of many animals imprecisely known, no reliable distinctions between nature and fantasy creatures could be made. Thus we find Luther's *Papal Ass* and *Monk Calf* side by side with other, scientifically sound information in many medical handbooks of the mid-sixteenth century. It was not until the mid-seventeenth century that scientists succeeded in differentiating between normal or abnormal forms in nature and the purely fictional or mythical. During the Reformation, however, the association of the monstrous with the diabolical went unchallenged and thus resulted in a bewildering but intriguing array of images in broadsheets that constitute—when accurately interpreted—a microcosm of popular belief and historical development in the early modern era.

NOTES

1. W. L. Schreiber, *Handbuch der Holz- und Metallschnitte des XV. Jahrhunderts* (Leipzig: Hiersemann, 1929), 7: 22.

2. Paul Heitz, ed. *Flugblätter des Sebastian Brant*, Jahresgabe der Gesellschaft für Elsässische Literatur, 3 (Strasbourg, 1915), III–V.

3. Campbell Dodgson, *Catalogue of Early German and Flemish Woodcuts Preserved in the Department of Prints and Drawings in the British Museum* (London: Bernard Quaritch, 1911), 2: 203, no. 4. The monstrous birth at Ertingen was also recorded by Albrecht Dürer in a drawing now at Oxford, on which he notes the separate baptism of the united bodies and the same circumstances of their birth; see Friedrich Winkler, *Die Zeichnungen Albrecht Dürers* (Berlin, 1938), 3, no. 645.

4. Dieter Koepplin and Tilman Falk, *Lukas Cranach: Gemälde, Zeichnungen, Graphik*, exh. cat. (Basel: Kunstmuseum, 1974), 1, cat. nos. 246–249.

5. R. W. Scribner, *For the Sake of Simple Folk: Popular Propaganda for the German Reformation*, Cambridge Studies in Oral and Literate Culture, 2 (Cambridge: Cambridge University Press, 1981), p. 127, n. 49; and see Hermann Meuche and Ingeburg Neumeister, *Flugblätter der Reformation und des Bauernkrieges: 50 Blätter aus der Sammlung des Schlossmuseums Gotha* (Leipzig: Insel Verlag, 1977), p. 102.

6. *Prodigiorum Acostentorum Chronicon Quae praeter naturae ordinem motum et operationem et in superioribus . . . conscriptum per Conradum Lycosthenem Rvbeaqvensem* (Basel: Henric Petri, 1557), woodcut on p. 591. See also the two sixteenth-century anonymous woodcuts illustrated in Anne Denieul-Cormier, *La France de la Renaissance: 1488–1559* (Paris: Arthaud, 1962), p. 432, fig. 3, p. 506; and Ambroise Paré, *Des monstres et prodiges*, ed. Jean Céard (Geneva: Librairie Droz, 1971), p. 103, fig. 41.

7. See the *Papstesel* from *Tomus Secundus Omnium . . . Martini Luther* (Wittenberg: Hans Lufft, 1546), fol. 424 verso, illustrated in Koepplin and Falk, *Lucas Cranach*, 1, cat. no. 248, fig. 202.

8. Meuche and Neumeister, *Flugblätter der Reformation*, pl. 50.

9. The broadsheet at the Zentralbibliothek Zürich, illustrated in fig. 9, is Inv. No. PAS II 1/3. Another variant, Inv. No. PAS II 12/34, is reproduced in Hans Fehr, *Die Massenkunst im 16. Jahrhundert* (Berlin: Stubenrauch, 1924), pl. 74.

10. This occurred if—as seems likely given its notoriety—the document recording the town councilors' deliberations concerning Hamer's request to republish "the misbirth" (*gemel der missgepurt*) indeed refers to this broadsheet. See Theodor Hampe, *Nürnberger Ratsverlässe über Kunst und Künstler im Zeitalter der Spätgotik und Renaissance, 1474–1618*, (Vienna: Karl Graeser, and Leipzig: B. G. Teubner, 1904), 1, no. 3165.

11. For a general survey of the censorship of such images, see my "Polemical Prints during the Reformation," in *Censorship: 500 Years of Conflict* (New York: New York Public Library, 1984), pp. 34–51.

12. Hampe, *Nürnberger Ratsverlässe*, 1, nos. 3256–3257.

13. The document is dated 1551; see Hampe, *Nuürnberger Ratsverlässe*, 1, no. 3311.

14. *Eyn kurtze anred zu allen missgünstigen Doctor Luthters und der Christenlichen freyheit* (Augsburg: J. Nadler, 1522), reprinted in O. Schade, *Satiren und Pasquille aus der Reformationszeit* (Hanover: Carl Rümpler, 1863), 2: 190–195.

15. Schade, *Satiren und Pasquille*, 2: 190, line 4.

16. Bernd Balzer, *Bürgerliche Reformationspropaganda: Die Flugschriften des Hans Sachs in den Jahren 1523–1525* (Stuttgart: Metzler, 1973), p. 59, or it may be Dr. Dam, mentioned in the pamphlet text, Schade, *Satiren und Pasquille*, 2: 190.

17. They are called *Margrethenwürmchen* (lice) in the text; see Jacob and Wilhelm Grimm, *Deutsches Wörterbuch* (Leipzig: S. Hirzel, 1885), 6: col. 1625. As an attribute of fools, see the insects swarming around fools in the title-page woodcut to Thomas Murner, *Narrenbeschwörung* (Strasbourg: Hupfuf, 1512), illustrated in *Hollstein's German Engravings, Etchings and Woodcuts, 1400–1700* (Amsterdam: van Gendt and Co., 1977), 11 (Urs Graf): p. 125, no. 268.

18. Koepplin and Falk, *Lucas Cranach*, 1: 330, cat. nos. 218–219, figs. 178–179.

19. For an alternate interpretation, see Peter Newman Brooks, ed., *Seven-Headed Luther: Essays in Commemoration of a Quincentenary, 1483–1983* (Oxford: Clarendon Press, 1983), p. 233. Cf. also the facsimile published in Konrad Hoffmann, ed., *Ohn' Ablass von Rom Kann Man Wohl Selig Werden: Streitschriften und Flugblätter der frühen Reformationszeit* (Nördlingen: Dr. Alfons Uhl, 1983), no. XIV.

20. R. Stupperich, ed., *Unterricht der Visitatoren: Melanchthons Werke in Auswahl*, Reformatorische Schriften (Gütersloh, 1951). Luther had revised Melanchthon's text and supplied a prologue in 1528.

21. *D. Martin Luthers Werke, Kritische Gesamtausgabe, Tischreden*, vol. 2 (Weimar: Hermann Böhlaus Nachfolger, 1913), p. 381, no. 2258a.

22. The analogy to the Antichrist is made even more explicit by the letter of indulgence attached to the cross, a reference to Colossians 2:14: "For he has forgiven us all our sins; he has cancelled the bond which pledged us to the decrees of the law. It stood against us, but he has set it aside, nailing it to the cross," as Konrad Hoffmann demonstrated recently. See *Martin Luther und die Reformation in Deutschland*, exh. cat. (Nuremberg: Germanisches Nationalmuseum, 1983), p. 235, cat. no. 294.

23. Given the reference to Pope Clement VII, Röttinger's dating of the broadsheet to 1543 must be abandoned. See Heinrich Röttinger, *Die Bilderbogen des Hans Sachs*, Studien zur deutschen Kunstgeschichte, vol. 247 (Strasbourg: J. H. Heitz, 1927), pp. 72–73, no. 1224.

24. See the goiter as satirical attribute in Hans Weiditz's woodcut *Mair ülin von der linden*, illustrated in Hugo Schmidt, *Bilder-Katalog zu Max Geisberg: Der Deutsche einblatt-Holzschnitt* (München: Hugo Schmidt, 1930), p. 261, cat. G. 1518, and cf. the popular expression "goitered fool" (*Chropfli-Narr*), *Schweizerisches Idiotikon, Wörterbuch der schweizerdeutschen Sprache* (Frauenfeld: J. Huber, 1885), 2: col. 106. (editor—see below, Moxey, "The Social Function of Secular Woodcuts in Sixteenth-Century Nuremberg," fig. 18)

25. See Jeffrey Chipps Smith, *Nuremberg, A Renaissance City, 1500–1618*, exh. cat. (Austin: The University of Texas Press for the Archer M. Huntington Art Gallery, 1983), p. 109, cat. no. 17. The source was first identified by Peter-Klaus Schuster, in *Luther und die Folgen für die Kunst*, exh. cat. (Hamburg: Kunsthalle, 1983–84), p. 163.

26. Erwin Panofsky, *Albrecht Dürer*, 3d ed., (Princeton: Princeton University Press, 1948), 1: 151–152.

27. Lutz Röhrich, *Lexikon der sprichwörtlichen Redensarten* (Freiburg/Basel/Vienna: Herder, 1973), 1: 166–167.

28. The magpie in early-sixteenth-century German is called either *Agerlaster*, *Atzel* (see Grimm, *Deutsches Wörterbuch*, 1: col. 596), or *Hetze* (see Grimm, vol. 4 [part 2]: cols. 1270–1271). It is unclear whether a specific religious order was meant, since the particular habit shown appears in contemporary illustrations of several different orders; see H. S. Beham's woodcuts in Hugo Schmidt, *Bilder-Katalog*, p. 54, nos. 230–233.

29. See Adelbert von Keller and Edmund Goetze, eds., *Hans Sachs Werke*, I, Bibliothek des literarischen Vereins in Stuttgart, 102 (1870), pp. 377–382. Keller's reference to a version of 1523 ("*Zeittafel*" on p. 478) remains unsubstantiated and doubtful, but Sachs himself dated the text "anno salutis 1524." A later edition exists at Frankfurt: *Der Zwelff reinen vögel eygenschafft zu den ein Christ vergleicht wird. Auch die Zwelff unreinen vögel darinn die art der Gottlosen gebildet ist* (Nuremberg: Friedrich Gutknecht, 1555), in Paul Hohenemser, *Flugschriftensammlung Gustav Freytag* (Frankfurt: Societäts-Druck, 1925), no. 4713.

30. "Ohne jede polemische Beimischung," W. Kawerau, *Hans Sachs und die Reformation* (Halle, 1889), p. 29; "hat es Hans Sachs . . . auf die innere Einkehr und die sittliche Besserung seiner Mitmenschen abgesehen," Karl Schottenloher, *Flugblatt und Zeitung* (Berlin: Carl Schmidt, 1922), p. 139. Jeffrey C. Smith considered that "it is devoid of any references to the . . . Roman Catholic church," *Nuremberg, A Renaissance City*, p. 172, cat. no. 70.

31. *Die Wittembergisch Nachtigall, Die man ietzt höret überall*, published in 1523 in Nuremberg and other cities; see *Hans Sachs Werke*, VI, Bibliothek des literarischen Vereins, vol. 110, pp. 368–386.

32. Balzer, *Bürgerliche Reformationspropaganda*, pp. 141, 214, n. 607–608.

33. This is additional evidence of its polemical meaning. "Hannsen Glockenthans [sic] gemalter vögl halben die andern trucker warnen lassen, ime die nit nachzemachen bey peen des gsetzs; wölche dan darüber verprechen, mit rügen furnemen lassen" (Hampe, *Nürnberger Ratsverlässe*, 1, no. 2567).

34. "Eyn ander volgel yetzund singt / In aller wellt seyn thon erklingt. / Welch gesang begert die gantze wellt / Nyemant das Atzeln geschrey gefelt," lines 21–24 of the second column of the broadsheet.

35. *Atzeln in der menschen schein*, line 20 in first column of the broadsheet.

36. Meuche and Neumeister, *Flugblätter der Reformation*, pp. 45–46, pl. 38, cat. no. B 38.

37. "Der tapffern mañ—(als kurtzlich geschach) / Durch dich Hetz ward eyn dicht gemacht / Darinn vil vögel zamen brachtt," lines 45–47 of third column of text in the broadsheet. The reference here to Sachs's *Twelve Birds* offers proof—previously lacking—that Sachs did publish his text in 1524. With the exception of Karl Drescher ("Die Spruchbücher des Hans Sachs und die erste Folioausgabe I," in A. L. Stiefel, ed., *Hans Sachs Forschungen, Festschrift zur 400. Geburtsfeier des Dichters* [Nuremberg: Johann Philipp Raw, 1894], p. 210) and Bernd Balzer (*Bürgerliche Reformationspropaganda*, p. 140), it has been assumed that Sachs held back the text and only published it in the 1530s.

38. *Schmach schrifft nenn jr namen nit*, fifth-to-last line of the third column of the broadsheet.

39. See the woodcut illustration to chap. 20 of Sebastian Brant's *Ship of Fools* (Basel: Johann Bergmann von Olpe, 1494), illustrated in Edwin H. Zeydel, *The Ship of Fools by Sebastian Brant* (New York: Columbia University Press, 1944), pp. 108, 331; and cf. Erhard Schön's woodcut, "Der Endchrist und Sankt Peters Schifflein," illustrated in Heinrich Röttinger, *Erhard Schön und Niklas Stör, der Pseudo-Schön*, Studien zur deutschen Kunstgeschichte, vol. 229 (Strasbourg: J. H. Heitz, 1925), pl. IV.

40. Not recognizing the round area as a goiter, R. W. Scribner incorrectly assumed that "the devil has grown into one creature with the monk" (*For the Sake of Simple Folk*, p. 134).

41. The impression at the Schlossmuseum Gotha (fig. 39) bears eight lines of text printed in an area left in reserve in the lower right corner of the image (Meuche and Neumeister, *Flugblätter der Reformation*, pl. 16, p. 88, cat. no. B 16). The two later impressions at the British Museum lack the corner verses but replace them with twenty-one lines of text arranged in three columns below the image. In one of the London impressions, the two eyes of the devil's abdominal grimace (not visible in fig. 39) are preserved (*Luther und die Reformation in Deutschland*, p. 239, fig. 301). See also Röttinger, *Schön und Stör*, p. 124, cat. no. 144, pl. III.

The Social Function of Secular Woodcuts in Sixteenth Century Nuremberg

by Keith P. F. Moxey

During the course of the first half of the sixteenth century the character of German woodcut production changed dramatically. The essentially religious nature of woodcut imagery in the fifteenth century was transformed by the introduction of a vast array of new secular themes. These range from decorative patterns intended for use as wallpaper or the decoration of furniture through Reformation and imperial propaganda, didactic and moralizing themes, portraits of historical figures and famous contemporaries to views of battlefields and sieges, accounts of crimes, and reports of monstrous births and celestial apparitions. In view of this bewildering variety, it is not surprising that relatively little attention has been paid to the way in which such subjects were received. Questions regarding who bought such prints and what purposes they put them to have rarely been raised, and, when they have, the answers have been restricted to an analysis of the means by which they were produced and distributed as well as an assessment of their probable cost.[1] As valuable and useful as such studies are, they provide us with little insight into the nature of the audience to which these woodcuts were intended to appeal. By contrast, this study will attempt to define the cultural values inherent in secular imagery and the way in which these values intersect with those held by different segments of contemporary society. In order to do so, it will examine two subjects: representations of peasant festivals and mercenaries.

Before beginning this discussion it will be useful to describe the principal theory currently available for understanding the social function of these prints. Undoubtedly, the most widely held opinion is that secular woodcuts served an informational role. This theory, which was perhaps most fully developed by William Ivins,[2] interprets the primary use of the woodcut as the transfer of information. For example, he accounts for the gradual replacement of woodcut illustrations by engravings in the printed books of the sixteenth century in terms of the ever increasing demand for more detailed information. This demand was better served by the more complex line system afforded by engraving than by the relatively limited linear possibilities of the woodcut.[3] This theory finds a parallel in that put forward by Bruno Weber, who has likened the function of some secular themes, notably those dealing with monstrous births and celestial apparitions, which were usually printed together with texts purporting to foretell the future, with the mass media of our own day. In doing so, he emphasized how, then as now, the information they provided was culturally determined and invested with a particular point of view that was meant either to con-

1. Sebald Beham, *Large Peasant Holiday*, woodcut (left half), 1535, Chicago, The Art Institute. (courtesy The Art Institute of Chicago)

vince the viewer of a certain attitude or to confirm an attitude that he or she already held.[4] However, representations of peasant festivals and of mercenaries, which were also frequently accompanied by texts, appear not to have served a comparable function. The following analysis seeks to define the cultural transaction they realize so as to come to a better understanding of the nature of their social role.

The peasant festival is one of the most popular themes of sixteenth century woodcuts. In Sebald Beham's 1535 *Large Peasant Holiday* for example (figs. 1–2),[5] the artist has represented a crowd of figures who celebrate a holiday with drinking, dancing, and fighting, among other activities. How are we to read such an image and how do we evaluate its significance for contemporaries? Is this a record of the way in which peasants lived and made merry, a straightforward representation of sixteenth century life? In other words, does this work possess the neutrality of an objective account, or was it intended to characterize its subject matter in a particular way? What

3. Sebald Beham, *Large Peasant Holiday*, detail.

2. Sebald Beham, *Large Peasant Holiday*, woodcut (right half), 1535, Chicago, The Art Institute. (courtesy The Art Institute of Chicago)

does the print itself betray about the values with which it may have been invested?

There is little doubt that the activities the peasants are engaged in are among the moral failings most frequently criticized by contemporary moralists. The prominence of the inn at the center of the composition with its group of drinking, love-making, and vomiting figures cannot be overlooked (fig. 3). Nor can the clumsy dancing scene or the violent altercation on the bowling green. Not only was drunkenness condemned as a serious breach of moral conduct but dancing was also viewed in an unfavorable light. The dance represented in which a woman is swung up in the air by her partner was singled out by contemporary commentators as particularly reprehensible since by exposing her legs it was thought to constitute the invitation to lust.[6]

Other representations of peasant feasts also concentrated on dancing. In Barthel Beham's *Church Anniversary Holiday at Mögelsdorf* of 1528, for example (figs. 4–5),[7] the spectator is offered a whole sequence of clumsy dance gestures, which include several instances of close hugging and fondling. It is no accident that dancing should have been used as a vehicle for social comment. Nuremberg's Dance Statute of 1521, which established which city families could attend dances in the city hall, also defined which families could see their members elected to the city council.[8] In doing so it established the structure of political power in the city for the rest of the sixteenth century. Dancing was therefore inevitably identified with social class distinctions in the popular imagination. Needless to say upper class dances differed considerably from those performed by the peasants. The former appeared to have possessed a measured and stately grace. Hans Sachs's verses that accompany a series of aristocratic dances represented by Georg Pencz and Hans Schäuffelein between 1531 and 1535 consist of courtly pleasantries, including references to heroic exploits in tournaments, a far cry from the satiric commentary by the same poet that accompanies the dancers in Barthel Beham's peasant festival.[9]

The conclusion that the iconography of the peasant festival represents a satiric form of humor that de-

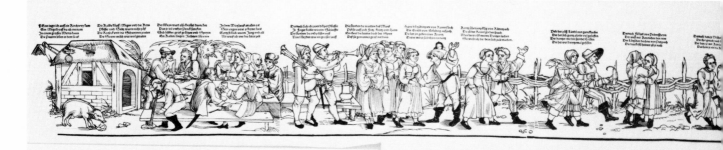

4. Barthel Beham, *Church Anniversary Holiday at Mögelsdorf*, wood-cut (left half), 1528, Gotha, Schlossmuseum. (courtesy Museen der Stadt Gotha)

pends upon a negative attitude toward the peasants as a social class is reinforced by an engraving by the Antwerp artist Frans Huys entitled *The Lute Maker's Shop*, which dates from the middle of the sixteenth century (fig. 6).[10] The composition represents the interior of a shop where a man holding a lute is confronted by a woman carrying a lute while his attention is drawn to another woman with a lute who stands in the doorway accompanied by a child. The text beneath the image reads: "Master John Bad Faith, will you string my lute? I will do so Dame Long Nose. But leave me in peace because I must keep it for Mother Mule who would also very much like to have her lute fixed."[11] The print depends on the sexual symbolism of the lute in the sixteenth century. It was used in literature, drama and song as a way of referring to female sexual organs.[12] The print is thus an allegory of promiscuity in which several women approach the same man for his sexual services. It is of interest that part of this suggestive scene should be a frieze of dancing peasants placed above the mantelpiece. These peasants are copies taken from two engraved series of dancing peasants executed by Sebald Beham in 1537 and 1546–1547, respectively,[13] which are very similar to the dancing figures in the peasant festivals just discussed. The representation of dancing peasants in the context of the sexual allegory of *The Lute Maker's Shop* would suggest that, in the eyes of some contemporaries, the theme represented values they shared.

In turning to discuss the nature of the audience at which these visual satires of the peasantry were directed, we are offered insight into cultural attitudes toward peasants as a social class by the Nuremberg *Fastnachtspiele*, or carnival plays.[14] An important element in these simple plays, which were performed in taverns or in the street, is peasant satire. Peasants are invariably described as crude and obscene and are made the butt of a wide variety of more or less taste-

less jokes. While such plays would presumably have been familiar to a cross section of society, those most directly involved in their production and performance were artisans.[15] Why were literary and perhaps visual satires of the peasantry interesting to urban artisans? What was it about their relation to the peasants that gave this sort of humor its appeal? Studies of urban life in the imperial free cities of Germany in the late middle ages have shown that city administrations viewed their responsibilities in a spiritual as well as a secular light.[16] Cities were considered Christian communities whose social life was to be inspired by Christian ideals of moral conduct. As a consequence, municipal legislation sought to regulate virtually all aspects of social behavior. The moral attitude that characterized official city life was incorporated in assertions of urban identity. In making use of the comic figure of the peasant as the vehicle for their humor, artisans contrasted their values as members of an urban community with those of their rural neighbors. It is not unlikely that the motivation underlying their interest in asserting the distinction between urban and rural ways of life had something to do with their own marginality within the life of the city. Not only were many artisans themselves either relocated peasants or children of peasants who had moved off the land in search of a better living and who were thus anxious to adopt a new urban identity but their commitment to an urban existence must also have been intensified by the threats posed to their employment by economic fluctuations. Needless to say, the satirical representation of peasant license and excess would have appealed not only to artisans but to all those who shared the view of the authorities regarding the necessity for a municipally regulated moral life. Not only was the difference between urban and rural life well known to the inhabitants of Nuremberg as a result of the city's control of a considerable amount of surrounding territory but during the Peas-

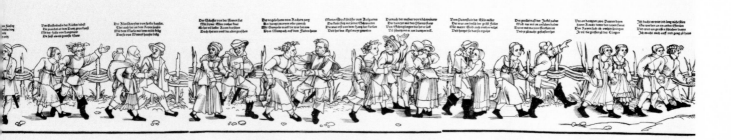

5. Barthel Beham, *Church Anniversary Holiday at Mögelsdorf*, wood-cut (right half), 1528, Gotha, Schlossmuseum. (courtesy Museen der Stadt Gotha)

MEESTER IAN SLECHT HOOT, WILT MIIN LVIITE VERSNAREN · ICK EN SAL VROV LANGNVESE, LAET MII ONGEQVELT.
WANT ICK MOETSE, VOOR MODDER MVIILKEN BEWAREN · DIE HADDE HAER LVIITE, OOCK SEER GEERNE GESTELT.

6. Frans Huys, *The Lute Maker's Shop*, engraving, Amsterdam, Rijksprentenkabinet. (courtesy Rijksprentenkabinet)

ants War of 1525 the country had also posed a real threat to the order of city life.[17]

Another important theme in secular woodcuts of this period is the representation of mercenaries (or *Landsknechte*). In Erhard Schön's *Company of Mercenaries* of about 1532 (figs. 7–8),[18] we are offered the spectacle of an army on the march. The text above the image, by the Nuremberg poet Hans Sachs, defines the various ranks represented and offers us a description of their military duties. Was this print intended to illustrate the organization of contemporary armies or was it, on the other hand, intended to project a particular attitude toward its subject matter?

The composition of Schön's *Company of Mercenaries* depends upon the *Triumphal Procession of Maximilian I*, which was published in 1526.[19] Executed for Emperor Maximilian by Hans Burgkmair, Albrecht Dürer, Albrecht Altdorfer, and others between 1514 and 1518, the *Triumphal Procession*, which was modeled on the revival of the iconography of the Roman imperial triumph by Italian artists during the fifteenth century, was specifically intended to spread the fame of Maximilian as Holy Roman Emperor.[20] Unlike most of the works patterned after this model, which used it to glorify imperial power in the form of ceremonial processions,[21] the composition is here used for the glorification of the imperial mercenary.

The focal point of Schön's procession is the standard bearer (fig. 9). His flag, which is decorated with the cross of St. Andrew and the flints and sparks adopted by Maximilian as imperial insignia after his marriage to Mary of Burgundy, informs us that these soldiers are in imperial service. The verses above this figure praise his exemplary character and describe his military role:

> I have been appointed standard bearer,
> Chosen from the noisy ranks.
> Whoever sees the flag flying
> Believes that his side can still win
> And is thus encouraged to carry on the battle
> And to fight with all his might.
>
> Therefore, I wave my flag
> Since it is worth my life and limbs.
> I will not retreat a step.
> Because of this I must be given triple pay by a powerful lord
> Who goes to war for honor and renown.[22]

The heroic characterization of the standard bearer in Schön's print is by no means unique in this period. A very similar figure is included in a series of mercen-

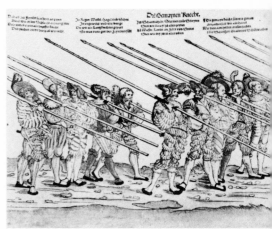

aries represented by Sebald Beham in the early 1530s (fig. 10).[23] Beham's standard bearer is presented as a young man with an athletic build whose pose and gestures exude confidence and ease. The elimination of context enables the figure to escape the limitations of time and place, thus endowing him with a sort of transcendental monumentality. The text enhances the impression that Beham has sought to represent an ideal figure rather than offer us a glimpse of reality:

> I want to let my flag fly
> In a just and worthy war
> And diligently serve a lord
> Who makes war for honor and renown.[24]

The military status of the standard bearer in armies of this period lent itself to this type of heroization. The importance ascribed to their role may be inferred from the fact that the basic German infantry unit of the sixteenth century was known as a *Fendlein*, or

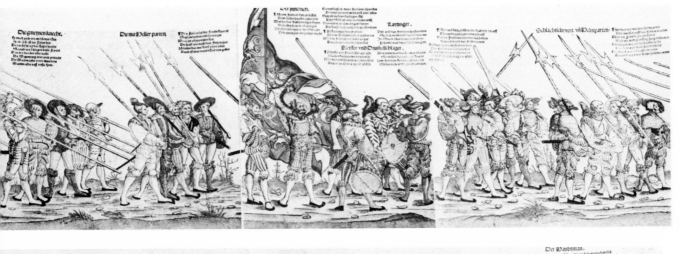

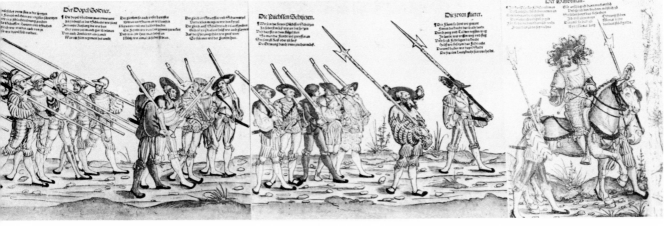

7. Erhard Schön, *Company of Mercenaries*, woodcut (left half), ca. 1532, Braunschweig, Herzog Anton Ulrich-Museum. (courtesy Herzog Anton Ulrich-Museum)

8. Erhard Schön, *Company of Mercenaries*, woodcut (right half), ca. 1532, Braunschweig, Herzog Anton Ulrich-Museum. (courtesy Herzog Anton Ulrich-Museum)

9. Erhard Schön, *Company of Mercenaries*, detail.

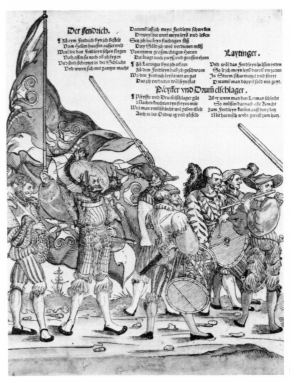

"flag" of soldiers. This unit, which consisted of between three and four hundred soldiers, fought as a densely packed phalanx, the flag serving as the point around which the troops could rally. Soldiers chosen to be standard bearers were paid up to five and six times the ordinary rate[25] and were provided with bodyguards and substitutes to take their place should they happen to fall in battle. The figure represented in Beham's woodcut, therefore, represents an idealized image of a member of a military elite.

The striking costumes worn by the mercenaries depicted in Schön's marching column, as well as in Beham's mercenary series, seem to have been neither damaged nor sullied by the rigors of military life. This garb, with its characteristic slit pattern, was by no means common in German society of the sixteenth century. It was used primarily by mercenaries and served to distinguish them from other social groups. These clothes, which echo North Italian fashions of the end of the fifteenth century, were popular in aristocratic and wealthy bourgeois circles in southern Germany between 1500 and 1520.[26] This may be seen, for example, in Lucas Cranach the Elder's portrait of Duke Henry the Pious of Saxony at Dresden, which is dated about 1514 (fig. 11).[27] Whereas the fashion for slit clothing was a passing whim among the upper classes, the mercenaries retained it long after it had been abandoned by other groups. In adopting aristocratic fashion, the mercenaries seem to have consciously sought to identify themselves with a class that had traditionally been associated with war. This represents an attempt by the new military class born of the capitalist organization of warfare to ally itself with the chivalric traditions of a bygone age.

The image of the mercenary as a heroic figure contrasts strikingly with the negative characterization of this figure in the writings of social commentators and moralists. For example, the Lutheran propagandist Johann Eberlin von Günzburg included the following remarks in his pamphlet *I Am Surprised That There Is No Money in the Land* of 1524: "An incalculable amount of money was wasted on the wars of Emperor Maximilian in the Netherlands, Hungary, Italy, against the Venetians, and in France. And in his time a new order of soulless people grew up called the *Landsknechte*. These people, who have no respect for honor or justice, travel to the place where they hope to receive payment and offer their services to the danger of their souls and to the detriment of ordinary honesty and good manners. There they learn and become habituated to all kinds of vice, to abuse, swearing, the use of bad words, oaths, and so forth. Indeed, they also learn whoring, adultery, rape, gluttony, drunken-

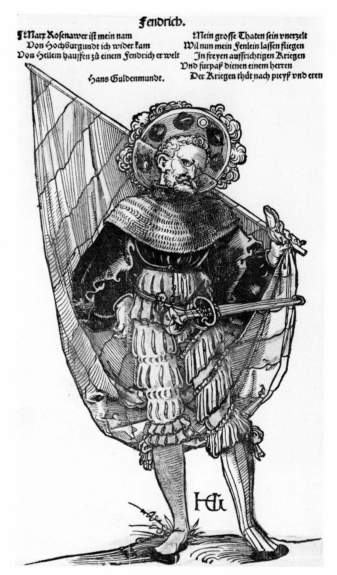

10. Sebald Beham, *Standard Bearer*, woodcut, early 1530s, Oxford, Ashmolean Museum. (courtesy Ashmolean Museum)

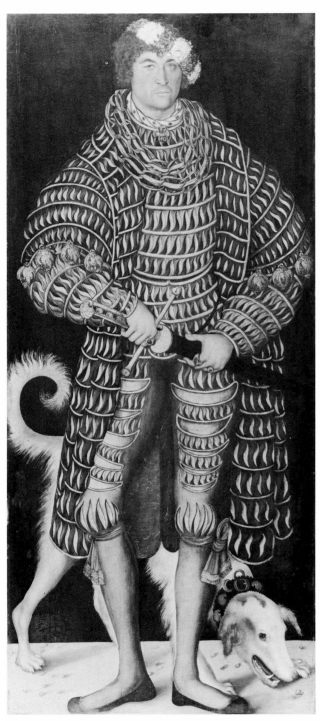

11. Lucas Cranach the Elder, *Duke Henry the Pious of Saxony*, painting, ca. 1514, Dresden Staatliche Kunstsammlungen. (courtesy Staatliche Kunstsammlungen)

ness, and beastly things, such as stealing, robbing, and murder. These things become their daily bread and they commit them against those poor people who have never harmed them. In short, they are entirely in the power of the devil, who pulls them about wherever he wants, . . ."[28]

In Nuremberg, Hans Sachs made a concerted effort to satirize the failings of the mercenaries in several of his poems. In the work entitled "Argument between a Housemaid and a Young Man" of 1532, Sachs used a fictive conversation between two young people to criticize youths who imitated mercenary customs and dress. Instead of leading a loose and antisocial existence, drinking, gambling, whoring, swearing, and brawling as mercenaries do, he argues that young people should become apprentices and dedicate themselves to the serious and sober task of learning a trade.[29] In his "Comparison of a Mercenary with a Crab" of 1532, Sachs portrays the mercenary's life as filled with hardship and suffering. The mercenary must suffer cold, wind, and rain and must await the resumption of spring operations in a shelter dug in the ground just as the crab, spends the winter months buried in the bottom of the sea. Like the crab, who is always wet because it lives under water, so the mercenary must always be drunk. In this manner he resembles the pig, whose greed also prevents it from knowing when it is to be killed and butchered. Like the crab that can grow back the claws it loses, so the mercenary replaces the limbs he loses brawling at the camp site with iron substitutes; and just as the crab is caught by the fisherman's trap while searching for food, so is the mercenary killed by the peasants while pillaging the countryside. Sachs's moralizing conclusion condemns mercenaries who offer their services in any conflict, suggesting that the only legitimate war is one conducted in defense of one's country.[30] In his poem "St. Peter with the Mercenaries" of 1557, an outbreak of peace forces some mercenaries to find other employment. They arrive at the gates of heaven and demand to be let in. Despite God's warnings, St. Peter takes pity on them and lets them in. No sooner have they entered heaven than they begin to gamble and then to fight with one another. Realizing his mistake, St. Peter attempts to stop the brawl only to be driven away. In order to be rid of them God arranges for an angel to play a drum outside heaven's gates. Thinking that they hear a recruiting drum, the mercenaries drop everything and rush out of heaven in their mad scramble to sign up. As a result of his experience, St. Peter resolves never to let another mercenary into heaven.[31] Finally, his poem "The Devil Refuses to Allow Any More Mercenaries into Hell" also

dated 1557, recounts how, on hearing of the lawless and dissipated life of the mercenaries, the Devil decided to have an example of this new form of human depravity brought before him. Beelzebub, who is commissioned to fulfil this wish, is so appalled by their fearsome appearance (slit clothing) and their violent manner, particularly when he misunderstands one of their remarks and thinks that they want to kill and eat him, that he abandons his mission. After hearing Beelzebub's report, the Devil is convinced that the mercenaries are too fierce a force to be contained in hell and that, therefore, he will accept none of them into his establishment.[32]

In view of the negative vision of the mercenaries found in moralizing literature, how do we account for the positive light in which they are represented in the works of Schön and Beham? Among the many ways in which the figure of the mercenary was used in the literature of this period was a metaphor of imperial might. In an allegorical play by Jakob Locher (a pupil of Sebastian Brant) dated 1502, calling on the Christian kings of Europe to support Maximilian's plans for a crusade against the Turks, the kings of France, England, and Hungary are joined by a representative of the mercenaries in pledging themselves to service in the war.[33] In a somewhat earlier play by the same author, which also advocated a campaign against the Turks, the last act is illustrated with a woodcut in which a group of mercenaries surround the idealized figure of a standard bearer whose flag bears a cross and the imperial eagle (fig. 12).[34] Another literary tradition in which the image of the mercenary occurs is song—particularly in those composed in response to the Turkish invasions of Eastern Europe, which culminated in the siege of Vienna in 1529. An example is the song written by Hans Sachs entitled "A Praise of the Worthy Mercenaries at Vienna" (fig. 13),[35] which was published as a broadsheet in 1529. It begins:

> Wake up heart, mind, and imagination.
> Help me to praise the good mercenaries
> For their chivalrous deeds,
> Which they have performed in Austria
> At Vienna, within the city. . . .[36]

The image of the mercenary was thus used to express German national feeling in the context of the Turkish menace to the empire.

In turning to the question of the reception of such images we must ask what social attitudes were confirmed or denied by the image of the mercenary as an assertion of imperial might and national strength? A characteristic of Nuremberg's national policy during

12. Anonymous, *Standard Bearer with Mercenaries*, woodcut from Jakob Locher's *Spectaculum de Thurcorum Rege et Sultano rege Babiloniae more Tragico effigiatum in Romani Regis honorem*, Strasbourg, 1497. (courtesy Herzog August Bibliothek, Wolfenbüttel)

13. Hans Vogtherr the Elder, *Two Mercenaries*, woodcut illustration to Hans Sachs, *Eyn lob der frummen Landsknecht zu Wyen*, Augsburg, 1529. (courtesy Hessische Landes- und Hochschulbibliothek Darmstadt)

the sixteenth century was its pro-imperial stance.[37] Following the Reformation, which was introduced into Nuremberg in the early 1520s, the city refused to join the rest of the Protestant estates in their attempt to challenge imperial authority.[38] Whereas the Protestant Confederation, the Schmalkaldic League, sought to force Charles V to grant them religious autonomy by refusing to vote funds for the defense of the empire against the Turks during their invasion of Hungary and Austria in the late 1520s and 1530s,[39] Nuremberg abandoned its coreligionists by insisting on putting its own secular interests (which depended on imperial goodwill) before all other considerations. Not only was Nuremberg prepared to vote funds, but the city itself also raised considerable numbers of troops during the Turkish emergencies of 1529 and 1532.[40] It is significant that the only documented municipal commission for graphic art in this period was

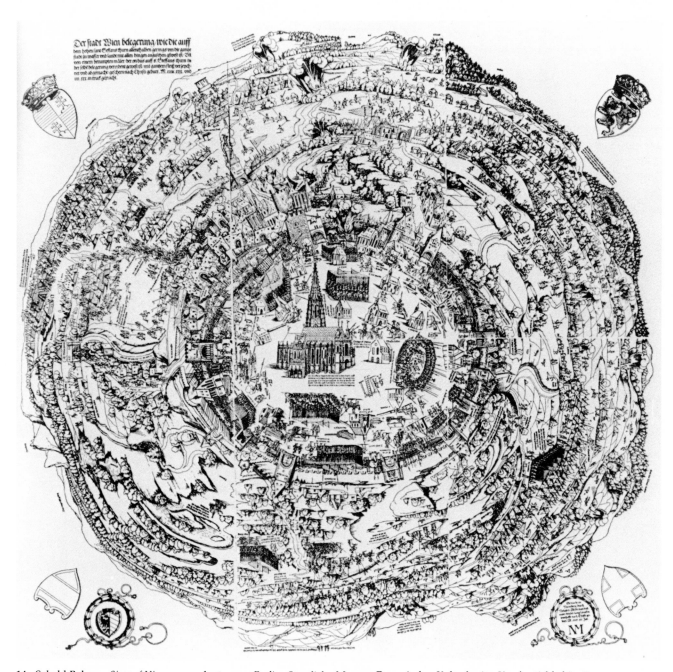

14. Sebald Beham, *Siege of Vienna*, woodcut, 1529, Berlin, Staatliche Museen Preussischer Kulturbesitz, Kupferstichkabinett. (courtesy Kupferstichkabinett, Staatliche Museen Preussischer Kulturbesitz)

for a view of the siege of Vienna (fig. 14).[41] It was paid for by the city secretary, Lazarus Spengler, the architect of the city's policy of obedience to the emperor.[42] It is possible, therefore, that the positive ideal of the mercenary profession presented in the woodcuts of Schön and Beham, which contrasts strikingly with the mercenary image offered by the moralists, is to be accounted for in terms of Nuremberg's official reaction to the national danger posed by the Turkish invasions. In other words, the city's identification with the emperor's cause during this crisis appears to have found visual expression in these works.

A more ambiguous characterization of the mercenaries, one that appears to express some of the criticism of this occupation found in the work of Hans Sachs, is found in Niklas Stör's woodcuts entitled *Cobbler* and *Tailor*, respectively (figs. 15–16).[43] In these compositions, the figures do not face the viewer but are seen from behind—a viewpoint that serves to create an informal impression. Instead of asserting their military status and function, the texts describe the motivation that led these artisans to become mercenaries. The "cobbler" says:

> May shoemaking go the Devil.
> I've had to suffer it too long
> Before being able to make a week's wage.
> However, things are different over there.
> I want to take up something else
> And go wandering in a doublet and trousers
> To see if I can't earn some money in the war.
> I'll leave this place like all the other good fellows.[44]

The "tailor" answers:

> Stay, good fellow, I want to go with you.
> What has happened to you is my fate too,
> I must sit long hours for little pay
> With which I can hardly survive.
> Therefore, I must take up something else
> And start sowing with a hop pole
> In the open field to the sound of drums
> And see if I can't earn a little money there.[45]

The contrast between the peaceful nature of their occupations and their military ambitions, between the "tailor's" needle and the soldier's hop pole, or lance, may have been intended as a form of irony. It is possible that, in expressing the artisans' desire to abandon their crafts for the profits to be made as mercenaries, the texts were meant to comment on their greed.[46] Not only do these artisans want to forsake

15. Niklas Stör, *Cobbler*, woodcut, ca. 1530s, Vienna, Graphische Sammlung Albertina. (courtesy Graphische Sammlung Albertina)

16. Niklas Stör, *Tailor*, woodcut, ca. 1530s, Nuremberg, Germanisches Nationalmuseum. (courtesy Germanisches Nationalmuseum)

socially useful occupations but also their desire for gain is unqualified. Unlike the more heroic images discussed, in which imperial service is stressed, these volunteers give us no hint of the type of service they are about to enter. The humor on which these prints seem to depend, however, is ironic rather than satiric. It appears good-natured and may even have been sympathetic to the economic circumstances that forced artisans to seek this type of employment.

Interestingly enough, peasants, who constituted the greater part of most mercenary armies in this period, are not referred to in this imagery. The only mercenary image that includes them is a particularly gross caricature. The comparison of Erhard Schön's *Tailor and Seamstress*, executed in the early 1530s, with Hans Weiditz's *Farmer Ulin and His Wife*, of 1521 (figs. 17–18),[47] affords us a striking contrast. Schön's print represents an elegantly dressed couple. The mercenary is indistinguishable in appearance and bearing from the heroic mercenary genre analyzed earlier. He says:

> Come along, you pretty seamstress,
> Come along with me to Norbeden.
> I want to clothe the mercenaries there
> And earn a lot of money.
> If you'll make their shirts
> Expensively embroidered with silk and gold,
> Then you'll make more in a month
> Thank you would in a whole year working for the seamstresses.[48]

The "seamstress," who is equally well clad, replies:

> If you'll be a good fellow
> I'll take my chances with you
> And hope my friends don't interfere.
> I trust we'll be able to feed ourselves.
> You'll make clothes in the mercenary style,
> Divided, slit, and cut,
> From silk, velvet, and satin,
> With which we'll earn much honor and profit.[49]

Weiditz's print, on the other hand, offers us a repulsive image of an enormously fat soldier with a protruding lower jaw and a large goiter whose body threatens to burst out of his nondescript clothing. His female companion is equally ugly, having a large hooked nose and an enormous belly. The soldier says:

> I am called Farmer Ulin from the linden tree.
> Where could you find a fiercer warrior?
> I'm armed with spear and pole
> And my armor hangs about me.[50]

The woman replies:

> I carry good wine and a goose along
> And stick close to this Hans.
> I also feel his goiter for him
> So that he feeds me well.[51]

Whereas the first work belongs to the humor that depended on the artisan's economic relation to war so that the sexual dimension of the relation between the tailor and the seamstress was subordinated to their common professional interests, the latter expresses a humor of a very different kind. The fatuous boasting of the overweight peasant and the prominence ascribed to sexuality as the basis for his relation to his companion serve to define it as coarse and suggestive. Whereas one depends on the contrast between the artisan's occupation and his military ambitions in a way that permits the viewer to identify with his plight, the latter depends on the extravagance of the peasant's claims and the indecency of the woman's role so as to establish a psychological distance between the subject and the viewer.

The conclusion that mercenary imagery offers us a generally favorable vision of the mercenary's social function is confirmed by the testimony offered by a tavern scene by the Brunswick Monogrammist (figs. 19–20),[52] an Antwerp artist active in the 1540s, in which a row of mercenary woodcuts can be discerned attached to the rear wall. This scene, in which prostitution, drinking, and fighting figure prominently, was probably intended to illustrate the consequences of drunkenness.[53] What is a series of mercenary images doing on a wall convered with obscene inscriptions and phallic drawings? Although a definitive answer to this question must await the discovery of further evidence, it is possible that their presence in this interior serves to identify the profession to which these denizens of the tavern belong. If this were the case, then in identifying these figures as mercenaries the prints would pass ironic comment on the gap that separated social reality from social ideal, or mercenary conduct from mercenary myth.

This analysis of the cultural values expressed in representations of peasant festivals and in representations of mercenaries in terms of the social and political attitudes held by the population of Nuremberg in the sixteenth century accords with what little we know about the audience for whom such prints were intended on the basis of the way in which they were produced and marketed. Print publishers appear to have acted as entrepreneurs in obtaining designs from artists, which they then proceeded to have cut

17. Erhard Schön, *Tailor and Seamstress*, woodcut, early 1530s, Nuremberg, Germanisches Nationalmuseum. (courtesy, Germanisches Nationalmuseum)

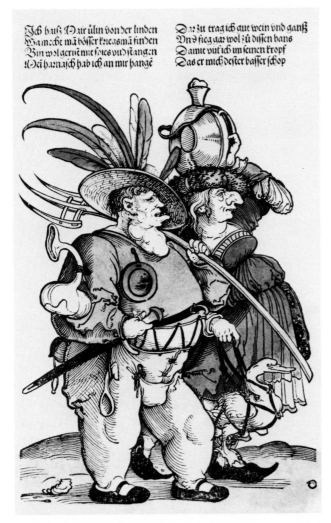

Ich haß Mir ülin von der linden
Vamicht man böser krieasman finden
Bin wolacruet mit foies vud itangen
Nei barnaich hab ich an mir hangé

Dar zu trag ich aut wein vnd ganß
Vnd fieg dar wol zu diffen bans
Damit vuf ich im feinen kropf
Das er mich defter baffer fchop

18. Hans Weiditz, *Farmer Ulin and his Wife*, woodcut, 1521, Gotha, Schlossmuseum. (courtesy Museen der Stadt Gotha)

onto wood blocks and printed.[54] The publishers saw to it that their names and addresses were prominently displayed on the prints so that members of the public had only to go to the location specified to obtain their own copies of any print they may have seen. Prints were sold directly from the printer's workshop and by traveling salesmen, who wandered to towns and fairs selling their merchandise. As a result, it seems likely that a fairly broad spectrum of society had an opportunity of familiarizing themselves with these images. Little is known about the quantities of woodcuts printed. While the size of individual editions was probably not as large as that of contemporary book production (in which woodcuts were widely used for illustration) which ran as high as one thousand or fifteen hundred copies,[55] many woodcuts of this period went through a number of separate editions.

The cost of the average woodcut must have depended not only on supply but also on the quality of the image offered for sale. Estimates of the cost of illustrated broadsheets during this period suggest that they were sold for approximately four to eight pfennigs apiece.[56] Such a price would have put them within the purchasing power of all but the very poorest classes of society. The peasant festivals and mercenary woodcuts, however, belong to the category of *Riesenholzschnitte* or giant woodcuts, which were not only larger than most woodcuts but also produced as a series meant to be viewed in relation to one another. Such series must therefore have been considerably more expensive than single prints. While a consideration of the circumstances in which woodcuts were produced, distributed, and sold can give us only a vague idea of what the audience for woodcuts may have been, we can at least conclude that they were intended for those for whom the basic necessities of life were taken care of. The moderate price of the prints—which would have put them within the grasp of the upper and middle classes, including artisans, and beyond the reach of the very poor, including peasants—coincides with some of the values inherent in the works themselves. Not only does it correspond with what we know about the artisans attitude toward peasants and their taste for peasant satire but it also intersects with our understanding of the repressive moral code of the imperial free cities at the end of the middle ages, a code imposed on urban dwellers by members of the wealthier classes. Furthermore, the availability of the prints to those who were better off corresponds with the official attitude toward the defense of the empire during the Turkish invasions of 1529–1532 and the sympathetic treatment of the

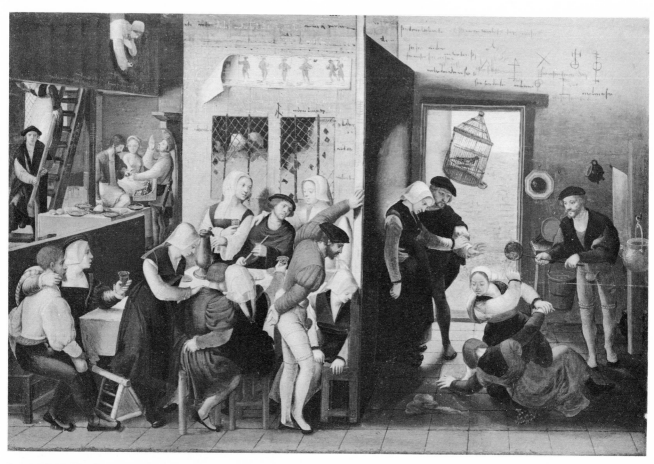

19. Brunswick Monogrammist, *Inn Scene*, painting, 1540s, Berlin, Staatliche Museen Preussischer Kulturbesitz. (courtesy Staatliche Museen Preussischer Kulturbesitz)

20. Brunswick Monogrammist, *Inn Scene*, detail.

20

artisan class expressed in the representations of mercenaries.

The study of the values inherent in the representation of peasant festivals and in the representation of mercenaries in the social context in which they were produced enables us to conclude that such images carried more than information for the sixteenth-century viewer. Both themes give expression to widely shared attitudes regarding social and political issues. The recognition of the values expressed in some of the secular subject matter of the sixteenth-century woodcuts means that the definition of their social function as communication must be re-evaluated. Unlike the prints referring to historical events studied by Weber, the expression of values in these subjects plays a greater role than the relay of information. Far from reflecting contemporary social and political developments, therefore, representations of peasant festivals and of marching mercenaries played an active role in shaping them. Rather than being passive documents of historical events, these woodcuts must be ascribed a historical momentum of their own, for they were an important force in the cultural transactions underlying social reality, one whose particular power lay in the way in which they added a visual dimension to the myths on which social action was grounded.

NOTES

This paper was written while working at the Kupferstichkabinett of the Staatliche Museen Preussischer Kulturbesitz in West Berlin. I am most grateful to the Alexander von Humboldt Foundation for its support during the academic year 1982–83 and deeply indebted to my sponsor, Professor Fedja Anzelewsky, for his interest in my work and for his generous assistance.

1. For an excellent discussion of these issues in relation to sixteenth-century broadsheets with woodcut illustrations, see Bruno Weber, *Wunderzeichen und Winkeldrucker, 1543–1586. Einblattdrucke aus der Sammlung Wikiana in der Zentralbibliothek Zürich* (Zürich, 1972).

2. William M. Ivins, Jr., *Prints and Visual Communication* (Cambridge, Mass., 1953).

3. Ibid, pp. 165–166.

4. Weber, *Wunderzeichen und Winkeldrucker*, pp. 50–52.

5. Gustav Pauli, *Hans Sebald Beham. Ein kritisches Verzeichnis seiner Kupferstiche, Radierungen und Holzschnitte. Mit Nachträgen sowie Ergänzungen und Berichtigungen von Heinrich Röttinger* (Baden-Baden, 1974), cat. no. 1245. The print was made from four blocks and measures 36.2 by 114 centimeters. For a more comprehensive discussion of this work, see my "Sebald Beham's Church Anniversary Holidays: Festive Peasants as Instruments of Repressive Humour," *Simiolus* 12 (1982): 107–130. For a different interpretation of the peasant festival theme, which depends on a reading of these images as informational rather than as value projecting, see

6. Sebastian Brant, "On Dancing." in *The Ship of Fools*, ed. E. H. Zeydel, (New York, 1974; 1st ed., Basle, 1494), p. 205.

7. Heinrich Röttinger, *Die Holzschnitte Barthel Behams* (Strasbourg, 1921), cat. no. 4.

8. See Gerhard Hirschmann, "Das Nürnberger Patriziat," in *Deutsches Patriziat 1430–1740*, ed. Hellmuth Rössler (Limbourg/Lahn, 1968), p. 265; Werner Schultheiss, "Die Mittelschicht Nürnbergs im Spätmittelalter." in *Städische Mittelschichten*, ed. Erich Maschke and Jürgen Sydow (Stuttgart, 1972), p. 138.

9. Max Geisberg, *The German Single Leaf Woodcut, 1500–1550*, trans. Walter Strauss, 4 vols. (New York, 1974), 3: cat. nos. 1001–1003; 1064–1079.

10. F. W. H. Hollstein, *Dutch and Flemish Etchings, Engravings and Woodcuts, ca. 1450–1700* (Amsterdam, 1949), 9: 164.

11. For a somewhat different translation, see Ardis Grosjean, "Towards an Interpretation of Pieter Aertsen's Profane Iconography," *Konsthistorisk Tidskrift* 43 (1974): n. 34.

12. See Karl Filzeck, *Metaphorische Bildungen im älteren deutschen Fastnachtsspiel* (Würzburg, 1933), p. 46; Lutz Röhrich, "Das verführte und das verführende Mädchen," in *Festschrift für Siegfried Gutenbrunner*, ed. O. Bandle, H. Klingenberg, and F. Maurer (Heidelberg, 1972), pp. 183–193.

13. F. W. H. Hollstein, *German Engravings, Etchings and Woodcuts, ca. 1400–1700* (Amsterdam, 1954-), 3: 94, 95, 98, 99.

14. See Heinrich Adelbert von Keller, *Fastnachtspiele aus dem fünfzehnden Jahrhundert*, 3 vols. Bibliothek des literarischen Vereins in Stuttgart nos. 28, 29, 30 (Stuttgart, 1853).

15. See Eckehard Catholy, *Das Fastnachtspiel des Spätmittelalters* (Tübingen, 1961), pp. 252 ff.; Johannes Merkel *Form und Funktion der Komik im Nürnberger Fastnachtspiel* (Freiburg, 1971); Rüdiger Krohn, *Der unanständige Bürger. Untersuchungen zum Obzönen in dem Nürnberger Fastnachtspielen des 15. Jahrhunderts* (Kronberg, 1974).

16. Bernd Moeller, *Imperial Cities and the Reformation: Three Essays*, ed. E. Midelfort and M. Edwards (Philadelphia, 1972).

17. Lawrence Paul Buck. "The Containment of Insurrection: Nürnberg and the Peasants Revolt, 1524–1525," Ph.D. dissertation, Ohio State University, 1971; Gottfried Seebass, "Die Reformation in Nurnberg," *Mitteilungen des Vereins für Geschichte der Stadt Nürnberg* 55 (1967–1968), 252–269; Rudolf Endres, "The Peasant War in Franconia," in *The German Peasants War of 1525: New Viewpoints*, ed. R. Scribner and G. Benecke (London, 1979).

18. Heinrich Röttinger, *Erhard Schön und Niklas Stör, der Pseudo Schön: Zwei Unterschungen zur Geschichte des alten Nürnberger Holzschnittes* (Strasbourg, 1925), cat. no. 236. The woodcut consists of nine prints taken from eight different blocks (one of the blocks being printed twice) and measures 35 by 261 centimeters. The version illustrated was probably hand colored in the sixteenth century.

19. Franz Schestag, "Kaiser Maximilian I. Triumph," *Jahrbuch der Kunsthistorischen Sammlungen des allerhöchsten Kaiserhauses* 1 (1883): 154–181; Stanley Appelbaum, *The Triumph of Maximilian I* (New York, 1964). (editor—see above, L. Silver, "Prints for a Prince.")

20. For this history of this revival, see Werner Weisbach, *Trionfi* (Berlin, 1919). For Maximilian's intentions in commissioning the work, see Erich Egg, "Maximilian und die Kunst." in *Maximilian I*, exh. cat. (Innsbruck, 1969), pp. 93–112.

21. See for example Jörg Breu the Elder's woodcut *Entry of Charles V into Augsburg*, 1530 (Geisberg, *Single Leaf Woodcut*, 1: nos. 357–366); Robert Peril's woodcut *Entry of Charles V into Bolo-*

gna, 1530 (Wouter Nijhoff, *Nederlandsche Houtsneden 1500–1550*, 2 vols. [The Hague, 1933–1936], 1: 12, pls. 46–69), and Hans Schäuffelein's woodcut *Triumphal Procession of Charles V*, 1537 (Geisberg, (*Single Leaf Woodcut*, 3: nos. 1080–1088).

22. Zy eym fendrich byn ich bestellt
 Vom Hellen hauffen ausserwelt
 Weyl die das fendleyn sehen flygen
 Verhoffen sie noch ob zu sygen
 Und sind behertzet in der Schlacht
 Und weren sich mit gantzer macht

 Darumb lass ich mein Fendleyn Schweben
 Die weyl hie wert meyn leyb und leben
 Setz ich hie keyn flüchtigen fuss
 Drey Sold jch wol verdienen muss
 Von eynem grossmechtigen Herren
 Der kriegt nach preyss und grosser ehren
 (This and the following translations are my own.)

23. Pauli, *Hans Sebald Beham*, cat. no. 1256A and p. 762.

24. Wil unn mein fenlein lassen fliegen
 In freyen auffrichtigen kriegen
 Und fur vass dienen einem herren
 Der kriegen thut nach preyss und ere

25. For mercenary pay, see the rates provided by Reinhart Graf zu Solms, *Kriegsregierung* (Lich, 1559), book 3, p. 64, and Leonhardt Fronsperger, *Kriegsbuch*, 3 vols. (Frankfurt, 1565–1573), 1: 145 v.

26. See Ruth Bleckwenn, "Beziehungen zwischer Soldatentracht und ziviler modischer Kleidung zwischen 1500 und 1650." *Waffen und Kostumkunde* 16 (1974): 107–118, esp. 108 (I am indebted to Dr. Wagner of the Lipperheidsche Kostumbibliothek, Berlin, for this reference); Eva Nienholdt, "Die bürgerlicher Tracht in Nürnberg und Augsburg vom Anfang des 15. bis zur Mitte des 16. Jahrhunderts (ca. 1420–ca.1550)," doctoral dissertation, Leipzig University, 1925, p. 40. For an opposing view, namely that the upper classes imitated mercenary costume, see Paul Post, "Das Kostum der deutschen Renaissance, 1480–1550," *Anzeiger der Germanischen Nationalmuseums*, (1954–1959), pp. 21–42, esp. 26 (Dr. Leonie von Wilckens kindly supplied me with this reference).

27. Dresden, Staatliche Kunstsammlungen (1975), cat. no. 1906 G.

28. Johann Eberlin von Günzburg, *Sämtliche Schriften*, 3, ed. Ludwig Enders (Halle, 1902), "Mich wundert das kein geld im land ist" (Eilenburg, 1524), p. 150: "Ein untzetlich gelt hat vertzert das kriegen K. Maximilian im Nyderlant, in Ungern, in Italia, in Frankreich, und zu seinen zeiten ist erwachsen ein newer orden der seellossen leuth, genant die Landsknecht welche on alles auffsehen auf ehre oder billigkeit, luffent an die ort, do sie hoffen gut zu uberkommen, geben sich mutwilliglich in geferligkeit yrer selen, und in verderbniss angeborner erberkeit, und guten landsitten, so sie lernen und gewonen aller untzucht in schetten, schweren, schandworten, fluchen etc., ya in hurerey, ehebruch, iungfrawschendung, fullerey, zusauffen, ya zu gantz vihischen sachen, stelen, rauben, mörden ist bey ynen wie teglich brot, und das thun sie ihenen armen leuthen, welche sie die landsknecht nie beleidigt haben. Kurtz, sie stehen ganz gebunden im gewalt des teuffels, der zeucht sie wohin er wil, . . ." The passage was quoted verbatim by Sebastian Franck in *Krieg Büchlin des Friedes* (Hildesheim, 1975; reprint of 1st ed., Frankfurt am Main, 1550), pp. 191–191 v.

29. Heinrich Adelbert von Keller, *Hans Sachs*, 5 (Hildesheim, 1964; reprint of 1st ed., Stuttgart, 1870), "Ein kampffgesprech zwischen eyner haussmagd und eynem gesellen," pp. 208–214.

30. Ibid., 9, "Vergleichung eines lantzknechts mit einem krebs," pp. 242–250.

31. Ibid., 5, "Sanct Peter mit den lands-knechten," pp. 117–120.

32. Ibid., 5, "Der teuffel lest kein landsknecht mehr in die helle faren," pp. 121–125.

33. W. Gerstenberg, *Zur Geschichte des deutschen Türkenschauspiels*, (Meppen, 1902), 1: 38–40.

34. Ibid, pp. 33–38.

35. Heinrich Röttinger, *Die Bilderbogen des Hans Sachs* (Strasbourg, 1927), cat. no. 352; Nürnberg, Stadtgeschichtliche Museen, *Die Welt des Hans Sachs*, exh. cat. (1976), cat. no. 31.

36. Wach auff hertz, sin und freyer muet,
 Hilff mir preysen die lanz-knecht guet,
 Ir riterliche date
 Pegangen itz in Osterreich
 Zu Wien wol in der state . . .

37. See Eugen Franz, *Nürnberg, Kaiser und Reich: Studien zur Reichstädtischen Aussenpolitik* (Munich, 1930).

38. Hans Baron, "Religion and Politics in the German Imperial Cities during the Reformation, I and II," *English Historical Review* 52 (1937): 405–437 and 614–633; Georg Ludewig, *Die Politik Nürnbergs im Zeitalter der Reformation (von 1520–1534)* (Göttingen, 1893), chap. 10; K. Schornbaum, "Zur Politik der Reichsstadt Nürnberg vom Ende des Reichstags zu Speier 1529 bis zum Übergabe der Augsburgischen Konfession 1530," *Mitteilungen des Verein für Geschichte der Stadt Nürnberg* 17 (1906): 178–245.

39. For an account of this policy, see Stephen H. Fischer-Galati, *Ottoman Imperialism and German Protestantism, 1521–1555* (Cambridge, Mass. 1959).

40. Ludewig, *Politik Nürnbergs*, pp. 100–101; Ascan Westermann, "Die Türkenhilfe und die politisch-kirchlichen Parteien auf dem Reichstag zu Regensburg 1532," *Heidelberger Abhandlungen zur mittleren und neueren Geschichte* 25 (1910): 1–237, 146–147.

41. Pauli, *Hans Sebald Beham*, cat. no. 1114; J. Bader, *Beiträge zur Kunstgeschichte Nürnbergs*, 2 vols. (Nördlingen, 1860–1862), 2: 52; T. Hampe, *Nürnberger Ratsverlasse über Kunst und Kunstler*, 3 vols. (Vienna and Leipzig, 1904), 1: 254, 255, 257, 258; Heinrich Röttinger, "Die Zeichner des nürnbergischen Flugblätter zur Wiener Türkenbelagerung von 1529," *Mitteilungen der Gesellschaft für vervielfältigende Kunst* (1921), pp. 3–7.

42. Ludwig Cardauns, *Die Lehre vom Widerstandsrecht des Volks gegen die rechtmässige Obrigkreit in Luthertum und im Calvinismus des 16. Jahrhundert* (Darmstadt, 1973; reprint of 1903 ed.), pp. 14–15; Heinz Scheible, *Das Widerstandsrecht als Problem der deutschen Protestanten 1523–1546*, (Gütersloh, 1969), pp. 29–39, 50–56; Cynthia Grant Schoenberger, "The Development of the Lutheran Theory of Resistance, 1523–1530," *Sixteenth Century Journal* 8 (1977): 61–76, esp. 69; Harold T. Grimm, *Lazarus Spengler: A Lay Leader of the Reformation* (Columbus, Ohio, 1978), pp. 141–143.

43. Röttinger, *Schön and Stör*, cat. nos. 24 (*Tailor*) and 25 (*Cobbler*). The prints are thought to date from the 1530s.

44. Ey geb dem schühmachen den rüten
 Ich hab mich lang darmit gelitten
 Ee ich wochen lon gewynn
 So ist das ander gar dahin
 Ich wil ein anders fahen an
 In hosen wammes wallen an
 Ob ich im krieg mocht gelt gewynnen
 Allde gut gsell ich far von hinnen

45. Halt gut gsell ich will mit dir
 Gleich wies dit gat also auch mir
 Lanng sitzen und ein klainer Lon

Do mit ich nyndert kan beston
Dess muss ein anders ich an fanngen
Und neen mit der hopffen stanngen
In freyen Felld mit pfeyffen Trummen
Ob ich auch gelt mocht über kummer

46. Fritz Redlich, *The German Military Enterpriser and His Work Force: A Study in European Economic and Social History* (Wiesbaden, 1964), p. 127. Even the lowest paid mercenaries made more than many skilled craftsmen.

47. Röttinger, *Schön and Stör*, cat. no. 225; Geisberg, *Single Leaf Woodcut*, 4: cat. no. 1518.

48. Wolauff du schone Neterin
Zeuch mit mir in Norbeden hyn
Da wil ich die Lantzknecht wol klayden
Und wil verdienen geltes leyden
So mach du jn Hemet gericht
Mit Seyden, Gold kostlich gestict
Magsb ein Monat mer geltz gewynnen
Dan ein Jar bey der Neterinnen

49. Wen do wolst sein ein guter gesel
So wagt ich mit dir al gefel
Und liess mir das mein freundt nit weren
Ich hoff wir wolten uns wol neren
Du machst klayder auf knechtisch syten

Geteylt, Zerhawen, und zerschnyten
Von Seyden, Atlas und Samut
Damit gewyn wir Eer und gut

50. Ich haiss Mair ulin von der linden
Wa mecht ma bosser kriegsma finden
Bin wol gerist mit spies und stangen
Mei harnasch hab ich an mir hange

51. Dar zu trag ich gut wein und ganss
Und sieg gar wol zu dissen hans
Damit vul ich im seinen kropf
Das er mich dester basser schop

52. Berlin, Staatliche Museen Preussischer Kulturbesitz, *Catalogue of Paintings, 13th to 18th Century*, trans. L. Parshall, (1978), cat. no. 558; Dietrich Schubert, *Die Gemälde des Braunschweiger Monogrammisten* (Cologne, 1970), cat. no. 26.

53. Konrad Renger, *Lockere Gesellschaft: Zur Ikonographie des verlorenen Sohnes und von Wirtshausszenen in der niederländischen Malerei* (Berlin, 1970).

54. Much of the following depends on the information provided by Bruno Weber, *Wunderzeichen und Winkeldrucker*.

55. L. Febvre and H. T. Martin, *The Coming of the Book: The Impact of Printing, 1450–1800*, trans. D. Gerard (London, 1976), pp. 216–219.

56. Weber, *Wunderzeichen und Winkeldrucker*, n. 71.

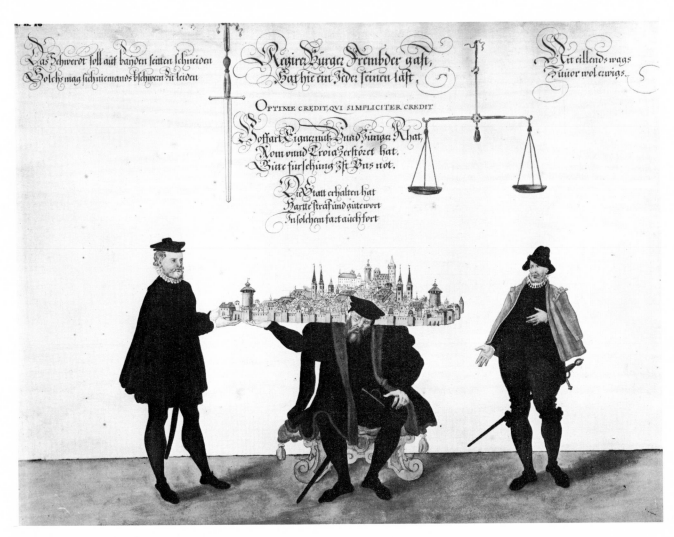

1. Anonymous, *Symbolic Representation of the Last of the City Authorities*, colored drawing, second half of the sixteenth century, Nuremberg, Stadtbibliothek, Abt. Sammlungen. (courtesy Stadtbibliothek)

The Transformations of Patrician Tastes in Renaissance Nuremberg

by Jeffrey Chipps Smith

Rapid changes in the sophistication and expectations of patrician patrons in sixteenth-century Nuremberg were just as remarkable as the artistic innovations of Dürer, the Vischer family, and their successors. Nuremberg was governed by an oligarchy of wealthy merchant families whose artistic tastes were highly conservative throughout the late Middle Ages; however, beginning in the 1490s their commissions increasingly reflected a preference for innovation and for Italian Renaissance forms. In this short paper, I wish to examine three different periods in Nuremberg's artistic development: the years up to 1525, the date that the city adopted Lutheranism; 1525–1550, an era in which Renaissance ideals were increasingly assimilated into the local cultural vocabulary; and 1550–1618, a time of active patrician rivalry and individual showiness. By focusing on a few representative patrons and artists, I hope to provide a general introduction to the dynamics of Nuremberg patrician patronage during the Renaissance.[1]

The term "patron" is used here to refer to an individual who acquired paintings and other art objects. The exact nature of the patron changed during the course of the sixteenth century. For example, most patrons of the pre-Reformation period obtained the majority of their paintings and other items from masters then living in Nuremberg. A half century later, as the ideal of the patrician connoisseur developed and as large collections were created, the patron increasingly sought classical antiquities and works by Dürer and other early-sixteenth-century German and Italian masters in addition to the creations of contemporary artists. This fascination with the past had two basic results: it enriched the range of stylistic sources that an artist could see in Nuremberg, but it also reduced the level of capital available to fund new projects. The coming of age of the Nuremberg patron brought mixed blessings to local artists.

The artistic situation in Nuremberg differed somewhat from most other German towns. While it was an imperial free city with political and financial ties to the Holy Roman Emperor, the patrician government, run primarily by the forty-two old families, had almost absolute control over all aspects of life and commerce (fig. 1). There were neither local nobles or ecclesiastical princes to contend with. The city council appointed most local religious leaders, many of whom were drawn from the patrician class, and then selected lay supervisors for each of the parish churches.

Furthermore, in contrast to other German towns, Nuremberg had no powerful craft guilds. In the mid-fourteenth century the trade guilds made an unsuc-

cessful bid for political power. The patrician city council banned the guilds and assumed total responsibility for their activities, including the organization and regulation of the painters, goldsmiths, and other craftsmen. Traditionally in Germany, the craft guilds and the Catholic Church were major artistic patrons. In the case of Nuremberg, most of the burden for supporting a community of talented artists fell upon the wealthy merchant families and the city government.[2]

1. PATRONAGE IN PRE-REFORMATION NUREMBERG

During the period prior to Nuremberg's adoption of Lutheranism in 1525, most artistic commissions were religious in nature. The patrician families vied with each other in adorning private house chapels and, more important, St. Lorenz, St. Sebaldus, or one of fifteen other ecclesiastical establishments within the city's walls. Seventeenth-century engravings, such as those by Johann Ulrich Kraus, reveal both the artistic bounty of these churches and the largess of the patrician class as every chapel and pillar is decorated with carvings or paintings (fig. 2). Although religious themes dominated artistic patronage at this time, many of the same merchants were beginning to purchase secular art for their homes.

The activities of Sebald Schreyer (1446–1520) exemplify the principal trends of patrician patronage, as well as some of the underlying motives. Although he was a more active patron than most of his peers, he nevertheless represents a middle point between such individuals as his nephew, Mattheus Landauer, with his consuming preoccupation with his own spiritual salvation, and the more secular minded Willibald Pirckheimer, Nuremberg's foremost humanist.[3]

Sebald Schreyer was one of the most fascinating and multifaceted individuals in pre-Reformation Nuremberg.[4] Like many members of Nuremberg's upper class, he received his formative education at the university in Leipzig. In 1477, two years after his return to Nuremberg, Schreyer was selected as a member of the greater city council, one of the many civic offices that he would hold. Between 1482 and 1503 he served as the *Kirchenmeister*, or lay superintendent, of the church of St. Sebaldus, a position that greatly influenced his interest in art. In order to enforce civic control over local churches, the city council appointed lay overseers who supervised all construction projects and artistic embellishments, among other duties. In 1482 and 1483 Schreyer initiated campaigns to erect the two western towers, which Heinrich Kugler completed by 1490. Schreyer's most significant contribu-

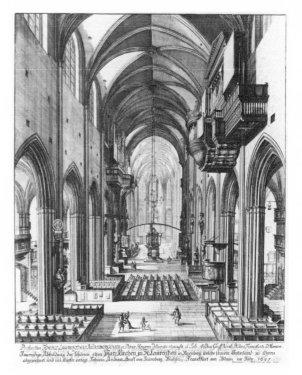

2. Johann Ulrich Kraus (after Johann Andreas Graff), *View of the Interior of St. Lorenz*, engraving, 1685, Nuremberg, Germanisches Nationalmuseum. (courtesy Germanisches Nationalmuseum)

3. Peter Vischer the Elder and his sons, *Tomb of St. Sebaldus*, bronze, completed in 1519, Nuremberg, St. Sebaldus. (courtesy author)

4. Adam Kraft, *Schreyer-Landauer Epitaph*, stone, 1490–1492, Nuremberg, St. Sebaldus. (courtesy Hochbauamt-Bildstelle, Nuremberg)

tion during this period was the shrine of St. Sebaldus (fig. 3).[5] In 1488 Schreyer and Rupprecht I Haller, a lay guardian of the church, requested Peter Vischer the Elder to prepare a preliminary working drawing for a monumental tomb to house the relics of the church's patron saint. The large drawing, which measures 1.77 by 0.431 meters and is now in Vienna, contains the nucleus of the form that the shrine would assume when it was finished and placed in 1519.[6] Vischer's sons grafted classical architectural motifs, putti, and grotesque forms onto his core design. During the completion of this project, Schreyer is recorded in 1493 and again in 1502 trying to raise funds for its execution. The shrine, which is one of the most outstanding examples of German Renaissance sculpture, provided a focal point within the church and a fitting monument for visiting pilgrims.

Schreyer's veneration of his name saint also resulted in several additional artistic projects. He commissioned Conrad Celtis, Germany's foremost humanist, to compose the *Ode to St. Sebaldus* (*In vitam divi Sebaldi carmen*), which first appeared in a Basel edition of ca. 1494 with a woodcut attributed to Michael Wolgemut and later in a Nuremberg edition of ca. 1501 with a woodcut depiction of the saint by Dürer. In 1508 Schreyer paid Dürer and his workshop for painting the *St. Sebaldus Alterpiece* that he presented to the Heilig-Kreuz-Kirch in Schwäbisch-Gmünd.[7]

While superintendent of St. Sebaldus, Schreyer and his nephew, Mattheus Landauer, commissioned Adam Kraft, Nuremberg's foremost stone sculptor, to create a huge family epitaph (fig. 4).[8] It was placed between two buttresses of the choir in what was then a small cemetery located in the narrow plot along the northern side of the choir, a site that Schreyer's father and uncle had purchased in 1453. The three-sided

epitaph, made between 1490 and 1492 and measuring 2.5 by 6 meters, is the most elaborate funerary monument produced in Nuremberg during the pre-Reformation period. In fact, with the changes in burial laws in the 1510s, citizens were no longer permitted to be interred within the city walls and their tomb decorations were limited henceforth to armorial and inscription plaques only. From its inception the monument was intended to be a symbol of the prestige and piety of these two families.

Kraft carved three principal scenes, beginning with Christ Carrying the Cross on the right wall and ending with the Resurrection on the left. The long central panel depicts the Entombment of Christ and, to the right, Golgotha with the two thieves still on their crosses. Immediately below the empty central cross are two men dressed in contemporary attire: these are Schreyer and Kraft, both rendered in the same scale as Mary and the other holy figures and depicted as integral participants present at Christ's death. Interestingly, Mattheus Landauer, the other donor, is not portrayed within the narrative scenes but merely as one of the tiny family members arranged along the bottom of the three panels. While his tools, a chisel and a hammer, symbolize Kraft's creative role, his presence must be understood as an expression of his religious piety. This is the earliest of the several self-portraits that Kraft would incorporate into his works, with the most famous example being the great sacrament house, or tabernacle, that he erected in St. Lorenz between 1493 and 1496.[9]

Schreyer's representation as a participant or witness is not surprising given his role as the patron of the epitaph, the superintendent of St. Sebaldus, and a devout Christian. Schreyer holds the crown of thorns and the three nails of the Crucifixion. He stares intently across the panel at Christ, whose head is set at the same level. Through the pictorial imagery, Schreyer becomes one of the devout followers who witness Christ's death. He is both physically and spiritually present at this momentous occasion. Late medieval devotional literature, from the meditational writings of Pseudo-Bonaventura and St. Birgitta to such treatises as Stephan Fridolin's *Schatzbehalter* (Nuremberg: Anton Koberger, 1491) and the popular *Hortulus Animae* to personal books of hours, stresses the individual's need to contemplate the life and death of Christ.[10] In his *Imitatio Christi*, one of the most influential texts of the fifteenth century, Thomas à Kempis exhorted the reader to

take up the Cross, therefore, and follow Jesus, and go forward into eternal life. . . . He died for

you on the cross, that you also may bear your cross, and desire to die on the cross with Him. For if you die with Him, you will also live with Him. And if you share His sufferings, you will also share His glory.[11]

Schreyer is a co-sufferer meditating on the death of Christ. This epitaph is but one of the many contemporary examples in local religious art that were intended to promote contemplation and spiritual reflection. Around 1505 Kraft carved the Stations of the Cross, seven large stone reliefs located on the road to the Johannisfriedhof, which provided a pictorial re-enactment of Christ's painful trip to Calvary.[12] Inexpensive woodcuts, such as the *Nürnberger Speerbildchen* of about 1500 with its illustration of the heart of Christ pierced by the lance and surrounded by his hand and feet wounds, facilitated the rapid spread of meditation and personal empathy with the suffering Christ.[13]

Underlying this epitaph commission and virtually all other religious projects of this period was the individual's concern with salvation. Schreyer hoped to share not only Christ's passion but also his glory. According to the Roman Catholic doctrine of good works or deeds, an individual could enhance his or her chances of eternal salvation by earthly actions, which included being charitable to the poor, venerating the holy saints and their relics, and making financial and artistic gifts to the church. Among other rewards, the worshipper would receive credit that would lessen the time that would be spent in purgatory. This point is emphatically stated in the design of Erhard Schön's *The Great Rosary* of 1515 in which angels gather those lucky souls who had amassed large indulgences from the flames (fig. 5).[14] This issue of salvation is especially relevant here since Kraft's monument was designed for Schreyer's intended burial site.

This epitaph also functions as a symbol of family prestige, a characteristic implicit in most religious commissions of this period. Schreyer, Landauer, and their relatives, carefully arranged and identified at the bottom of the three panels, are part of a large, showy monument. The sheer scale and complexity of the epitaph testify to their financial well-being. The epitaph is also advantageously set on the exterior of the choir of St. Sebaldus directly facing the Rathaus and the Burgstrasse, one of the city's principal thoroughfares; Schreyer's own residence on this street was only a couple hundred meters north of the church. Unless a high wall originally obscured the cemetery, and I have found no city maps or views that indicate that such a

5. Erhard Schön, *The Great Rosary*, woodcut, 1515, New York, Metropolitan Museum of Art (Rogers Fund, 1920). (courtesy Metropolitan Museum of Art)

wall existed, the epitaph was in full view of all who passed by. Thus anyone walking from the Hauptmarkt to the Burg or to the Rathaus would have been able to see this artistic symbol of Schreyer's piety and family prestige.

Sebald Schreyer's religious activities were matched by his support for various important humanist projects. His house, located at Burgstrasse 7 (or Unter der Veste, as the street was then called) and just up from St. Sebaldus, was a meeting place for local scholars and educated patricians.[15] Appropriately, he had his library painted, possibly by Wolgemut, in 1495 with relevant classical images. On one wall Apollo was depicted surrounded by the nine Muses and seven ancient wisemen, while adjacent were half-length portraits of Schreyer and his friends Conrad Celtis, Peter Danhauser, and Petrus Schoberlein. Celtis, who may have inspired the entire program, composed the epigrams that were inscribed beneath each figure. The intellectual conceit embodied in this program was obvious: under the aegis of Schreyer and other intellectuals, Apollo, his Muses, and the collective knowledge of the classical world had triumphantly re-emerged in Nuremberg. These sentiments reflected Celtis's personal campaign to awaken classical learning and the arts in Germany.

Through his actions, Schreyer sought to contribute to this awakening.[16] In either late 1487 or early 1488 he and his brother-in-law, Sebastian Kammermeister, commissioned Michael Wolgemut and Wilhelm Pleydenwurff to illustrate a lengthy chronicle then being composed by Hartmann Schedel. The result was the *Nuremberg Chronicle* (or *Liber Chronicarum*), which Anton Koberger published in Latin and German editions in 1493. With its 1809 illustrations of famous cities, people, and biblical events, this book quickly set a new standard for publishing and it is, after Johann Gutenberg's Bible of 1453, the most famous incunabula. In 1493 Schreyer asked Peter Danhauser, a Nuremberg lawyer and astrologer, to write the *Archetypus Triumphantis Romae*, a collection of classical texts that were to be published with illustrations by Wolgemut and his shop. Unfortunately, this ambitious project was never completed because Danhauser left Nuremberg for Vienna in about 1497. During the 1490s and 1500s, Schreyer was one of Conrad Celtis's principal financial backers. Besides commissioning the *Ode to St. Sebaldus*, mentioned above, he subsidized Celtis's *Norimberga*, the elaborate eulogy to the city's government and people that was written by 1496 and published by Hieronymus Höltzel in Nuremberg in 1502. Schreyer was also instrumental in forming the Sodalitas Celtica, a group of the humanist's friends

who published his two principal writings, his edition of Hroswitha von Gandersheim's *Opera* (1501), and his poetic masterpiece *Quatuor Libri Amorum* (1502).

Although a more active patron than the average patrician of the late fifteenth and early sixteenth centuries, Sebald Schreyer nevertheless typified the fervant Christian who commissioned religious art for reasons of both personal devotion and family pride. He was also representative of the first generation of patrician humanists. Whereas fellow patrician Willibald Pirckheimer was himself an active scholar, Schreyer might be more correctly termed an enthusiast who sought to foster the humanistic endeavors of others in order to make his city intellectually richer. Schreyer and others like him were responsible for stimulating local interest in the classical world and for facilitating the introduction of Renaissance ideas in Nuremberg.

2. 1525–1550

While the next generation of patricians was no less pious than Schreyer, Landauer, and their contemporaries, they commissioned very little religious art. This is due to the fundamentally different spiritual climate that existed in Nuremberg after the official adoption of Lutheranism in 1525.[17] Luther, Karlstadt, and other Protestant reformers questioned the traditional role of religious art. Many considered it idolatrous, and Luther, while more moderate since he recognized the beneficial pedagogical role that art served, called for the end of the adornment of churches. In his *Church Postils* of 1522, Luther wrote, "See, that is the proper worship, for which a person needs no bells, no churches, no vessels or ornaments, no lights or candles, no organs or singing, no paintings or images, no panels or altars. . . . For these are all human inventions and ornaments, which God does not heed, and which obscure the correct worship, with their glitter."[18] Instead Luther urged his followers to care for the poor and the infirm.

Certainly, many Nuremberg patricians took Luther's advice seriously; however, this eliminated their primary outlet for patronage and for displaying their family's prosperity. During the quarter century following the adoption of Lutheranism, Nuremberg's leading families were forced to develop new means for expressing their artistic tastes and for conveying their and their family's social status. Under the direction of such artists as Georg Pencz and Peter Flötner, the gradual introduction and assimilation of Renaissance ideas and forms that had started with Dürer and the Vischer family were completed. The taste for classical themes and architectural motifs was no longer ex-

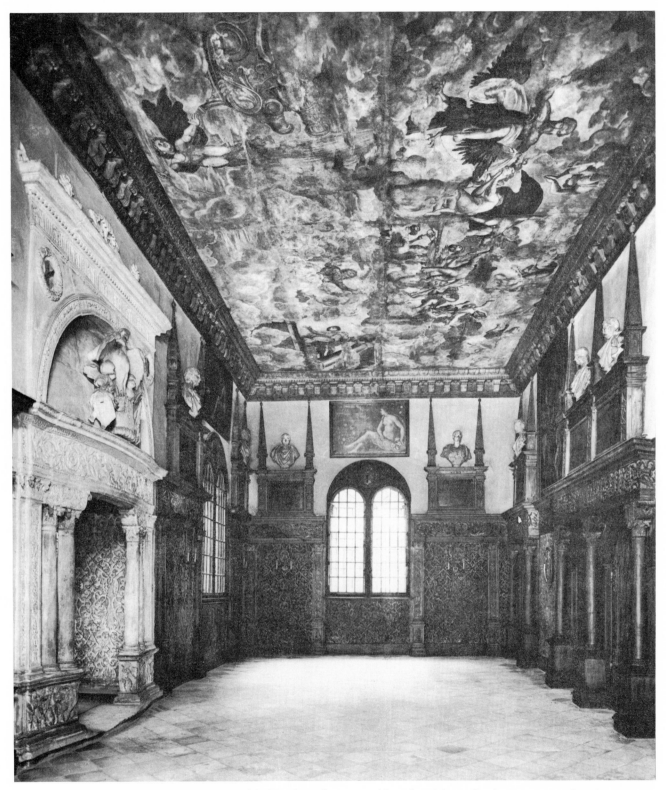

6. Peter Flötner and Georg Pencz, Garden Room of the Hirschvogelhaus, 1534, Nuremberg (photo taken between 1934 and 1936). Partially destroyed in 1945. (courtesy Hochbauamt-Bildstelle, Nuremberg)

clusively limited to such humanists as Willibald Pirckheimer or Sebald Schreyer. Merchants, sent abroad for their education or for business, were familiar with the latest Italian, French, or Netherlandish artistic fashions. One result was the erection of several new, richly decorated patrician houses during the 1530s and 1540s. To demonstrate this, I wish to look briefly at the activities of Peter Flötner (1486/95–1546), who did more than any master during the 1530s and 1540s to influence the tastes of both the patrician class and the local artists.[19] Cognizant of the fact that I am switching from an examination of a specific patron to one of a single artist, I do so since Flötner worked for a wide variety of different clients, and his career, rather than the actions of any single patron, provides the clearest insight into the shifts in patrician artistic preferences.

In 1534 Leonhard Hirschvogel (Lienhart Hirsvogel) added a large new garden room to his spacious house on the Hirschelgasse (figs. 6–7).[20] Unlike most houses in Nuremberg, which occupied their entire site and were bound on the sides by other residences, the Hirschvogel house was one of the few residences in the northeastern corner of the city that had additional land to permit small private gardens. During the 1530s and early 1540s, wealthy patricians, such as Hirschvogel and his neighbor, Lorenz II Tucher, initiated new architectural projects that would reflect their social position and cultural refinement.

Although adequate documentation for the Hirschvogel garden room is lacking, Peter Flötner must be credited with the overall conception and design, the execution of the architectural decoration, and possibly the architectural plans as well. The recondite, if ultimately simplistic, allegorical scheme of Sebald Schreyer's library gave way to the wholesale assimilation of classical architectural forms in the garden room. One enters from the garden through an ornate stone doorway (fig. 7) with framing pilasters filled with Roman-style graffito; above are two dolphins, rinceaux, and, in the tympanum, a siren. The interior (fig. 6) is even more ornate. The wooden revêtement that encases the chamber is broken only by the door to the garden and a much larger stone entrance way from the house. Flötner has carved both with Corinthian pilasters, filled with floral motifs and trophies, garland, rinceaux, and triglyphs and metopes. A large eagle, the family's symbol, and two putti holding the Hirschvogel coat of arms are placed on top of the lintel in the tympanum of the doorway.

Flötner's designs have no local precedents, other than perhaps the forms that appear in his own woodcuts of doorways and furniture. His carved architectural decoration provides an ideal setting for the revo-

7. Peter Flötner, Exterior Doorway of the Garden Room of the Hirschvogelhaus, 1534, Nuremberg (photo taken between 1934 and 1936). Destroyed in 1945. (courtesy Hochbauamt-Bildstelle, Nuremberg)

8. Georg Pencz, *Fall of Phaeton*, detail, Ceiling Painting of the Garden Room of the Hirschvogelhaus, 1534, Nuremberg, now in the Fembohaus (Stadtmuseum). (courtesy Hochbauamt-Bildstelle, Nuremberg)

lutionary ceiling painting, the *Fall of Phaeton*, by his collaborator Georg Pencz (fig. 8).[21] This mythological picture creates the illusion that the ceiling has dissolved and been replaced with a seemingly infinite view of the heavens about Jupiter. The ensemble can better be compared to Giulio Romano's work in the Palazzo del Tè in Mantua of the 1520s than to any other patrician house in Nuremberg. It demonstrates that both of these artists were familiar with the current trends in Italian art and that certain enlightened patrons, such as Hirschvogel, were prepared to redefine and update the aesthetic tastes of the local ruling class. Hirschvogel's personal tastes were doubtlessly affected by his visits to Venice, where his family was one of the principal members of the Fondaco dei Tedeschi, the German merchants' organization.

The Hirschvogel house was not an isolated instance during these two decades.[22] Pencz also supplied elaborate perspective ceiling paintings for the Volckamers and other patrician families. Flötner and his workshop created the wooden paneling and some of the furniture for the magnificent new house of Lorenz II Tucher between 1533 and 1544. His paneling for the house at Hans-Sachs-Gasse 9 of 1546, now in the Germanisches Nationalmuseum, is typical of his introduction of classical forms into local residences (fig. 9).[23] Flötner's ideas reached a broad audience both within and outside Nuremberg through his decorative prints and his many plaquettes. His designs were adopted readily by sculptors, carpenters, architects, and metalworkers. Such works as the large chest of 1541 in the Germanisches Nationalmuseum or the carved wooden lintels of the courtyard of the house formerly at Tucherstrasse 15 show the influence of Flötner's designs.[24]

Flötner also helped to redirect the course of local goldsmith work.[25] He collaborated with several artists, including Master M. E. and, most important, Melchior Baier. Earlier goldsmiths, such as Hans and Ludwig Krug, tended to favor either flamboyant Gothic tracery motifs or radically twisted stems and intricate leaf patterns that threaten to run wild. Flötner's taste for classical architectural forms and a Renaissance sense of balance and order was in sharp contrast to the prevailing styles when he introduced them in such beautiful pieces as the *Pfinzing Dish*, which he produced in 1534–1536 to celebrate the fraternal ties of Martin, Melchior, and Sigmund Pfinzing, members of one of the city's leading families (fig. 10).[26] Flötner created the overall design of the dish and, likely, carved the wooden model, which was then transformed into silver, gilded, and enameled by Baier. His sense of architectonic order prevails in even his most lavish patrician commissions, the *Agate Dish*

of 1536 and the tall *Holzschuher Covered Cup* made before 1540.[27]

Flötner's influence is also evident in the growing patrician demand for small bronze statues and fountains. In this case, however, the Vischer family had already introduced bronzes of mythological figures and animals into the limited circle of Nuremberg humanists during the first quarter of the century. Flötner supplied similar statues as the demand for bronzes grew after 1525.[28] His finest example is actually neither small nor intended for a patrician house; nevertheless, it does illustrate the broadening in taste that occurred during the second quarter of the century. In 1532 the members of the gentlemen's archery club commissioned Flötner to make a large fountain of Apollo for their shooting yard (fig. 11).[29] Apollo is shown standing and taking aim with his bow. The artist has transformed his original model, Jacopo de' Barbari's 1503 or 1504 engraving *Apollo and Diana*, to appear more realistic. He placed the god on top of a base ornamented with putti, sea monsters, and masks. This project provides further proof that Nuremberg's patricians were increasingly accepting a new, non-Gothic style both in their homes and in their social establishments.

It must be mentioned, however, that the adoption of a taste for Renaissance art was not universally accepted in Nuremberg. Many patricians continued constructing houses whose facades or courtyards were decorated with lavish Gothic tracery. Some houses possessed a fascinating blend of the old and new styles. This can be seen, for instance, in the courtyard of Tucherstrasse 15 of the 1530s; while the balustrades are carved with flamboyant Gothic interlacing, some of the coursings below are adorned with Flötner-inspired profile medallions and foliate patterns.[30]

3. 1550–1618

During the ensuing decades before the outbreak of the Thirty Years War in 1618, Nuremberg's patricians and a growing number of newly rich merchants continued to be active artistic patrons in spite of the city's waning economic vitality and political prominence. Indeed this was an era that witnessed the building of sumptuous residences and the amassing of important art collections that rivaled those of contemporary princes. The city's artistic regulations encouraged talented painters, sculptors, and other craftsmen to settle in Nuremberg.[31] In fact, the city's goldsmiths, led by Wenzel Jamnitzer, reached their creative zenith as local merchants demanded ever richer, ever more beautiful cups, dishes, and chests. In this section, I

9. Peter Flötner or his circle, Wooden Paneling for the House formerly at Hans-Sachs-Gasse 9, 1546, Nuremberg, Germanisches Nationalmuseum. (courtesy Germanisches Nationalmuseum)

10. Peter Flötner and Melchior Baier, *Pfinzing Dish*, 1534–1536, Nuremberg, Germanisches Nationalmuseum. (courtesy Germanisches Nationalmuseum)

wish to consider the activities of three patricians: Willibald Imhoff (1519–1580), Paulus Praun (1548–1616), and Martin Peller (ca. 1559–1629). Admittedly these men were exceptionally significant collectors, yet their actions were emulated on more modest levels by many other patricians.

In 1570 Johann Gregor van der Schardt, the Dutch sculptor who had only recently arrived in Nuremberg, created a life-size terracotta bust of the wealthy merchant Willibald Imhoff (fig. 12).[32] Traditionally, portrait busts were produced exclusively for members of the nobility, and even then there exist relatively few sixteenth-century German examples. Thus, the very idea of commissioning a bust of oneself was quite revolutionary at this time. In addition, van der Schardt's choice of a pose is unique. Imhoff is not represented in prayer or, like most ruler portraits, looking resolutely past the viewer. Instead he adopted a relaxed pose in which he carefully examines the ring held in the fingers of his left hand. Van der Schardt captured the character of his patron: Imhoff is depicted as the

quintessential connoisseur who quietly contemplates the aesthetic merits of the ring and its set gem. This image conforms with our limited knowledge of Imhoff's personality as expressed in his writings.

With Imhoff, a new type of patrician patron emerged in Nuremberg.[33] He was the city's first great art collector who amassed a *kunstkammer* worthy of any German prince. His grandfather, Willibald Pirckheimer, and other early humanists had gathered small collections of contemporary paintings and prints, together with a number of ancient coins and bronzes, yet none of their holdings can compare with the wealth and diversity of Imhoff's. Furthermore, none seem to have shared his relish in the conscious pursuit of individual pieces, be it the medals and antiquities purchased in Venice and Lyons or the acquisition of works by Albrecht Dürer, which Imhoff described in his account books of 1557–1564. With obvious pride, he recorded in his inventory of 1573 that his *Crucifixion*, painted by Dürer, was then valued at 120 gulden rather than the 80 that he had paid for it.[34]

11. Peter Flötner, *The Apollo Fountain*, bronze, 1532, Nuremberg, now in the courtyard of the Pellerhaus (Stadtbibliothek). (courtesy Hochbauamt-Bildstelle, Nuremberg)

However, Imhoff must not be viewed solely as a merchant who was pleased with his investment, because it was his intention, as specified in his 1580 will, that his collection not be sold or split among his heirs at his death.[35] He stipulated that it remain intact in his house at Egidienplatz 25/27 for eternity.

Imhoff's collection was built around the nucleus of the collection of his grandfather, Willibald Pirckheimer. On Pirckheimer's death in 1530, his possessions were divided between his two daughters, Felicitas, Willibald's mother, and Barbara. Imhoff inherited his mother's share and, following his aunt's death in 1560, was able to reassemble most, if not all, of Pirckheimer's possessions. These included numerous paintings, prints, and drawings by Dürer. When examining Imhoff's accounts or his inventories of 1573–74 and 1580, it is difficult to determine which works by Dürer were from Pirckheimer's collection, which were added when Imhoff acquired portions of Dürer's personal possessions from the widow of Endres, the artist's younger brother, and which items were acquired from other sources. In any case, Imhoff possessed at least ten paintings and numerous watercolors of Dürer's, including his *Portrait of Hans (Johannes) Kleberger*, a large *Descent from the Cross*, the *Crucifixion* mentioned above, a *Salvator Mundi*, portraits of Dürer's parents (perhaps a shop work), a watercolor *Portrait of Emperor Maximilian I*, and a watercolor *Self-Portrait at Age 26* (1496–97).[36] He owned twenty-nine books filled with Dürer's woodcuts and engravings and, presumably, such drawings as the *Four Heads in Profile*, now in Kansas City.[37] The authors of the inventories single out copies of the *Adam and Eve* and the *Saint Jerome in His Study* that were printed on parchment and impressions of *Saint Eustace* and *Melencolia I* that were hand painted.[38] Another item is referred to as the great book in green parchment that contained the best of his hand, that is, drawings and illuminations; it was valued at 200 florins and was later sold to Emperor Rudolf II.[39]

Imhoff, like so many of his contemporaries, recognized the artistic merits of the works by Dürer and his generation. As a result, there existed a keen competition for paintings by such masters as Lucas Cranach the Elder, Albrecht Altdorfer, Hans Holbein the Younger, and the Dutch artist Lucas van Leyden, all of whom were represented in Imhoff's collection.[40] Imhoff was less interested in acquiring paintings by living German artists or by Italians.

Following Imhoff's death in 1580, his widow, Anna, kept the collection intact for a few years. Their house was so richly appointed that the city council occasionally borrowed it to lodge important princely visitors,

such as Archduke Mathias of Austria, who visited Nuremberg in 1582.[41] Nevertheless, because of the tremendous importance of the paintings and sculptures his widow was pressed by Emperor Rudolf II and others to sell portions of the art collections.[42] By 1634 only fourteen of Dürer's twenty-nine books of prints were still in the family's possession; and by 1650 only fourteen watercolors and drawings by Dürer were in the Imhoff collection. Parts of the collection were sold to Rudolf II and Albrecht V, Duke of Bavaria, while Thomas Howard, Earl of Arundel, purchased large portions, especially works by Dürer, and took these to England.

Willibald Imhoff set a standard for his peers in Nuremberg. He passionately sought and acquired works by Dürer and his contemporaries, as well as medals and antiquities. He embodied the connoisseurship that became the prerequisite of the patrician collector.

Toward the end of Imhoff's life a new Nuremberg collector, Paulus Praun, began to acquire paintings, sculptures, and other items for what would eventually become the largest nonprincely *kunstkammer* in Germany.[43] Praun is somewhat of an anomaly since he spent much of his life, from 1570 until his death in 1616, living abroad in Bologna. Yet the collection must be considered in the context of our discussion of Nuremberg patrician patronage for several reasons. First, most of his collection was acquired in Nuremberg through the assistance of his artistic advisors, Jost Amman and Wenzel and Christoph Jamnitzer. Most of his 250 paintings, 4,000–5,000 drawings, and 13 volumes of prints were made by Nuremberg masters. Praun also patronized contemporary Nuremberg painters, such as Amman; Lorenz Strauch, who painted his portrait in 1598; Georg Gärtner; Nicolas Neufchâtel; and, above all, Hans Hoffmann. Praun owned at least 25 paintings and 159 drawings by Hoffmann. Praun considered Nuremberg to be his home, and by 1589 a substantial portion of his collection was housed there. In 1616 he shipped the rest of his holdings back to Nuremberg; however, Praun died in the same year before returning himself. In his will he stipulated, as Imhoff had in 1580, that his heirs were to keep the collection intact and in Nuremberg. His wishes were honored for almost two hundred years, until 1797, when much of the *kunstkammer* was acquired by Hans Albert von Derschau; in 1806 it was moved to Saxony.

The core of Praun's collection consisted of works by Dürer and his contemporaries. From the heirs of Wenzel Jamnitzer, he purchased a complete set of Dürer's prints, reportedly in their first editions.[44] He

12. Johann Gregor van der Schardt, *Bust of Willibald Imhoff*, terracotta, 1570, Berlin (West), Skulpturengalerie, Staatliche Museen Preussischer Kulturbesitz. (courtesy Staatliche Museen Preussischer Kulturbesitz)

13. Johann Gregor van der Schardt, *Portrait of Paulus Praun*, terracotta, 1580, Nuremberg, Germanisches Nationalmuseum. (courtesy Germanisches Nationalmuseum)

acquired another portion of Endres Dürer's personal collection of his brother's works, including the *Portrait of Michael Wolgemut*, a *Self-Portrait*, a *Portrait of Hans Dürer*, and at least seven other paintings.[45] The comprehensive inventory of the collection that de Murr made in 1797 lists a hellish picture ("un incendie") by Hieronymus Bosch and a *Lot and His Daughters* by Joachim Patinir that Dürer obtained during his 1520–21 journey to the Netherlands.[46]

Praun possessed a connoisseur's appreciation for Italian art as well. The inventory of his holdings lists paintings by Michelangelo, Leonardo, Raphael, Mantegna, Titian, Andrea del Sarto, Giulio Romano, Tintoretto, Jacopo Palma (Il Vecchio) and his son, Sebastiano del Piombo, Parmigianino, and even Caravaggio.[47] Not surprisingly, several Bolognese painters caught Praun's fancy, including Guido Reni, who was one of his artistic advisors; Piero Lanfranco; Lavinia Fontana; and Denis Calvart.[48] Praun avidly collected the work of Giovanni Bologna, whom he apparently knew well; at least eight of his bronzes are recorded.[49] Interestingly, among Praun's collection of 171 terracottas were 4 of Michelangelo's models for the Medici tomb figures, 2 of his slaves, and a flayed man.[50]

Praun's collection was a comprehensive *kunst- und wunderkammer*.[51] He sought works of art in virtually all media and from all periods. He possessed 38 Egyptian, Etruscan, and Roman marbles; 1,163 engraved stones, some by the Jamnitzer family but most Egyptian with hieroglyphics, Persian, or classical; 3,797 medals; "many portraits" in wood and wax, including presumably van der Schardt's wax likeness of Praun that is now in Nuremberg (Germanisches Nationalmuseum); and a host of other carvings in wood and alabaster (fig. 13).[52] Most of his terracottas were by van der Schardt, including many made after Greek and Roman statues then in either Rome or Florence.[53] He owned nine manuscripts and numerous books, including the treatises of Dürer, Palladio, Serlio, Scamozzi, and the *Vitruvius teutsch*; however, some of the books were added only after his death.[54] Praun shared his period's fascination with natural objects. Listed among his natural curiosities are various corals and shells, precious stones and an assortment of Florentine marbles, animal horns, bird beaks, whale and other marine mammal teeth, ostrich eggs, amber, and various minerals.[55] Displayed with these were two world globes by Jodocus Hondius, a marquetry table of eighty-one precious stones, elaborate mirrors, two Turkish lamps, and many other objects. Some of the more exotic items may have been obtained from his older brother Stephen III (1544–1591), who traveled extensively throughout the Middle East, the Iberian peninsula, and northern Europe.

Praun's holdings may not have equaled the much larger collections of Emperor Rudolf II in Prague or Ferdinand of Tirol in the Schloss Ambras outside Innsbruck, yet he surpassed most other nobles and wealthy merchants of his period.[56] Like them, he sought to build a collection that included the finest contemporary paintings and sculptures, together with a representative sampling of Egyptian, Greek, and Roman art. The vogue for exotic natural wonders is also evident although Praun's holdings were never encyclopedic in scope. Like Willibald Imhoff before him, Praun typifies the patrician connoisseur for whom art was a source of both great aesthetic pleasure and personal prestige. Both men built collections, or protomuseums, that were to stand for eternity as monuments to themselves and their international tastes.[57]

Nuremberg possessed many other collectors who on more modest levels also embodied the ideal of the patrician connoisseur. Whereas Imhoff and, especially, Praun were wide ranging in the type of works that they purchased, others sought to specialize. The clearest example of this is the collection of Melchior Ayrers (died 1570) and his son Julius, who possessed approximately twenty thousand woodcuts and engravings, making theirs one of the most important and earliest print cabinets in Europe.[58] In order to provide a somewhat more typical representation of the city's upper class and its collecting habits, I wish to focus briefly upon the wealthy textile merchant Martin Peller.

In 1602 Peller commissioned Jakob Wolff the Elder to design and to erect a large new townhouse at Egidienplatz 23 (fig. 14).[59] The square around St. Egidien, the former Benedictine abbey, was one of the most fashionable neighborhoods in the city. Willibald Imhoff's art collection was located next-door immediately west of Peller's dwelling.[60] Between 1589 and about 1610, twenty-seven major new houses were erected in Nuremberg.[61] Of these, twenty-four were made for newly rich merchants, such as Peller or his father-in-law, Bartholomäus Viatis (1538–1624), and only three for members of the older ruling families. One could argue that a *nouveau riche* aesthetic emerged in Nuremberg during this period. These new houses were larger, especially in height, than older residences, such as the Hirschvogelhaus or the Tucherhaus. These new buildings possessed a systematic scheme or plan throughout. Their rich sandstone façades were overlaid with elaborate decorative motifs. In fact, the splendor of these houses was decried by some of the old patricians, including Wolf

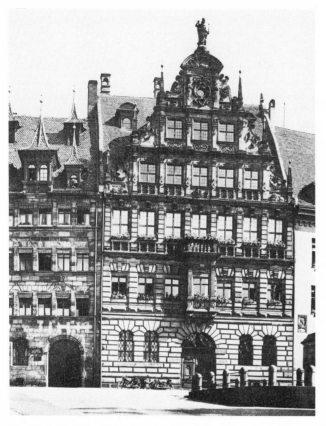

14. Jakob Wolff the Elder, Façade of the Pellerhaus, 1602–1607, Nuremberg (photo taken in 1935). Partially destroyed in 1945. (courtesy Hochbauamt-Bildstelle, Nuremberg)

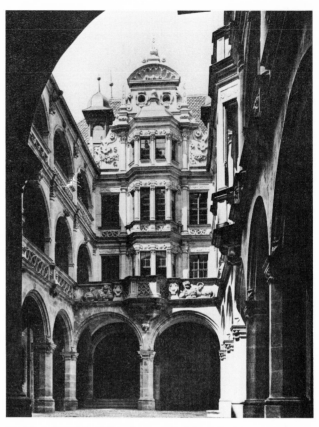

15. Jakob Wolff the Elder, Courtyard of the Pellerhaus, 1602–1607, Nuremberg (photo taken in 1935). Partially destroyed in 1945. (courtesy Hochbauamt-Bildstelle, Nuremberg)

Jakob Stromer, the city *baumeister* between 1597 and 1614, who characterised them as being "mit Schmuck überladen" ("overladen with ornament").[62] The façades of several of these houses were painted with allegorical or mythological scenes.

Peller's house was certainly the finest of these new residences. Jakob Wolff's original plan was apparently much more Italianate in design than the structure completed in 1607. Peller's neighbors objected to the design on the grounds that it did not match the styles of their houses, which were by comparison late Gothic and thus old-fashioned. Wolff was required to submit several modified designs before the present one was accepted.[63] The final appearance was, nevertheless, quite striking and, for Nuremberg, very modern. The five-story façade culminates in an elaborate scrolled gable with a scalloped pediment, obelisks, caryatidlike figures, and, at top, a statue of Jupiter. The surface decoration, which includes garlands, a relief of St. Martin, crouching lions, and strapwork, somewhat obscures the very remarkable basic design of the façade.

Wolff's structure is based upon the five classical or-

ders: Tuscan, Doric, Ionic, Corinthian, and Composite, in ascending order. His source seems to have been the fourth book of Sebastiano Serlio's *Regole generali di architettura* (*General Rules of Architecture*), which had been translated into German in 1542. His treatment of the masonry of the portal and the windows of the groundfloor, for instance, is almost identical to specific plates in Serlio's treatise.[64] While Peller's house is the most academic, Italianate residence in the city, no one would mistake it for a merchant's dwelling in Mantua or Florence because of its characteristically German scrolled gable; the prominent oriel, or bay window, above the portal; and the surface decoration. Thus, Wolff skillfully blended the two artistic traditions.

Another typical Nuremberg adaptation may be seen in the large interior courtyard that was erected between 1605 and 1607 (fig. 15). Grafted to the two upper loggias, or open galleries, that ring the courtyard are elaborate strapwork decoration, Gothic balustrade tracery, and a triple oriel. Many of the houses built in the city during this period have similar galleried courtyards that blend Gothic motifs with an

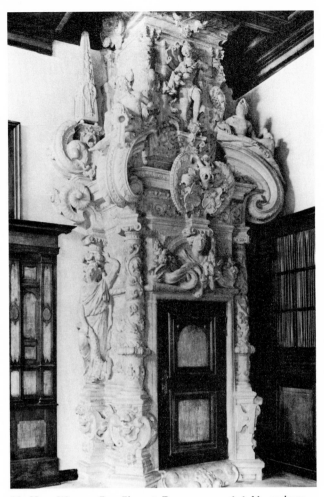

16. Hans Werner, *Four Elements* Doorway, ca. 1606, Nuremberg, Pellerhaus (photo taken in 1935). Destroyed in 1945. (courtesy Hochbauamt-Bildstelle, Nuremberg)

17. Paul Juvenel the Elder, *The Fall of Phaeton*, ceiling painting formerly in the Pellerhaus, ca. 1607, Nuremberg, now in the Fembohaus (Stadtmuseum). Photo taken between 1934 and 1936. (courtesy Hochbauamt-Bildstelle, Nuremberg)

Italianate architectural core.[65] Visually, the architectural design is simple and attractive while the surface decoration is a complex and somewhat chaotic mix of old and new styles.

The taste for complicated decorative motifs is evident in the four richly carved portals that lead to the circular staircases that unite the different floors of the house. All are either by or attributed to the sculptor Hans Werner (ca. 1560–1623).[66] The most elaborate of these is the Four Elements doorway on the third floor, completed in about 1606 (fig. 16). The basic rectilinear structure of the doorway has been all but obscured beneath the heavy scrolls, vine-covered Ionic columns, foliate patterns, obelisks, the Peller and Viatis family coats of arms, and other decorations. Set about the doorway are statues of personifications of earth, water, air, and, in the guise of Prometheus, fire. Werner or, conceivably, the architect Wolff based the design for this doorway and much of the house's decoration on the engravings in Wendel Dietterlin's *Architectura*, which had been published in the second, enlarged edition in Nuremberg in 1598.[67] While no single plate is copied exactly, most of the architectural and sculptural forms can be found in this book, notably its chapter on the Ionic order. This demonstrates the willingness of the patron to erect a house in the latest fashion rather than simply rehashing an older style. If the Hirschvogelhaus typifies the careful and accurate copying of classical forms that occurred in the early Renaissance under Flötner, then the Pellerhaus is characteristic of the Mannerist, or late Renaissance, preference for a style that, while based upon such canons as that of Serlio, still exhibits a predilection for an overabundance of intricate ornamentation.

Peller owned an important if small painting collection, which he displayed mainly in the reception rooms of the third floor (second upper floor).[68] An eighteenth-century inventory listed thirty-four paintings, most of which had been purchased by Peller. From the Holzschuher family, he had been able to acquire Dürer's *Lamentation*, which formerly had hung in St. Sebaldus. Like Praun, Peller was partial to Italian painters. He possessed twelve pictures by Palma Giovane, a *Portrait of Catherine de' Medici* by Paolo Veronese, and an *Entombment* and an *Ecce Homo* attributed to Tintoretto. In 1607 Peller commissioned Paul Juvenel the Elder, one of Nuremberg's leading artists, to paint the ceiling of the *Schöne Zimmer*, or the Beautiful Room (fig. 17).[69] The principal subject was the *Fall of Phaeton*, the same theme that Georg Pencz painted for the ceiling of the Hirschvogelhaus. Juvenel, however, placed this scene at the center of

the ceiling and surrounded it with twenty other pictures, including images of Venus, Mercury, Jupiter, Saturn, the Moon (Luna), and Mars, each set into the richly carved ceiling.

Peller's opulent new house, built by the city's leading architect and decorated by two of the city's best sculptors and painters, typifies the prevalent attitude among the upper class during the last years of the sixteenth century and the opening two decades of the seventeenth. This was arguably the greatest period for patrician architecture as the Scheurls, the Toplers, the Oyrls, the Plobens, the Viatiss, and other leading families built ever grander houses. Wolff, Werner, and Juvenel are all documented working for Peller's peers. While none sought to rival Willibald Imhoff or Paulus Praun in the scope of their collections, all were conscious of the social and familial prestige associated with owning art.

During the course of the sixteenth century the patrician class in Nuremberg had come of age. Appreciation of and support for the arts had become both their privilege and, in actuality, a requisite activity. Much of the art prior to 1525 was ordered in the expectation that the donor was enhancing his or her chances of obtaining salvation. Once the religious underpinnings were removed with the advent of the city's adoption of Lutheranism, art was increasingly commissioned and collected for its own aesthetic merits. Through the actions of Dürer, the Vischers, Flötner, and Pencz, classical and Italian Renaissance ideas made their way into the residences of Nuremberg humanists and, soon, wealthy merchants in the city. In addition to their understandable preference for the paintings and prints of Dürer and his generation, they collected classical statues and coins as well as works by many of the finest contemporary Italian and Netherlandish artists.[70] One rather ironic result of this trend, however, was the gradual weakening of a distinctively Nuremberg style. This was especially true in painting where none of the later-sixteenth-century or early-seventeenth-century masters enjoyed a national or international reputation comparable to Dürer's or Pencz's. While it would be incorrect to blame the decline in Nuremberg's art solely on the increased patronage of non-Nuremberg masters, whose works were acquired abroad, this certainly was one of several contributing factors.[71] The principal explanation for the subsequent decline was the advent of the Thirty Years War in 1618, which rapidly eroded Nuremberg's economy and its political role within central Germany. The city's patricians and upper class merchants continued building new homes and purchasing paintings, but not on the scale of their ancestors.

NOTES:

1. I wish to thank the Archer M. Huntington Art Gallery and the University Research Institute of The University of Texas at Austin for providing funding for this project. On the patrician class, see G. Hirschmann, "Das Nürnberger Patriziat," in *Deutsche Patriziat 1430–1740*, ed. H. Rössler (Limburg/Lahn, 1968), pp. 257–276; general comments in G. Strauss, *Nuremberg in the Sixteenth Century: City Politics and Life between Middle Ages and Modern Times* (Bloomington, 1976). On patrician patronage, see T. Hampe, "Kunstfreunde im alten Nürnberg und ihre Sammlungen," *Mitteilungen des Vereins für Geschichte der Stadt Nürnberg* 16 (1904): 57–124; W. Schwemmer, "Aus der Geschichte der Kunstsammlungen der Stadt Nürnberg," loc. cit. 40 (1949): 97–206, esp. 122ff.; J. C. Smith, *Nuremberg, A Renaissance City, 1500–1618* (Austin, 1983). Many questions concerning patronage and stylistic changes in Nuremberg remain to be answered and are beyond the scope of this paper. When possible I have provided some information about the educational and business backgrounds of the patrons. An examination of the developments in education and humanistic curriculum upon the arts has yet to be done. On educational practices, see K. Goldmann, "Nürnberger Studenten an deutschen und ausländischen Universitäten, 1300–1600," *Mitteilungen aus der Stadtbibliothek Nürnberg* 12 (1963): 1–10.

2. The artists in Nuremberg, of course, continued to enjoy the patronage of princes, ecclesiastics, and wealthy merchants who lived outside the city. A goldsmith, such as Wenzel Jamnitzer, received commissions from across the continent.

3. On Landauer and Pirckheimer, see Smith, *Nuremberg*, pp. 25–26, 41–42, and 125, with additional literature. Pirckheimer studied law at Padua and Pavia between 1488 and 1495.

4. L. Grote, "Die 'Vorderstube' des Sebald Schreyer," *Anzeiger des Germanischen Nationalmuseum* (1954–59), pp. 43–67; E. Caesar, "Sebald Schreyer, ein Lebensbild aus dem vorreformatorischen Nürnberg," *Mitteilungen des Vereins für Geschichte der Stadt Nürnberg* 56 (1969): 1–213; Smith, *Nuremberg*, pp. 39–42, 94–95.

5. H. Stafski, *Der Jüngere Peter Vischer* (Nuremberg, 1962), pp. 9–36 and figs. 1–74; K. Pilz, *Das Sebaldusgrabmal im Ostchor der St.-Sebaldus-Kirche in Nürnberg—Ein Messinggus aus der Giesshute der Vischer* (Nuremberg, 1970); Smith, *Nuremberg*, pp. 26, 220.

6. Vienna, Akademie für bildende Kunste. See Stafski, *Der Jüngere Peter Vischer*, fig. 1.

7. A. Gümbel, "Sebald Schreyer und die Sebalduskapelle zu Schwäbisch-Gmünd," *Mitteilungen des Vereins für Geschichte der Stadt Nürnberg* 16 (1904): 125–150; Smith, *Nuremberg*, p. 49.

8. W. Schwemmer, *Adam Kraft* (Nuremberg, 1958), pp. 16–19 and figs. 1–5; Caesar, "Sebald Schreyer," pp. 152–156.

9. Schwemmer, *Adam Kraft*, pp. 19–24 and figs. 6–27. Albrecht Dürer is noted for including his portrait in such religious paintings as the *All Saints Altarpeice* (Vienna, Kunsthistorisches Museum) and the *Feast of the Rose Garland* (Prague, Nationalgalerie); see F. Anzelewsky, *Albrecht Dürer: Das malerische Werk* (Berlin, 1971), nrs. 118, 93. Was Dürer inspired by Kraft's well-known precedents?

10. Smith, *Nuremberg*, pp. 23–24, 93, 165.

11. Thomas à Kempis, *The Imitation of Christ*, tran. L. Sherley-Price (Harmondsworth, 1972), p. 85 (chap. 12).

12. Smith, *Nuremberg*, pp. 24–25.

13. G. Schiller, *Iconography of Christian Art*, tran. J. Seligman (Greenwich, Conn., 1972), 2: 194–195, 671ff. Schiller (p. 191) observed that the "devotions of the Arma Christi were connected with pardon or a promise of protection that assured Christ's mercy to him who suffered with him."

14. Smith, *Nuremberg*, pp. 162–163.

15. Ibid., p. 40; and Grote, "Die 'Vorderstube' des Sebald Schreyer."

16. Caesar, "Sebald Schreyer," pp. 104–135; Smith *Nuremberg*, pp. 40, 94–95, 103.

17. Smith, *Nuremberg*, pp. 30–36. Two major studies on this subject were published in 1983; see *Martin Luther und die Reformation in Deutschland*, exh. cat. (Nuremberg: Germanisches Nationalmuseum; Frankfurt am Main, 1983); *Kunst der Reformationszeit*, exh. cat. (Berlin[East]: Staatliche Museen; West Berlin, 1983). It should be noted that the city council forbade non-ecclesiastical burials within the city walls in 1518 and, in further regulations of 1520 and 1522, required tombs to be of stone and limited in decoration to a bronze plate with the name, coat of arms, and profession of the deceased. Thus, unlike in most German towns, there were no elaborate funerary monuments in Nuremberg after about 1520. Only in the seventeenth century did the wealthy families begin to revive this practice, as seen, for example, in Johann Kreuzfelder's *Beheim Family Epitaph*, painted in 1603 for St. Sebaldus, or the anonymous stone tomb of Bartholomäus Viatis in the Johannisfriedhof. See G. Pfeiffer and W. Schwemmer, *Geschichte Nürnbergs in Bilddokumenten*, 3d ed. (Munich, 1977), p. 42; *Baroque in Nürnberg, 1600–1750*, exh. cat. (Nuremberg: Germanisches Nationalmuseum, 1962), A46 and pl. 5 (Kreuzfelder); G. Seibold, *Die Viatis und Peller, Beiträge zur Geschichte ihrer Handelsgesellschaft* (Cologne-Vienna, 1977), p. CLXXVII.

18. C. C. Christensen, *Art and the Reformation in Germany* (Athens, Ohio, 1979), p. 43.

19. A critical monograph on Flötner is needed. On his work, see K. Lange, *Peter Flötner, ein Bahnbrecher der deutschen Renaissance auf Grund neuer Entdeckungen* (Berlin, 1897); Smith, *Nuremberg*, pp. 60–65, 224–233, with additional literature.

20. Lange, *Peter Flötner*, pp. 64–73; W. Schwemmer, *Das Bürgerhaus in Nürnberg* (Tübingen, 1972), pls. 23A, 105C. On the business activities of the Hirschvogel family, see the brief comments in L. Veit, *Handel und Wandel mit aller Welt* (Munich, 1960), p. 45; G. Pfeiffer, ed., *Nürnberg, Geschichte einer europäischen Stadt* (Munich, 1971), p. 181.

21. H. G. Gmelin, "Georg Pencz als Maler," *Münchner Jahrbuch der bildenden Kunst* 17 (1966), p. 86 (cat. nr. 22) and fig. 17; Smith, *Nuremberg*, p. 57. It is painted on twenty pieces of canvas that together measure 5.6 by 12.2 meters.

22. See note 21; Lange, *Peter Flötner*, pp. 64–84.

23. P. Strieder and L. von Wilckens, *Germanisches Nationalmuseum Nürnberg—Führer durch die Sammlungen* (Munich, 1980), nr. 229 (circle of Flötner). On his work in the Tucherhaus, see Schwemmer, *Bürgerhaus*, pl. 120B. On this subject, see O. von Falke, "Peter Flötner und die süddeutsche Tischlerei," *Jahrbuch der preussischen Kunstsammlungen* 7 (1916): 121ff.; H. Kreisel, *Die Kunst des deutschen Möbels* (Munich, 1968), 1: 63–74.

24. Kreisel, *Die Kunst des deutschen Möbels*, p. 66 and fig. 147.

25. H. Kohlhaussen, *Nürnberger Goldschmiedekunst des Mit-* telalters und der Dürerzeit, 1240 bis 1540 (Berlin, 1968), pp. 437ff.; Smith, *Nuremberg*, pp. 64–65.

26. Kohlhaussen, *Nürnberger Goldschmiedekunst*, nr. 465.

27. Ibid., nrs. 467, 469.

28. Lange, *Peter Flötner*, pp. 85–103; H. R. Weihrauch, *Europäische Bronzestatuetten* (Braunschweig, 1967), pp. 287–292.

29. T. Müller, *Deutsche Plastik der Renaissance bis zum dreissigjährigen Krieg* (Königstein im Taunus, 1963), pp. 12–13 and fig. 43; Weihrauch, *Europäische Bronzestatuetten*, p. 318.

30. Schwemmer, *Bürgerhaus*, pl. 85C.

31. On the city's craft organizations and the government's policy of encouraging talented masters to settle in Nuremberg, see Smith, *Nuremberg*, pp. 46–47, with additional literature.

32. Ibid., pp. 77–78; *Der Mensch um 1500: Werke aus Kirchen und Kunstkammern*, ed. H. Gagel, exh. cat. (Berlin [West]: Staatliche Museen, 1977), pp. 47–53 and, for van der Schardt's bust of Willibald's wife, Anna Harsdörffer, of 1580, pp. 54–57.

33. A. Springer, "Inventare der Imhoff'schen Kunstkammer zu Nürnberg," *Mitteilungen der kaiserl. königl. Central Commission* (Wien) 5 (1860): 352–357; Hampe, "Kunstfreunde," pp. 67–82, 108–120; Schwemmer, "Aus der Geschichte," pp. 123–124; *Der Mensch um 1500*, pp. 41, 47–54.

34. Springer, "Inventare," p. 354 (nr. 8); *Der Mensch um 1500*, pp. 51–52.

35. Schwemmer, "Aus der Geschichte," p. 123.

36. Springer, "Inventare," pp. 354–356 (nrs. 1, 4, 5, 8, 12, 14, 24).

37. Ibid., p. 356; Smith, *Nuremberg*, p. 108.

38. Springer, "Inventare," pp. 354–356 (nrs. 19–21, 28).

39. Ibid., p. 356. Many of these drawings are now in the Graphische Sammlung Albertina in Vienna. On the avid collecting of Dürer's works during the second half of the sixteenth and the early seventeenth centuries, see Schwemmer, "Aus der Geschichte," pp. 115–120.

40. Springer, "Inventare," p. 354 (nrs. 15, 18, 34, 41). Imhoff's tastes were less Italianate than many of his contemporaries. While the reasons for this have yet to be studied, a partial explanation is suggested by his upbringing. At age fourteen he was sent to the family trading office in Lyons, where he remained for four years. Imhoff spent the next three years in Antwerp before returning to Lyons for another three years. Between 1542, when he was twenty-three, and 1544 he worked in Spain, mainly in Saragossa. Although he did travel to Venice, most of his business was with France and Spain; he was frequently back in Lyons and Saragossa between 1554 and 1560. See "Imhoff, Willibald" in *Neue deutsche Biographie* (Berlin, 1974), 10: 150–151.

41. For this and the visits of several other important nobles and ecclesiastics who used the house during Willibald's lifetime, see Hampe, "Kunstfreunde," pp. 74, 110–113.

42. On the subsequent history of the collection, see Schwemmer, "Aus der Geschichte," pp. 123–124.

43. C. T. de Murr, *Description du Cabinet de Monsieur Paul de Praun à Nuremberg* (Nuremberg, 1797); Hampe, "Kunstfreunde," pp. 82–87; Schwemmer, "Aus der Geschichte," pp. 124–125.

44. De Murr, *Description du Cabinet*, p. 67.

45. Ibid., pp. 10ff. (nrs. 81, 87–91, 119, 120, 150, 156).

46. Ibid., pp. 29, 31 (nrs. 218, 239).

47. Ibid., pp. 3–32 for the inventory of paintings.

48. Ibid., pp. VII, 3–32.

49. Ibid., pp. 230–236.

50. Ibid., p. 241.

51. On this subject, see J. von Schlosser, *Die Kunst- und*

Wunderkammern der Spätrenaissance—ein Beitrag zur Geschichte des Sammelwesens, 2d ed. (Braunschweig, 1978).

52. De Murr, *Description du Cabinet*, pp. 230–485. On the portrait of Praun, see E.F. Bange, "Ein Tonrelief des Johann Gregor van der Schardt," *Münchner Jahrbuch der bildenden Kunst* n.f. 1 (1924): 169–171 and fig. 2 (then in Stuttgart).

53. De Murr, *Description du Cabinet*, pp. 240–241.

54. Ibid., pp. 486–489.

55. Ibid., pp. 484–485.

56. On Rudolf II, see Schlosser, *Die Kunst- und Wunderkammern*, pp. 120–126; T. D. Kaufmann, *Variations on the Imperial Theme in the Age of Maximilian II and Rudolf II* (New York, 1978), pp. 103–123; the series of articles in "Rudolf and His Court," *Leids Kunsthistorisch Jaarboek* (1982). On Ferdinand, see Schlosser, pp. 45–118; P. W. Parshall, "The Print Collection of Ferdinand, Archduke of Tyrol," *Jahrbuch der kunsthistorischen Sammlungen in Wien* 78 (1982): 139–184.

57. While these collections were intended to be preserved, questions about the maintenance of the holdings and who, other than family members, would have access to the objects have yet to be addressed.

58. Schwemmer, "Aus der Geschichte," p. 125.

59. The house was erected between 1602 and 1605, and the elaborate courtyard was constructed between 1605 and 1607. R. Schaffer, *Das Pellerhaus in Nürnberg* (Nuremberg, n.d. [1934]); Schwemmer, "Aus der Geschichte," pp. 126–127, and *Bürgerhaus*, pp. 71, 81, 117, 119–120, and pls. 67, 100, 103, 128A, 129; Siebold, *Die Viatis und Peller*, esp. pp. 114–123; Smith, *Nuremberg*, pp. 76–77. Martin Peller was born in Radolfzell and was sent to Venice in 1575 to learn about business. It was here that he probably first encountered Bartholomäus Viatis, one of Germany's wealthiest merchants. Peller is mentioned in Nuremberg in 1580. Eight years later he is recorded, together with Horaz Fenzel, as Nuremberg's counsel at the Fondaco dei Tedeschi in Venice. On 26 February 1590 he married Maria Viatis and in the following year founded the Viatis-Peller company with his father-in-law, Bartholomäus. Peller became a Nuremberg citizen only in 1596. Although the Viatis-Peller company had branches throughout Europe, most of its trade was with Italy. Peller's fascination with Italianate architecture is thus understandable. On Peller's life, see Seibold, pp. 78–86.

60. Another neighbor was the print collector Melchior Ayrer; see Hampe, "Kunstfreunde," pp. 87, 110. The best view of the Egidienplatz in the seventeenth century is given in Johann Ulrich Kraus's engraving after Johann Andreas Graff's design; see Seibold, *Die Viatis und Peller*, p. CLXIX.

61. Schwemmer, *Burgerhaus*, p. 71.

62. Ibid., p. 76.

63. Schaffer, *Das Pellerhaus in Nürnberg*, pp. 22–24 and figs. 3–8; C. C. Christensen, "The Nuernberg City Council as a Patron of the Fine Arts, 1500–1550," dissertation, Ohio State University, 1965, p. 69; Siebold, *Die Viatis und Peller*, pp. 115–116.

64. Sebastiano Serlio, *The Five Books of Architecture—An Unabridged Reprint of the English Edition of 1611* (New York, 1982), chapt. 5, fols. 5 verso and 7. On the editions of Serlio, see J. von Schlosser, *La Letteratura artistica*, 3d Italian ed. (Florence, 1977), pp. 418–419.

65. Schwemmer, *Bürgerhaus*, pls. 86, 87, 89—Tucherstrasse 21 of 1609; Weinmarkt 6 of 1616 owned by a member of the Praun family; and Karlstrasse 3 of 1610–1620.

66. Schaffer, *Das Pellerhaus in Nürnberg*, pp. 36ff. and figs. 27–28; F. Traugott Schulz, "Werner, Hans," in *Allgemeines Lexikon der bildenden Künstler von der Antike bis zur Gegenwart*, ed. U. Thieme and F. Becker (Leipzig, 1941), 35: 409–412. All four doorways are reproduced in the *Marburger Index*, fiche nr. 2563, KBB 1511–1514; Schwemmer, *Bürgerhaus*, pl. 129.

67. A. K. Placzek, intro., *The Fantastic Engravings of Wendel Dietterlin—The 203 Plates and Text of His Architectura* (New York, 1968).

68. Schwemmer, "Aus der Geschichte," p. 127. After finishing this article, I learned of the excellent short study of Peller's painting collection; see G. Seibold, "Die Pellersche Gemäldesammlung," *Anzeiger des Germanischen Nationalmuseums* (1982), pp. 70–82.

69. On Juvenel and this chamber, see Schaffer, *Das Pellerhaus in Nürnberg*, pp. 13, 36 and figs. 34–38; Smith, *Nuremberg*, pp. 72–73, 301–302 and fig. 43.

70. A thorough economic history of Nuremberg patronage remains to be done. Such collectors as Paulus Praun, Willibald Imhoff, Bartholmäus Viatis, and Martin Peller were much wealthier than their predecessors. Comparative data, while probably available, have yet to be gathered. According to Seibold, when Mattheus Landauer died in 1515, his estate was valued at 31,514 florins. Andreas II Imhoff, Willibald's cousin and business partner, left an estate worth about 200,000 florins in 1597. The property of Martin and Maria Peller, calculated only in 1641 following her death, was assessed at 206,945 florins, which in fact may represent only about half of Martin's worth in 1629 since his share in the Viatis-Peller company alone was set at 225,346 florins in 1609. Bartholomäus Viatis's wealth at his death in 1625 was determined to be 1,098,862 florins. The elaborate residence and the extensive artistic collections of the later patrons coincide with the amassing of great wealth. Since their businesses were increasingly international in scope, it should not be surprising that their artistic tastes also became more complex. The financial data cited above are given in Seibold, *Die Viatis und Peller*, pp. 87, 234, 241–242, and 276–283.

71. On artistic patronage in the later seventeenth century, see Hampe, "Kunstfreunde," pp. 88–102; Schwemmer, 'Aus der Geschichte," pp. 127–130.

Notes On The Contributors

CHRISTIANE D. ANDERSSON received her Ph.D. in 1977 from Stanford University. She taught at Columbia University before accepting the position as Curator of Northern Renaissance Painting at the Städelsches Kunstinstitut in Frankfurt. Dr. Andersson is a specialist in Renaissance drawings. Her extensive list of publications include *Dirnen, Krieger, Narren: Ausgewählte Zeichnung von Urs Graf* (Basel: GS-Verlag, 1978); co-organizer (with Charles Talbot), *From a Mighty Fortress: Prints, Drawings, and Books in the Age of Luther, 1483–1546* (Detroit: Detroit Institute of Arts, 1983); and articles on Urs Graf, Niklaus Manuel, Lucas Cranach the Elder, and censorship in German art. She is presently completing a monograph on the drawings of Urs Graf.

THOMAS DACOSTA KAUFMANN received his Ph.D. in 1977 from Harvard University. He is currently an Associate Professor of Art History at Princeton University. Professor Kaufmann has written at length on the court of Rudolf II at Prague and on theoretical issues in Northern European art. His publications include *Variations on the Imperial Theme in the Age of Maximilian II and Rudolf II* (New York: Garland Publishing, Inc., 1978); *Drawings from the Holy Roman Empire, 1540–1680: A Selection from North American Collections* (Princeton: Princeton University Press, 1982); *L'Ecole de Prague: la Peinture à la Cour de Rodolphe II* (Paris: Librarie Ernest Flammarion, 1985) and articles on "mannerism," the theory of shadow projection, Arcimboldo, and Adriaen de Vries. Among other projects, he is presently working on a study of Central European drawings of the eighteenth century.

KEITH P. F. MOXEY received his Ph.D. in 1974 from the University of Chicago. He is currently an Associate Professor of Art History at the University of Virginia. Professor Moxey's research has focused upon the development of secular themes in Northern Renaissance art. Among his publications are *Pieter Aertsen, Joachim Beuckelaer and the Rise of Secular Painting in the Context of the Reformation* (New York: Garland Publishing, Inc., 1977) and articles on the theme of folly, iconoclasm, Pieter Aertsen, Joachim Beuckelaer, Pieter Bruegel the Elder, Housebook Master, Master E. S., and Sebald Beham. He is preparing a book of essays on the functions of secular imagery.

LARRY A. SILVER received his Ph.D. in 1974 from Harvard University. He is currently a Professor and Chair of Art History at Northwestern University. Professor Silver has published extensively on satirical and moralizing themes in Netherlandish art. Among his writings are *Prayer and Laughter: The Paintings of Quinten Massys* (Montclair [New Jersey]: Allenheld and Osmun, 1984); catalogues of the Northern Renaissance painting collections of the Ringling Museum of Art in Sarasota and the Saint Louis Art Museum; and articles on Albrecht Altdorfer, Jan van Eyck, Lucas van Leyden, and Quentin Massys. He is presently preparing a book-length study on the patronage of Maximilian I and an article on the notion of microcosm in the art of Albrecht Altdorfer.

JEFFREY CHIPPS SMITH received his Ph.D. in 1979 from Columbia University. He is presently an Associate Professor of Art History at The University of Texas at Austin. Much of his research has been concerned with the artistic patronage of Philip the Good, Duke of Burgundy (1419–1467) and the artists of Nuremberg. His publications include *Nuremberg, A Renaissance City, 1500–1618* (Austin: The University of Texas Press, 1983); *Seventeenth-Century Dutch Landscape Drawings from a Private Collection*, exh. cat. (Austin: The Archer M. Huntington Art Gallery, 1982); and articles on the art at the Chartreuse de Champmol, Burgundian tombs, and Jan van Eyck. Professor Smith is currently working on a book of German sculpture of the late Renaissance, 1525–1618.

Archer M. Huntington Art Gallery Staff

Designed by Barbara Jezek

Typography by G&S Typesetters, Inc., Austin, Texas

Printed by Hart Graphics, Austin, Texas